Bruce F. Kawin

MINDSCREEN

Bergman, Godard, and First-Person Film

PRINCETON UNIVERSITY PRESS
Princeton, New Jersey

Library of Congress Cataloging in Publication Data will
be found on the last printed page of this book

Publication of this book has been aided by a grant
from The Andrew W. Mellon Foundation

Clothbound editions of Princeton University Press books
are printed on acid-free paper, and binding materials
are chosen for strength and durability

This book has been composed in Linotype Baskerville

Printed in the United States of America
by Princeton University Press, Princeton, New Jersey

One thinks that one is tracing the outline of the thing's nature over and over again, and one is merely tracing round the frame through which we look at it.
—Ludwig Wittgenstein,
Philosophical Investigations

CONTENTS

LIST OF FIGURES

ix

PREFACE

This book is an attempt to address one of the central problems of film theory: who narrates a narrative film? The classic assumption is that all film narration is third person—and must be, since the camera can record and present only *its*. What I hope to show is that although a camera does not have consciousness, and cannot therefore literally be an *I*, it is possible to encode the image in such a way that it gives the impression of being perceived or generated by a consciousness. Although this mind remains offscreen, its existence is implicit and can be integrated into the fiction, with the result that the field is properly termed first person.

Although this is not a history of first-person film, the reader will find that examples are taken from works as old as *The Life of an American Fireman* (1903), *The Cabinet of Dr. Caligari* (1919), and *Sherlock Junior* (1924), and as recent as *Persona* (1966), *Tout va bien* (1972), and *Annie Hall* (1977). The films are arranged according to the complexity of their narrative systems, so that what emerges—although it has historical implications—is a demonstration of the range and structure of what, at the risk of proliferating terms, I call mindscreen cinema. A mindscreen is a visual (and at times aural) field that presents itself as the product of a mind, and that is often associated with systemic reflexivity, or self-consciousness. These two first-person modes, mindscreen and self-consciousness, are kept as separate as possible during the first part of the book, which is an overview of first-person modes, and are interrelated in the second part, which explores the possibility that these modes are at the heart of an emerging genre.

The specific films I discuss have been chosen, then, not for their historical importance but for what they reveal about the dynamics of film narration. In most cases, sufficient information is given about each film to enable the

reader who has not seen it, or not seen it recently, to follow the argument. I hope, then, that this book will find an audience not just of professional theorists but of film enthusiasts in general, and that it will enrich their appreciation of how film works, and how it is being used.

My thanks are due to Frank McConnell and Judy Zatkin, who gave the manuscript the benefit of their comments and sustained me by their unflagging encouragement; to Stan Brakhage, Frantisek Daniel, David James, Joseph Juhasz, Marian Keane, Hugh Kenner, Marilyn Rivchin, Linda Williams, and Holly Yasui, who helped me think the book out or suggested revisions; to Elsi Frederiksen, who typed it; to Joan Gilbert, who took it on; to Ernest Callenbach and Joanna Hitchcock, who guided it toward its present form; and to my father and mother, to whom it is dedicated.

Boulder, Colorado
October 1977

PART ONE

First-Person Structures

Something about the lens is very akin to the human consciousness which looks out at the universe.

—King Vidor

The stars are the optical nerve-endings of the eye which the universe is.

—Stan Brakhage

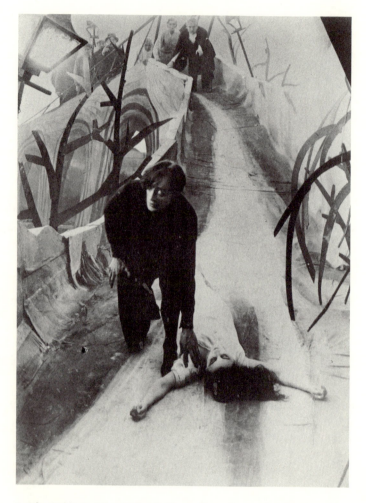

1. *The Cabinet of Dr. Caligari*: Cesare drops Jane and continues to flee through the landscape of Francis's mind.

The Mind's Eye

Film is a dream—but whose? One rests in the dark, and sees; one is silent, and hears. One submits to the dream-field, yet actively scans it—for play, for release, for community, solitude, truth. The viewer's interplay between passivity and creation is analogous to the sleeper's, since both forget, almost continuously, that the dream-world is "made"; only while picking the fantasy over in the daylight or breaking contact with the narrative field is one moved to congratulate oneself, or the artist, for thinking up so many wonders. In the dark one participates, thinks, and guides the eye. Whether the film is nonrepresentational or documentary, whether it tells a story or simply weaves the light, it presents itself to the audience as privileged vision: an image the mind can search, a revelation to deny or accept.

The filmmaker dreams in the daylight—stages, blocks, budgets, points, shoots, edits, writes, acts—solo or as a member of a collective: but always with reference to the image he creates for the dark. The film lives under his eyelids, till the means of reproduction make it public. Between the dreaming artist and the dreaming audience, the artifact mediates.

Most analyses of film consciousness have swung on these two gates and left out the garden. Might not the artifact, too, have or imitate mindedness? The dialectic between the world before the camera and the image before the projector; the relationships between the artist's intentions, the emotive capacity of the image, and the audience's response; the mutual influence of guided fantasy and willed behavior —all these have been opened to question. Auteur criticism, in particular, has paid so much attention to the ways

an artist (director or not) manifests himself in his work that the questions of who *narrates* the work and of how, as a pseudo-autonomous text, the film might construct or comment upon itself, have come to sound almost foolish. Marxist semiotics, on the other hand, has reacted against the bourgeois emphasis of much auteur criticism and has called attention to the ways an image itself can be encoded and thence to the ways an audience deals with this culturally predetermined iconography.

I do not mean to oversimplify or disparage the achievements of film theory and criticism here, but there does appear to be a need for a more complex rhetoric of film than has yet been attempted. The issues of narrative consciousness and reflexivity have hardly been defined for film. The "impersonal" nature of photography, for instance, appears to have dominated many of our rhetorical assumptions, so that a wide range of film theorists generally accept that a film must be narrated in the third person, whether it tells a story or not. The image, however encoded or manipulated, is presumed to consist of *he*s and *she*s and *it*s. While it seems reasonable to agree with one of the implications of this approach—that the organizer of the image must be offscreen—it does not seem necessary to deny the possibility that the organizer, as a persona of the artist or even just as a character, can be fictitious, and that he can include an image of himself (or an indicator of his offscreen presence) in the filmed field without compromising his status as narrator. I do not mean to negate the importance of such nonfictional organizers of the image as the filmmakers, the interpretive audience, or the culture itself; clearly, they exist, and contribute to what can be structured, presented, and seen. Clearly, the selective intelligence of the filmmaker is always at work, whether he keeps a large field in deep focus, or interrelates its fragments through montage, or fires the camera "at random." The frame itself is selective; two-dimensionality itself is artificial; the world itself is politicized and emotive. There is much to analyze, much that is seen

4

to be *meant*, in even the most third-person photographs.

Still, any art would be impoverished if it could speak only in the third person. The reader of *Moby-Dick*, for example, recognizes his own creative interpretation of the novel's world, and Melville's structural intentions, and whaling as a capitalist process that exists in reality—but he is also aware of the narrator, Ishmael, who is neither Melville nor the reader nor whaling. As an essential condition of one's response to the novel, one forgets at some point that Ishmael is Melville's puppet, just as one forgets that the camera is not independent.

The audience at a film is presented with a world; the question remains what is "a fictitious presenter"? How can it be recognized, how responded to? If a film, which is already both the dream of its maker and the dream of its audience, can present itself as the dream of one of its characters, can it, finally, appear to dream itself? Implicit in my ordering of these questions is the assumption that there are several narrative modes and voices in film; I shall try to clarify these before going further.

A narrator is someone who does not simply speak, but tells. As a medium of presentation and communication occurring in time, film is no less a "language" (or system of signification) than literature. Although it is "spoken" by some combination of filmmaker and movie theater, it can *appear* to be spoken by a character within the fiction, or by the filmmaker who intrudes in his own voice.

The simplest kind of narration to recognize is, of course, the purely verbal or voice-over. Buñuel's *Land without Bread (Las Hurdes,* 1932), for instance, includes a mock-travelogue voice-over commentary by Pierre Unik. The audience feels, with some justification, that it is not simply eavesdropping on the people of Las Hurdes but is being *told* about them. Both here and in Resnais's *Night and Fog* (1956; commentary by Jean Cayrol), the voice-over narration counterpoints rather than simply explains what one is seeing, so that both word and image function as narrative

units. The camera, as an active presence, probes and relates, but does not assign its viewpoint to any character. In the later work of Resnais and Buñuel, however, the subjectivity of both camera and commentary is often fictionally assigned, as when the soldier narrates his death-dream in *The Discrete Charm of the Bourgeoisie* (1972), or the actress her visit to the museum in *Hiroshima, mon amour* (1959).

Voice-over narration is a literary device—one that is, in fact, often used to anchor an adaptation in its literary source. *Finnegans Wake* (1965), for instance, like *The Reivers* (1969) or *A Clockwork Orange* (1971), is haunted by the eloquence of the novel, and continually returns to the voice of the story teller as if to an oasis—not because the imagery is unable to sustain interest or clarity, but because the film aspires, among other things, to some kinship with literature.

When the voice-over narration is assigned to a fictitious speaker, it expresses not the filmmaker's judgments on his material (as in *Night and Fog*) but the character's interpretive response to his own experience. Whether the narrator talks directly to the audience, as Alex in *A Clockwork Orange*, or to himself, as Charlie in *Mean Streets* (1973), one understands that the film is limited to this character's point of view, that one is seeing the world as Alex or Charlie presents it. I say "presents" rather than "experiences" so as not to exclude the possibility of a narrator who lies, and to maintain the emphasis on narrativity rather than subjectivity. It is necessary, however, to clarify the nature of subjective presentation before returning to the issue of narration.

Subjectivity is essential to any first-person construct, but many uses of subjective imagery function without specifically first-person narrative intent. When a fight scene is heightened by a shot of a fist's heading straight for the camera, one understands that the victim's angle of vision is being shared for a moment, but one does not necessarily go chasing through the film in search of a consistently sub-

6

jective point of view. In this case the subjective angle is merely one of many available camera positions.

In the opening sequence of *Rebecca* (1940), however, both the tracking camera and the moody voice-over explicitly belong to a first-person narrator. Her opening line, "Last night I dreamed I went to Manderley again," makes it clear that the image takes place in her dreaming mind (or that her narrating mind is re-creating the image of her dream). Even when the heroine appears before the camera, one understands that this is still *her* story; it is not necessary, in other words, for the audience to share her angle of vision in order to feel itself confined to her point of view. (In order not to lose sight of this distinction, I have avoided the term "point of view shot," or POV, to describe subjective camera.)

In another Hitchcock film, *Spellbound* (1945), several varieties of first-person narration occur. At the end of the film, one shares the villain's angle of vision as he looks from behind his revolver at his accuser, then turns the revolver to fire point-blank at himself; no voice-over is necessary to make the audience understand that this is a first-person image. In the more complicated sequence of the hero-doctor's dream, however, voice-over combines with subjective imagery (designed by Salvador Dali) to give the impression not only that one is sharing the dreamer's experience (as one shares the sight of the gun), but also that the hero is deliberately telling his dream as he relives it. As a whole, *Spellbound* is narrated anonymously, in the third person, but includes first-person sequences.

There are, then, two ways of using what is generally called "subjective camera": to show what the character sees, or to show what he thinks. The first mode is that of the physical eye, the second is that of the mind's eye. The modes overlap in many Surrealist and Expressionist sequences, but it will clarify matters to examine them separately.

The first mode, as has been suggested above, is commonly

used only to achieve momentary identification between character and audience, or for shock effects (the revolver in *Spellbound*). For technical reasons, it is rarely used at length; the most noteworthy exceptions are Robert Montgomery's *Lady in the Lake* (1946)—where the hero appears only in mirrors—and the first half of Delmer Daves's *Dark Passage* (1947). (It is also worth mentioning Orson Welles's unproduced *Heart of Darkness* [1940], in which both subjective camera and a Welles voice-over were to embody Marlow, with Welles appearing before the camera as Kurtz—an intriguing way to dramatize Conrad's "secret sharer" theme.) One of this mode's recent vehicles, the wide-angle close-up, appears strikingly unrealistic when the near object (or the camera) moves. The huddling faces in John Frankenhemier's *Seconds* (1966), for example, are much harder to accept than the hovering face of the scientist in Chris Marker's *La Jetée* (1962), a film made up almost entirely of stills. Such distortion paradoxically contributes to the realism of a film like *2001* (1968), however, in which the eye of the character (HAL) is *supposed* to be a wide-angle lens. Such effects become ludicrous when they are not perfectly executed in terms of the human facial anatomy—as when a glass of wine is raised to lens height and poured out just below camera range to give the illusion of drinking, or where the filmed subject attempts a passionate kiss of the tripod. Most such shots leave out those portions of the face and body one's own eye normally sees. Furthermore, most camera movements are slower than eye movements (so the image can remain clear) and of a completely different nature: more akin to movements of the head, complicated by a neckbrace. And a cut, short of blinking, is virtually out of the question.

Resnais gets around these problems by deliberately ignoring the conventions of animal movement. His fluid trackings through the corridors at Marienbad or the hospital and museum at Hiroshima are movements of the mind more than of the physical eye. As the characters fantasize, remem-

ber, or concentrate on certain places and events, the camera acts out the movements of their attention. At times Resnais achieves great realism by juxtaposing both modes of subjective camera, as when the actress in *Hiroshima* sees the twitching hand of her Japanese lover in one shot, and remembers the twitching hand of her German lover in the next-but-one (a shot of her own face intervenes).

The earliest use of this second mode occurs in Edwin S. Porter's *Life of an American Fireman* (1903). As described in the Edison Catalogue:

> The fire chief is dreaming and the vision of his dream appears in a circular portrait on the wall. It is a mother putting her baby to bed, and the impression is that he dreams of his own wife and child. He suddenly awakens and paces the floor in a nervous state of mind, doubtless thinking of the various people who may be in danger from fire at the moment.[1]

Here a first-person shot is vignetted within a third-person shot as a sort of thought balloon. In 1908, D. W. Griffith arrived at a more flexible and sophisticated device for showing what a character might be thinking: the subjective cutaway. In his first version of Tennyson's *Enoch Arden (After Many Years)*, Griffith cut from a shot of Enoch's wife (disconsolate over his long absence) to a shot of Enoch himself, stranded on a remote island. Since Annie has in fact no idea where Enoch is, it is perhaps necessary to describe this as a primitive instance of parallel cutting, but the impression is nevertheless given that Annie is thinking of Enoch, whether or not the inserted shot precisely incarnates her fantasy. By the time he made *Judith of Bethulia* (1914) Griffith had learned how to make it explicit that a character is imagining what is shown in this kind of cutaway. The heroine of that film, wavering in her resolve to kill Holofernes, "sees" images of her people starving in the streets of Bethulia, then cuts off the head of her lover/enemy. If this were a third-person insert shot of her people's troubles in-

stead of a direct presentation of Judith's thought process, the reason for her change of heart would not be clear; as it is, the subjective insert and its aftermath (the murder) stand in an evident cause-and-effect relationship.

In his masterpiece, *Mother* (1926), Pudovkin experimented with more complex uses of subjective camera and subjective montage. Early in the film, the mother watches her son, Pavel, hide a parcel of guns and leaflets under a floorboard. She is half-asleep, and the image comes only gradually into focus. The camera's position is hers, in bed; an iris indicates the concentration of her attention on Pavel; and the shifting focus unmistakably identifies the image as her visual field. Later on, just before the police question Pavel in this same room, the mother remembers (via a cutaway) what she saw; a series of dissolves goes on to make her *thinking* manifest. She looks at the loose floorboard; a dissolve appears to penetrate the floor and reveal the parcel; a further dissolve to the "opened" parcel reveals the guns. In the "Tomorrow!" sequence near the end of this film, a montage of images of exuberance expresses Pavel's emotion on discovering a plan to release him from prison. Clearly, he is not looking at a happy child or rushing water; he is probably not even thinking of them. But the images express, metaphorically, what his thinking feels like, and belong therefore to the second subjective mode.

There are, then, three familiar ways of signifying subjectivity within the first-person narrative field: to present what a character says (voice-over), sees (subjective focus, imitative angle of vision), or thinks. The term I propose for this final category is *mindscreen*, by which I mean simply the field of the mind's eye. From here on I shall use the term *subjective camera* to denote only the field of the character's physical eye.

All three modes can include distortion. A voice-over narrator can lie, contradicting either what appears in the visual field ("You saw nothing at Hiroshima") or what the audience surmises "really happened" (*Rashomon*, 1950). Sub-

jective camera can imitate anything from nearsightedness to X-ray vision, as in Roger Corman's *X—The Man with the X-Ray Eyes* (1963). And the mindscreen can present the whole range of visual imagination—not just Dorothy's dream of Oz (1939), or the unverifiable memories of Marienbad (1961), but also the interpretive bias of private experience (*Citizen Kane*, 1941).

The opening of *Rebecca*, then, though it includes both voice-over and what appears to be subjective camera, is primarily an instance of mindscreen, since it presents what the character imagined in her sleep. There are numerous examples of such overlap, some of which do not admit of resolution. In Abel Gance's Surrealist short, *La Folie du Docteur Tube* (1914), the world is presented as a mad doctor sees it after experimenting on himself. There is no way to determine whether these stretched, spread, and otherwise grotesquely distorted images belong to the doctor's physical or mind's eye. (In *X*, it is obviously the physical eye that is affected, as in Emile Cohl's *Hasher's Delirium* or Porter's *Dream of a Rarebit Fiend*—both 1906—it is the mind's.) There are instances, too, where the modes occur not in confusion but in combination. Like that of *Rebecca*, the opening of *Hiroshima* employs both voice-over and mindscreen. The shot in *8½* that presents Guido's being handed a glass of mineral water by his fantasy-angel instead of by the mundane attendant employs subjective camera to identify itself as *his* fantasy. It is entirely possible, of course, for the "dreamer" to occur as a "he," or object, in his own mindscreen, as is the case in *The Wizard of Oz* or *An Occurence at Owl Creek Bridge* (1961).

It is, then, comfortable to include in one's response to an image the possibility of its fictitious origin. Indeed, once one admits the notion of the *authorial* persona (or fictionalized author), it becomes much easier to deal with apparently unmotivated subjective imagery. *Persona* (1966), for instance, continually appeals outside itself to a dreaming mind that it would be simplistic to identify as either Berg-

man's or the boy's in the morgue. The sets of *The Scarlet Empress* (1934), and the image of Dietrich herself, on the other hand, appear to have proceeded, without the intervention of a persona, directly from the mind of Von Sternberg. (To the extent that *The Scarlet Empress* successfully integrates this imagery into its own "world," however, its subjectivity comes to seem internally motivated, and therefore autonomous.)

In this latter sense, many films as wholes—those of Stan Brakhage, for instance—literally represent the mindscreens of their makers. Lest the term get out of hand, however, let me suggest that in such cases the authors are acting as narrators, and that not only certain first-person sequences, but also sustained narrations can be identified as the visualized mentations of their "speakers." Even with this qualification, mindscreen begins to suggest itself as an encyclopedic term for "visual narration." It must be emphasized, then, that mindscreens belong to, or manifest the workings of, *specific* minds. A mindscreen sequence is narrated in the *first person*. There will be times the filmmaker casts himself as a narrator, whether in the flesh ("This is what *we* saw at Las Hurdes . . .") or as a persona. The filmmaker may posit a fictitious persona ("Last night I dreamed I went to Manderley again"), a credible one (the budgeteers at the opening of Godard's *Tout va bien* [1972]), or a version of himself.[2] When the filmmaker keeps himself out of it and presents his images in the third person (as Lumière does, for instance), his therapist can call the film a mindscreen, but we do not have to.

All three modes of first-person discourse, then—voice-over, subjective camera, and mindscreen—can be presented as if they were fictitious in origin. (*8½* is Fellini's mindscreen, but presents itself intermittently as Guido's.) All three present their origins as outside the image field; the audience is led to imagine an offscreen speaker, seer, or image-maker who is not necessarily the auteur. When the image-maker appears within the field, the audience understands that this is

12

his imagined self-portrait (Dorothy is offscreen, in bed). The intimacy of these modes contrasts markedly with those of the stage, where a narrator must appear in the flesh and talk about his experience.[3] (*Strange Interlude* is a relevant exception, in which one hears the characters' unspoken thoughts.) When the narrative techniques of *Our Town* are used in film, as in *Amarcord* (1974), one tends to reject them and seek out a more cinematic "first person"—in the case of *Amarcord*, the boy whose experience is the center of attention, in preference to the "citizen" who addresses the camera. Film is closer to literature, then, in its ability to allow the audience to participate in—rather than hear about—a character's life-space. It is insufficient, however, to identify modes of first-person narration; it remains to establish just what narrativity is.

As Christian Metz has observed—taking his cue from Albert Laffay—the very existence of an image indicates that it has been selected and arranged by some narrating intelligence, whether that be the intelligence of the filmmaker, of "the film itself as a linguistic object," or of "a sort of 'potential linguistic focus' situated somewhere behind the film." The viewer "is leafing through an album of predetermined pictures, and it is not he who is turning the pages but some 'master of ceremonies,' some 'grand image-maker.' . . ."[4] (Such a discussion applies to third- as well as first-person narration, of course, with the distinction arising from the manner in which this "linguistic focus" is characterized— or, more precisely, ascribed.) The image does not simply *appear*, but gives the impression of having been *chosen*. It is in this sense that the distinction I asserted earlier between speech and narration—that the narrator *tells*—becomes applicable to cinema. An image is the result, and the indicator, of directed attention. The filmmaker (or his surrogate) points the audience's eye *at* something, whether the film documents a period in history (*The Sorrow and the Pity* [1970]), tells a story (*Psycho* [1960]), or is the product of a wild night with salt and pepper and thumbtacks (*Re-*

turn to Reason [1923]). Although this last example reminds one that a film can be made without the use of a camera, it will simplify matters to identify the camera as the narrator's vehicle, his principal means of guiding the audience's attention. (This is not to ignore the eye-attractance of *mise en scène*, movement within the frame, composition, etc.) To point a camera at something, then, may indicate discursive intent. In the cinema, to show deliberately is to tell. Just as "discourse is not language,"[5] a perceptibly random series of images fails to generate the sense of narrativity. It is "filmic manipulation," as Metz observes, that "transforms what might have been a mere visual transfer of reality into discourse."[6]

It is unnecessary, then, to present a character in a conventional "story-telling" pose in order to identify him to the audience as a narrator (as Wilder and Chandler do in *Double Indemnity* [1944], whose hero relates his story into a dictaphone—and, subsequently, voice-over). One is alerted by camera position, montage, etc., to narrative intent, and by what emerges as the logic of their changes to narrative bias. The remainder of this book will explicate these ideas, but for the moment a short look at Bergman's *Cries and Whispers* (1972) should help to clarify the ways in which bias and intent can be ascribed, so that they become not just properties inherent in the image field as a "linguistic" object, but recognizable elements of the fiction.

Cries and Whispers is the story of four women: Agnes, who is dying of cancer; her two sisters, Karin and Maria; and Anna, her maid. The film is carefully, almost geometrically structured to explore two contrasts: that between community and isolation, and that between spiritual and physical pain. Agnes, who thrives on loving companionship, suffers intense physical pain; she is nurtured by Anna, who freely and physically comforts her. The fact that both Anna and Agnes are devout is something of a red herring (as the minister's speech and the final sequence from Agnes's diary make explicit): their principal comfort, and their means of

banishing the "whispers and cries" that beset them, is their commitment to love and friendship. (This theme, which is general in Bergman's work, is here most convincingly divorced from the issue of religion, although it finds related expression in *Wild Strawberries* [1957], *Through a Glass Darkly* [1961], and to some extent *Persona*.) Karin, who is terrified of—and starving for—intimacy, is in spiritual (or psychological) pain, but has for her nurturer only the selfish and insincere Maria. When Agnes dies, halfway through the film, the emphasis shifts from her pain to Karin's.

Each of the women is presented in her aloneness and in relationship with the others. Each woman has an extended first-person sequence, and among these sequences there is a structure of ascending intimacy. (The burden of the film, then, appears to be on the side of loving, of community, and of self-knowledge.) In response to the vastly differing capacities for openness and loving touch each woman possesses, their subjective sequences achieve different degrees of intimacy. The audience is encouraged to enter deeply the mind of Anna, for instance, but is largely kept outside of Maria and Karin. Appropriately, Bergman exploits the differences in intimacy of the various narrative modes to control the intimacy of the respective sequences.

The film as a whole is third person: there is no character to whom the film's overall narrativity is ascribed. The opening montage of dawn and clocks is an objective introduction to the house in which the action takes place. (Compare the opening of Resnais's *Providence* [1977].) Agnes wakes up in pain and goes to her diary, where she writes (and we hear), "It is early Monday morning and I am in *pain*." This is the most literary first-person mode. She looks into the next room, where Maria is sleeping; the mode is subjective camera. Soon afterward, Agnes begins to think about her mother. While she addresses herself (and the eavesdropping audience) in the first person, voice-over, her mindscreen presents images both of the mother and of herself as a young girl. The voice-over makes plain that Agnes

15

is attempting to organize and understand this experience—that the sequence is not a directorial flashback but a deliberate and presented memory: a first-person narrative in both word and image, rather literary in feel, but—for the audience—more interior than either the diary entry or the shot of Maria asleep.

The next private sequence, Maria's, is introduced voice-over by a male. He informs the audience that the forthcoming scenes took place "some years ago." One watches Maria's attempt to seduce the family doctor, and her husband's aborted suicide attempt, with the understanding that although Maria is the central figure in these scenes, she is not their narrator. The mode is third person, but might be more precisely designated "point of view," in that the story is confined to Maria's experience; the narrator avoids the appearance of omniscience and limits himself to presenting the world as Maria sees it. (This is the method of *The 400 Blows* [1959] and *The Maltese Falcon* [1941], as it is of most of Henry James's major fiction.)

Karin's sequence, too, is presented by the male narrator. Like Maria's, it presents a dinner scene, a bedroom scene, and an act of bloody self-mutilation (although here the woman, not her husband, performs the act). Again the mode is point of view, but the impression of self-knowledge is more intense. Whereas Maria's sequence is tied into the plot by a simple act of association (another attempt to seduce the doctor), Karin's appears not simply to explain but to influence her behavior during the second half of the film, as if she had been *considering* her fear of intimacy.

Anna's sequence, however, is pure mindscreen. No voice-over is necessary; one understands almost immediately that Anna is having a dream in which Agnes demands to be comforted after death. (This is not to deny the possibility that Agnes does need such loving, and is, as a ghost, appearing to Anna in a dream.) One sees the world as Anna imagines it; one shares her mental experience. Point of view is not operative here, since Anna, the dreamer, is creating, or deliber-

16

ately manipulating, the image. (It is not necessary that she be aware of presenting the image to an audience, as a narrator often is in first-person literature; if she were, however, I would propose that the mode be identified as self-consciousness. As with Agnes, the audience here is eavesdropping on a first-person sequence, rather than being addressed and acknowledged.)

Each sequence is bracketed by dissolves between a close-up of the character's face and a field of intense red. Although there are numerous ways to interpret Bergman's use of red (and its counterpart, white) in this film, the one that seems most interesting in this context is the possibility that the image field is retinal: that of all the blood in this film, the most inescapable is that which circulates through the retina and which, analogously, gives color to the eyelids closed against intense light. Such an interpretation is consistent with the device's intent here—which is to introduce a sequence of private "vision"—as well as useful in suggesting that the screen is itself retinal. (Bergman has defended his color scheme and, by implication, the use of this red field, on the ground that it somehow signifies the "moist membrane" of the soul.)

The final sequence, which fades to red only at its conclusion, emphasizes the theme of community in a manner that the foregoing discussion can help to clarify. Anna reads Agnes's diary entry of a day in which she was thoroughly happy and at peace. As in Agnes's "Mother" sequence, the words of the diary are heard voice-over, and the image includes Agnes along with Karin, Maria, and Anna. But the image must in some manner be taken as Anna's, since it is she who is reading. The narrator of the diary is Agnes; the narrator of the mindscreen is Anna. Their private experiences have, as a fact of the image, conjoined. It is at this point possible to argue that the red field has become communal, that it indicates a "mind's eye of the film." Although this last statement may reflect an overdose of *Persona*, it is clear in any case that there is a structure of

17

ascending privacy from Agnes's literary first person, through Maria's and Karin's more cinematic, although less deliberately "presentational," points of view, to Anna's mindscreen; and it is in keeping with the film's apparent intent to suggest that increased intimacy (in which Bergman has led the audience to participate) results not in isolation but in community.

Another reading of Karin's and Maria's sequences is possible: they may be mindscreens, identified by the male narrator as having their basis in the factual past. The "red membrane" and bracketing close-ups may be taken to indicate that Maria and Karin are deliberately remembering these experiences. It is further possible that Karin's self-mutilation is entirely fantastic—an extension, originating in the present, of her memory of the tense dinner. If these sequences are not flashbacks but mindscreens, they are still more closely tied to the shared, "real" world than the sequence of Anna's dream (the structure is still one of ascending intimacy), but Maria's is a memory, Karin's a memory that may or may not shift to fantasy, and Anna's an entirely *created* mental event. There is no need for a mindscreen to present itself as fact-based; the point is that Karen's self-mutilation is a mental event in the film's present (and in her mental present, if this interpretation is followed) whether or not it is also a physical event in the past.

To recapitulate: Subjectivity can be indicated through voice-over, subjective camera, and mindscreen. The narrative voices possible in cinema are, broadly: third person —in which there is no apparent narrator except the anonymous "grand image-maker"; point of view—a variety of third-person cinema in which the "grand image-maker" presents the experience of a single character, subjectivizing the world but not the narrative; first person—where a character appears to present his own view of himself and his world; and self-consciousness—which can exist in combination with (or as an aspect of) any of these voices, and in

which the film itself, or the fictitious narrator, is aware of the act of presentation.[7] This final category will be discussed at length later in the book, but it bears mention at this point that self-consciousness most often expresses itself through mindscreen, characterizing the aural and visual fields as those of *its own* mentation.

So far I have confined my discussion of sound to the pseudo-literary technique of voice-over narration; before embarking on a series of readings of first-person films, I should like to make a few points about subjective sound. Although some aspect of each of these narrative modes and categories was explored, and is demonstrable, in silent film, any series of demonstrations that aspires to thoroughness must acknowledge that sound has become integral to the presentational field. Sound is not, as was first feared, a "third leg," but a highly expressive aspect of the filmed world. It is as indicative of subjectivity to present what a character hears as to present what he sees. Owing to the prevalence of the literary first person in our culture, and the dearth of analyses of visual narration, one tends to identify auditory with verbal narration, to consider that only by speaking can one narrate in sound. (The assumption holds even in music, where the sounds' presentation is identified with the point of origin.) But it should be clear that a narrator "speaks" simply by presenting what is meant or encountered, and that it is a simple matter, in the sound film, to present what is heard, just as in subjective camera one presents what is seen. The narrator does not have to "tell" sounds orally, but can allow the audience to share his ears, just as he does not have to construct the landscape in front of him. The issue is still that of narrativity as deliberate manipulation or selection (which can include both creation and re-creation), of telling as presenting.

The "finger-twitch" sequence from *Hiroshima, mon amour* provides a straightforward example of the uses of subjective sound. From fade-in to fade-out, the sequence runs less than two minutes and includes thirteen shots, ten

of which average four seconds in length; indeed, the cutting is so dynamic and revelatory that one hardly has time to pay attention to the sound. An outline of the visual track, then, may prove helpful in understanding the visual/aural relationships (shot durations are approximate):

1. Full shot, 24 seconds: Fade in. Bicyclists pass the actress's hotel. The camera pans from them to the actress on her balcony, holding a cup of coffee. She turns and walks back toward her room.

2. Mid-shot (reverse angle), 8 seconds: She completes her swing over a low divider, then leans against the door-frame and looks down toward the bed.

3. Mid-shot, 7 seconds: The Japanese lover, asleep in bed. His hand twitches slightly.

4. Close-up, 3 seconds: Her face in the doorway.

5. Close-up, 4 seconds: The twitching hand of her German lover; then a rapid pan up to his bloody face, which she is kissing.

6. Mid-shot, 3 seconds: The Japanese lover in bed.

7. Close-up, 2 seconds: Her face in the doorway.

8. Mid-shot, 8 seconds: The Japanese lover in bed. Waking, he moves his arm and starts to turn.

9. Close-up, 3 seconds: Her face in the doorway. She snaps herself back to the present.

10. Mid-shot, 4 seconds: He completes his turn, sits up, and ruffles his hair.

11. Mid-shot, 7 seconds: She comes over to him, smiling, and offers coffee.

12. Mid-shot, 18 seconds: He smiles and rests on his elbow, accepts the offer. She enters the frame, kneeling, and pours coffee. He drinks it.

13. Mid-shot (closer in), 21 seconds: She rests against the bed; he looks at his hands; they talk. She settles her head on her forearm. Fade out.

Three sound tracks are used here: dialogue, music, and natural. The natural sounds shortly precede the fade-in: bicycle bells, a train whistle. As the actress starts to walk,

light Japanese-sounding music begins, but one still hears her footsteps on the balcony. During shots 2 to 5, one hears only music. At the start of shot 2, the actress enters a shadow; at shot 3, the music deepens in pitch and mood; the flutes are replaced by bass woodwinds and (if I heard correctly) some brass. At the first twitch, the music becomes louder; as the note is held, it continues to increase in volume and intensity. The bass continues through shot 4, with flutes laid in. The music peaks at the beginning of shot 5, then ceases altogether. During the pan, one has the impression of silence; as she kisses the face, one becomes aware of the return of natural sound, which in this case is primarily room tone, but which is recognized during shot 6 as the "silence" before the train whistle. Natural sound is continuous from shot 6 to the end of the sequence; no music returns. In shot 7, the street sounds are noticeable. In shot 8, a second train whistle continues to motivate the man's waking up and the woman's return to the present. In shot 9, room tone increases, and the sound of his arm on the sheet is quite loud. The train whistle repeats in shot 10, and shots 11 through 13 use room tone and dialogue.

Natural sound and music combine, in the first shot, to define the actress's mood and environment. The disappearance of natural sound during her "flash" indicates that she has become disoriented, has ceased to listen to the street, etc. The music indicates her change of mood, from peace to apprehension to crisis; it also controls the audience's expectations. The return of natural sound *during* shot 5 brings both her and the audience back to "the present." My point is that the music here functions both impersonally and in the service of point of view—registering the levels of tension in the story (and controlling those of the audience) on the one hand, and indicating how the woman feels on the other. (An example of music as purely subjective sound can be found in Hitchcock's *Strangers on a Train* [1951], where Bruno hears/remembers "The Band Played On" when he is struck by the resemblance between

21

Barbara and his victim.) The presence or absence of natural sound, however, here forms a first-person structure. Where the visuals tend to alternate between the modes of point of view (shots 1, 2, 4, 7, 9, 11, 12, 13) and subjective camera (shots 3, 6, 8, 10), with shot 5 a mindscreen—the natural-sound track is consistently limited to what the actress hears. In this sense, subjective sound is analogous, as a first-person mode, to subjective camera. It remains arguable that the music track functions, in this sequence, as a nonliteral, aural element of her mindscreen.

The first step in mindscreen analysis, then, is the recognition and attribution of selectivity. Once one has recognized that the opening duet of *Hiroshima*, for instance, is not spoken "aloud," and may in fact be the film's autonomous expression of the implications of the lovers' encounter (despite the fact that much of that sequence imitates the woman's point of view), one can go on to interpret not simply the film's narrative structure, but the effect of that structure. The question of voice becomes, finally, the question of mind, and both are inseparable from the question of meaning.

"Citizen Kane"

When we enter the cinema we have to accept the
implications of a controlled viewpoint. Since the
camera has no brain, it has vision but not percep-
tion. It is the film-maker's task to restore the selec-
tivity of the cinematic eye. In this process he may
control our perception so that *his* vision and em-
phases dominate our response to the created world.
—V.F. Perkins, *Film as Film*[1]

Citizen Kane (1941) is to the sound film what *Intolerance*
(1916) is to the silent: a formal masterpiece that experi-
mented convincingly with the problems of time and narra-
tion, and educated a generation of directors. Because so
much has been written on the excellence and influence of
Kane's direction, cinematography, editing, screenplay, and
performances, it seems unnecessary to indulge in a shot-by-
shot hymn of praise. Instead I should like to explore two
aspects of the picture that particularly fall in with my gen-
eral topic: its method of generating mystery and the in-
tricate subjectivity of its narration. What Welles, Mankie-
wicz, and Toland achieved was not only the restoration of
"the selectivity of the cinematic eye," but also a means of
ascribing that "vision and emphasis" not to the filmmaker
but to the elements of the fiction.

Neither the technical excellence of this film nor the aura
of daring that surrounds its makers is sufficient to account
for a phenomenon I have noticed in myself and in others
who have seen *Citizen Kane* repeatedly: its ability to in-
volve the viewer in its mystery no matter how many times

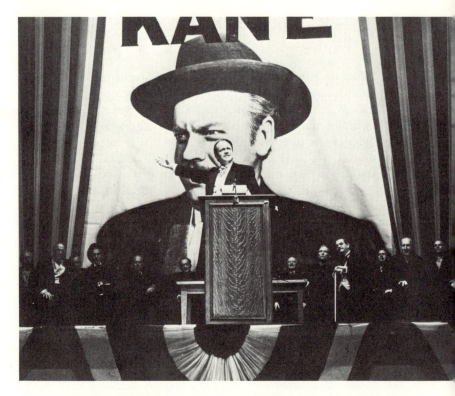

2. *Citizen Kane* (courtesy of RKO Radio Pictures): Kane's campaign for the governorship, as told by Leland. A straightforward juxtaposition of two images of Kane—person and poster—whose subtext is Leland's awareness of the incompatibility of political idealism and grandiose theatricality.

one has seen it. This is not just a question of Rosebud, whose revelation is simply that point in the film where the snake takes a healthy bite of its own tail. The mystery is inseparable from the narrative structure itself, which fills the audience with a sense of mystery the more it pretends to explain things, giving its central character the feel of a system as incomprehensible as one's own life.

Near the end of the film Jerry Thompson, the reporter who has been researching Kane's life, picks up a jigsaw puzzle. It is an appropriate souvenir of his quest because, as he explains, the elements of a man's life are like the parts of such a puzzle: no single piece can explain him. Only this reporter has interviewed enough of Kane's friends to be able to assemble most of the puzzle, and only the camera eye discovers the piece that eludes him. But even the identity of Rosebud, which only the audience discovers, despite its sense of fitting so rightly into the labyrinth, does not dispel the mystery of the man. To appreciate the relation between mystery and mindscreen, one must probe several related aspects of *Kane*'s structure: its antichronology; its literary echoes; its visual themes of frames, icons, and mirrors; its questing camera; the ways each narrator biases his rendition; and the dialectic between fragmentation and coherence. Because the narrative system is so complex, it may be helpful here to present its elements (including the story) in detail.

Laid out chronologically, the story reveals how much of the film's brilliance depends on its unchronological approach. Charles Foster Kane (a character based in part on William Randolph Hearst, the yellow journalist and friend of the great who built himself a castle at San Simeon) is sent away from his snowy Colorado home by his mother when she comes into a huge fortune. She entrusts him to a banker, Mr. Thatcher, whom Charles hits with a sled; their relationship remains hostile for the rest of their lives. When he becomes an adult, Kane goes into the newspaper business with two friends, Bernstein (business man-

ager) and Leland (drama critic), and turns the *New York Inquirer* from a "respectable newspaper" into a publishing empire. He attacks big capitalistic interests (including Thatcher's and his own) and writes a "Declaration of Principles" that commits him to championing the people's rights. The idealistic Leland saves the manuscript of this editorial. While on a European tour Kane begins collecting statues and woos Emily Norton, niece of the president of the United States. They marry, have a child, and drift apart.

One night, long after his mother has died, Kane heads for a warehouse to which he has had her furniture (and his old sled) shipped, but is splashed with mud by a passing carriage and accepts some hot water from Susan Alexander, a lower-class girl whose mother had had ambitions for her to sing opera. This incident slightly predates his idealistic campaign for governor against a political boss, Jim Gettys. When Gettys finds out that Kane has taken Susan as his mistress, he tells Emily but gives Kane a chance to withdraw from the race without scandal. Kane accuses him of trying to "take the love of the people of this state away" from him, chooses scandal, and loses the election. Leland accuses Kane of betraying the cause; they quarrel, and Leland moves to a branch paper in Chicago.

Emily divorces Kane, but soon dies with their son in a car accident. Kane marries Susan and forces her into an operatic career, even building the Chicago Opera House for her debut, but she is a poor singer. (His insistence on Susan's fulfilling her mother's plans appears to connect with his ambivalence about his own mother's ambitions for him; in fact, the key line in their courtship is Susan's "You know how mothers are.") Leland passes out drunk while writing a hostile review of the performance; Kane finishes the review in the same spirit but fires Leland. In spite of the bad notices, Kane demands that Susan continue with her singing because he "doesn't propose to have himself made ridiculous." In the middle of their argument a letter arrives from Leland, containing his shredded severance check and the

"Declaration of Principles," which Kane tears up. Later, Susan attempts suicide and is allowed to abandon her career.

The Depression forces the closing of many Kane papers; he is put on an annuity by Thatcher, who is still his banker. During their encounter Kane muses that he might have been a really great man if he hadn't been so rich, and declares that his ambition was to be everything Thatcher hated. With time on his hands, Kane continues construction of Xanadu, a palace in Florida, filled with the statues he continues to collect. He and Susan entertain often, but she is bored and spends most of her time doing jigsaw puzzles. Finally she leaves him, and Kane wrecks her room, saving only a glass ball with a snow scene inside (a paperweight that had been in Susan's room the first night he met her, and which reminds him of Colorado, etc.). He lives the rest of his life alone in the unfinished Xanadu.

At this point the narrative present of the film begins. Kane dies holding the glass ball in his hand; his last word (overheard somehow by his butler, Raymond) is "Rosebud." His news syndicate prepares a film on his life, but finds that it needs human interest. Jerry Thompson (who made the newsreel) is assigned to discover the identity of Rosebud, and begins interviewing the people who knew Kane best. He tries to see Susan in the nightclub where she is singing, then reads Thatcher's memoirs, then visits Bernstein (who has become chairman of the board), then Leland (faking senility in a hospital), then Susan, and finally Raymond. He makes his jigsaw puzzle speech and leaves Xanadu with the news staff, while workmen begin burning the worthless items in Kane's estate—among them Rosebud, the sled.

All of which goes to prove that money cannot buy love. The literary origins of this story range from Coleridge's "Kubla Khan" (Kane) with its Xanadu pleasure-dome to *The Great Gatsby* and *Absalom, Absalom!* with their lower-class, overreaching heroes and impressive estates—not to mention Genesis. The title expresses much of the film's

crux in its pun on the outcast Cain, who is still somehow a member of a community; it also puts neatly the problem of an aristocrat who wants to be an ordinary citizen but who insists on controlling everything that touches him.[2] Yet all of these allusions do not add up to a mystery. The excitement of this picture is generated by its indirect, fragmented approach, both to subjective narration and to time.

Welles and Mankiewicz identify the audience's eye with that of the camera from the first shot, which is of a "No Trespassing" sign on a Xanadu fence. From there until the next-to-last shot, which is of the same sign, the camera flagrantly trespasses, and the audience is encouraged to share its privileged view. This camera eye appears to hold to a strict present tense, filming first Kane's death, then the newsroom, then the interviews (illustrating the characters' words but not flashing back to "the past" in a strict sense, since it follows the train of the interviewees' narrations and incorporates all their emphases, however subtle), and finally the burning of the sled—all of which takes place in a few consecutive days. The overlapping nature of the reminiscences (among which must be included the biographical newsreel) provides the chronological complexity. The discrepancies among their renditions account for much of Kane's depth. The camera everywhere asserts its curiosity, going through the fence, later through the lighted sign and then the skylight of Susan's nightclub, into the furnace, and (arguably) through time. It rushes up when doors are slammed in its face, and if they are not opened, appears inside the room. This device gives one the sense of passing through all the barriers that surround Kane and his story, and leaves the viewer the only one who has all the pieces of the puzzle. It also dramatizes the fact that there *are* barriers to be broken through—barriers that close up again as the camera retires, leaving the mystery discovered but intact.

From the beginning, Kane is fragmented—so much so, that he barely appears in the film's narrative present at all. After passing through the fence, the camera roams the pal-

ace grounds until it finds a light in Kane's window. As the music peaks, the light goes out. The next shot is taken from the other side of that window, as a light (the sun?) comes on. The next shot, a close-up of the glass ball, looks like a snow scene; the shot after that cuts in even closer to show the miniature house, then moves back to show Kane's hand around the ball. The next shot is a close-up of Kane's mouth as it whispers "Rosebud." In the next shot his hand drops the ball, and one realizes Kane has died. The next few shots get a nurse into the room and his body covered, but the shot after those reveals the silhouette of his corpse in the dimly dawnlit room. The fade-out that preceded the final shot of this sequence may be intended to suggest that Kane's death scene itself has been a flashback, and that the light which went out at the camera's first approach corresponded to the moment of Kane's death—an unusual interpretation but one that the music appars to bear out. When the light comes on again, the camera can be understood to have traveled into the recent past to witness this scene. Although the sequence may be dismissed as confusing (the lights may simply be going off for dawn), if time travel is indicated it means not only that the camera can pass even that boundary but also that Kane never does appear in the picture's present tense. Such an approach to the film is not far from the mark in any case, since even if this scene is construed to be in the narrative present, all that is shown of Kane is his hand, his mouth, and his silhouette. Apprehended only in pieces, he gives the sense of being too great to be photographed whole. One becomes immediately curious about the rest of his features, which are here as much of a mystery as the meaning of his last word. The present, physical Kane eludes the simple act of photography, not because he is ineffable but because he is so complex, a jigsaw puzzle even now.

After that opening sequence, Kane is dealt with entirely in terms of his *image*: the memories others have of him, the props of his life, and a series of what can only be called

29

icons. At one point Bernstein, recalling his impressions of Kane for Thompson, stands in front of his office fireplace; above the mantel is a portrait of Kane's face that dwarfs everything else in the room. (Its "impressiveness" function is prepared for by an even larger portrait of Thatcher in the preceding shot.) The film's final long shot of Xanadu is dominated by the gate's monogram, a hugh iron *K*. Kane even surrounds himself with his image while he is alive, as in the gubernatorial campaign, where he speaks in front of a poster of his face that is several stories high (fig. 2), or in the office party where ice-sculptures caricature the profiles of Bernstein and Leland, but for Kane offer only a *K*. From beginning to end there is a dialectic between Kane and his image that expresses both his attempt to mythologize himself and the difficulty of arriving at an adequate representation of the man.

To clarify the importance of this theme, the film announces its own dialectic between image and "reality" by dissolving between the "lovenest" and its reproduction in the paper, or the photograph of the *Chronicle* staff and their pose for a new portrait as the *Inquirer* staff; the artificial-snow scene in the glass ball at first has a similar effect. The flow between object and image is counterpointed by another theme: that of *things*. The Rosebud problem, for example, emphasizes not just Kane's longing for his lost mother and the simple life, but also the way he defines himself through his possessions: from the sled, an emblem of home; and the statues, emblems of an unbuyable European culture; to the emblems of his own kingly personality— a presence he can neither live up to nor escape.

Each of the narrators has a theory about Kane. Their distortions are much subtler than those of a film like *Rashomon* and might better be called emphases. Like the proverbial blind men who describe an elephant in terms of whichever part they have hold of, the narrators slant their presentations of Kane according to their relationships with him. The various narrative sections (or frames) are: the

newsreel, Thatcher's memoirs, and the interviews with Bernstein, Leland, Susan, and Raymond. Their portraits are supplemented by several scenes in which other characters—notably Jerry Thompson—make speeches about Kane, and by the office party song.

The author of this song, which describes Kane intimately, is not identified, but there is a hint that Kane may have written it himself. As the dancing girls come in, Kane says, "You buy a bag of peanuts in this town, and you get a song written about you," so his prior knowledge of the song's existence may explain away his singing it with the girls: he may have commissioned and memorized it, rather than written it. In either case, the implication is that he favors the song's presentation of him, so that it is both another of his icons and a self-portrait, meant by the filmmakers to be compared with the theories of Kane's friends. The song asserts that "for the poor you may be sure / That he'll do all he can," but more significantly says that Kane "wouldn't get a bit upset / If he were really broke. / With wealth and fame / He's still the same ... / He doesn't like that Mister, / He likes good old Charlie Kane." Kane himself is on camera while singing that he "thinks that dough was made to spend / And acts the way he thinks."[3] The line from this song that Leland sings to himself in a later scene is "Just by his action / Has the Traction magnates on the run"—an adoption that fits in well with his own image of Kane. The portrait emerging from these verses is of an extravagant man who wants to be accepted not as "Mister" but as "good old Charlie," a powerful, generous, and idealistic person who could get along fine without money. These views are expressed by Kane elsewhere in the picture, particularly in the final scene with Thatcher when he says he "always choked on that silver spoon." Under the film's final credits (and just before Leland breaks with Kane, after the election), the music from this song is heard again.

The newsreel, which immediately follows the death scene, so closely resembles the *March of Time* shorts, and is so ex-

plicitly dated 1941, that it accomplishes the same media shock as the *Invasion from Mars* broadcast. Its contemporaneity achieves both an alienation effect and a strong sense that the fictional events are happening in the real world. *News on the March* announces the recent death of a great American, a public figure. Although it is primarily the story of his career and is appropriately impersonal, it shows several sides of Kane that the other narrators leave out. Such details as the name of Susan's opera and the death of Emily occur nowhere else in the film. The great journalist's visits to heads of state (including Hitler) are emphasized, as are the people's reactions to his political aspirations. A picket sign photographed during a demonstration carries a grotesque caricature of Kane. A labor leader calls him a Fascist—then during a government investigation, Thatcher calls him a Communist; these two shots are followed by a title in which Kane calls himself "an American." (Mankiewicz's original property was called *American*.) His goading of a journalist who interviews him after a political tour of Europe reveals that Kane considers himself an old-hand reporter, a professional. Only the newsreel shows Kane in his old age at Xanadu, abandoned and secretive, bundled in a wheelchair. The newsreel is an organizing force in the film, presenting the public face of private moments, linking the various aspects of his life by topic (Xanadu, marriages, Americanism, etc.).

Although in the newsmen's view this film says only that Kane is dead, it actually argues a thesis. Where Leland, for example, says that Kane built Xanadu for Susan, the newsreel calls the palace "the costliest monument a man has built to himself." Kane is described as a king, and Xanadu compared to his pyramid, one of the many stones he has left "to mark his grave." The emphasis is on Kane's immense power and egotism, with some attention paid to his attempt to mythologize himself. The newsreel contributes to the myth by calling him the "greatest newspaper tycoon of this or any other generation," and by introducing

the film's central narrative method: the accumulation of conflicting appraisals within an involuted chronology. Even the series of newspaper headlines announcing Kane's death, which flash by almost too rapidly to be read, introduce the controversy. The *Inquirer* praises his "lifetime of service," and the *Chronicle* speculates that "few . . . will mourn for him"; the *Globe* calls him "U.S. Fascist No. 1," and the *Herald* labels him a "sponsor of Democracy." Most of these papers have pictures of Kane in their stories, announcing the theme of his image. The whole newsreel, emphasizing Kane's public self, omits any hint that this emperor wanted to be accepted as "good old Charlie," and reflects Thompson's impressions of Kane before he is educated by his quest.

Comparing Thompson's newsreel with Thatcher's memoirs, the audience can understand the logic of their respective emphases. The newsreel presents Kane as Thompson first encountered him: in film clips and public statements. Thatcher knew Kane as a rebellious youth: his ward, his client, and his enemy. He concentrates on Kane's financial decisions, not just because he is Kane's banker but because he is *a* banker. He tells the story of his relations with Kane, and what emerges is the portrait of an idealistic yet vengeful spendthrift. He bolsters his sense of Kane's fiscal immaturity by recounting a scene in which Kane admits that he never made an investment but used money only to buy *things*. He describes a man motivated by spite, interested more in defying Thatcher's values than in establishing any of his own. Furthermore, he portrays a compulsive consumer—an insatiable, irresponsible, and permanent child. However more intimate Thatcher's vantage point may be than that of the newsreel maker, their narrative limitations are theoretically identical: each describes the man not just as he judged him, but as he encountered him, and what the audience sees is not a flashback to Kane but an illustration of each narrator's conception of Kane. The "monologues" are in the first person, not in the third. They are, in short, mindscreens.

Welles uses an extremely interesting technique to an-
nounce the first-person nature of these portraits. Instead of
relying on subjective camera positions, he photographs the
various narrators in what appears to be a third-person man-
ner, but informs each section with an emphasis clearly iden-
tifiable as the narrator's bias. Thatcher's monologue, for
example, shows the banker reading Kane's exposés of their
mutual illegal holdings, then arguing with the fervent ideal-
ist/irresponsible smartaleck in the newspaper office. The
point is not that Thatcher is photographed from outside
his physical viewpoint, but that every scene corresponds
with his personal conception of Kane, and illustrates this
conception rather than subjectively records "what hap-
pened." Thatcher narrates no scenes in which he himself
does not appear, or of which some character did not per-
sonally tell him—nor does any other speaker. Leland, for
instance, is unconscious during most of the scene in which
Kane composes the hostile review of Susan's performance,
but it is reasonable to assume that he heard what happened
from Bernstein—whose point of view is dominant until
Leland wakes up.

It is likely that none of the narrators lies, and apparent
that each scene, although selected to make some kind of
point, is presented as it happened (*as if* the mode were
point of view). Thus one understands that Thatcher has
decided to emphasize Kane's fiscal and political immaturity
by relating the scene in the *Inquirer*'s office, but one is able
to acknowledge that bias and still see past it to "what really
happened." Without distorting them, Thatcher's mind dom-
inates those portions of the film that relate his part of Kane's
story. His narrating mind is offscreen. The film presents not
Kane's life with Thatcher in third-person flashback but
Thatcher's tale (which is presumed to be both biased and
accurate) in mindscreen. (The finger-twitch in *Hiroshima* is
an example of first-person flashback, presented in mind-
screen.)

These crucial observations concern Thatcher's *film* mono-

logue. In the context of the Thompson-as-interviewer fiction, each of the narrators is using first-person verbal narration; Thatcher is even writing. Apparently Welles and Mankiewicz set out to perfect a visual narration that could correspond to first-person discourse; the opening Xanadu scenes, with their theme of the trespassing camera, extended this method into a principle of visual narration that need not be considered an "illustration" of verbal storytelling.

Bernstein's section makes this narrative principle even clearer. He gives himself most of the good lines, relating those conversations that he was able to cap with an aphorism. Appropriately, it is in this part of the film that Kane is seen at his wittiest. Some of their exchanges are nearly vaudeville:

BERNSTEIN: Promise me, Mr. Kane.
KANE: I promise you, Mr. Bernstein.
BERNSTEIN: Thank you. (BERNSTEIN *sits down*)
KANE: Mr. Bernstein?
BERNSTEIN: Yes?
KANE: You don't expect me to keep any of those promises, do you? (BERNSTEIN *shakes head—crowd heard laughing and applauding*)[4]

Again, Bernstein appears in all the scenes he relates, and the camera continually pays attention to him. Kane's argument with the *Inquirer*'s editor is interrupted by a mid-shot of Bernstein's dropping a load of furniture, bringing the rhythm of the argument to a full stop with his "Oops!" Since Bernstein does not witness the entire scene and does relate it whole, the audience is probably meant to assume that he has reconstructed the events from hearsay. In any case, this crash and the banter that follows call attention to Bernstein's role in the scene. In this later exchange, Bernstein clearly dominates:

LELAND: Bernstein, am I a stuffed shirt? Am I a horse-faced hypocrite? Am I a New England schoolmarm?

35

BERNSTEIN: Yes. If you thought I'd answer you very different from what Mr. Kane tells you, well, I wouldn't.

LELAND: World's biggest diamond. I didn't know Charlie was collecting diamonds.

BERNSTEIN: He ain't. He's collecting somebody that's collecting diamonds. Anyway, he ain't only collecting statues.[5]

Throughout their renditions, Leland calls Kane "Charlie" and Bernstein calls him "Mr. Kane"; this helps to define the limits of their stories, since Bernstein's contacts with Kane are on a business basis and Leland's are more intimate. (In fact, there is a structure of increasing intimacy—though not of modes—as the film proceeds from newsreel to Thatcher to Bernstein to Leland to Susan, which is broken by Raymond and capped by Thompson, who is by then a representative of the enlightened audience.)

From the start, Bernstein takes issue with Thatcher's interpretation of Kane. To Bernstein, Thatcher is a fool for caring so much about money, and is prevented by that concern from understanding Kane: "You take Mr. Kane. It wasn't money he wanted. Thatcher never did figure him out." Although he goes on to say that Kane confused even him sometimes, Bernstein does have a theory: that Kane was "a man who lost everything he had." Clearly this is an important interpretation, one that accounts for Kane's compulsive acquisitiveness as well as his nostalgia for a lost innocence. It does not invalidate Thatcher's view—that Kane was a rebel unsuited to high finance—or Leland's—that Kane was unable to give—but enlarges them. It is Bernstein, after all, who remembers the exchange: "Are you still eating?" "I'm still hungry!"

Leland's view of his oldest friend is both sympathetic and bitter. He describes a man who was never brutal, but did brutal things, a man whose essential limitation was his self-centeredness, whose failure lay in never giving of himself. Kane's fascination with things, Leland implies, was a de-

36

fense against intimacy: relating to people as objects (buying their love) and through objects (buying them presents), he protected himself from those threatening relationships in which people deeply accept each other and so can give each other pain as well as love. This view of Kane is fundamentally tragic, for it argues that his isolation was caused by his need to be loved—a need so intense that it was dominated by the fear of its own failure. Bringing Thatcher and Bernstein to bear, the audience may deduce that Kane's loss of his mother taught him to protect himself against being abandoned or rejected by others he might allow to become close to him, and that the "good life" of power and privilege his mother determined he should enjoy became in his hands a weapon to prove her wrong. For Kane, "love on my terms" means manipulating the world into loving him without offering an emotional commitment in return; his self-centeredness is like that of the armadillo, curled up inside the shield of his skin.

Above all, Leland values commitment: to ideals as well as to friends. A man who will not give himself to others cannot expect others to give themselves to him; a man who is afraid of life cannot commit himself to its betterment; a man who hides in a castle can never become a citizen, can never believe in anything but himself—and that only tentatively. Where the newsreel emphasizes the imperial career, Thatcher money, and Bernstein acquisition and loss, Leland emphasizes idealism and love. Bernstein prepares the audience for Leland by recalling the latter's interest in the "Declaration of Principles," a document whose commitment he had demanded Kane live up to. When Kane runs for governor, Leland calls him "the fighting liberal, the friend of the workingman." During the speech to which Welles then cuts, Kane makes several promises in this spirit, but the camera, with exceptional economy, counterpoints his words. His boast that his opponent is finished is heard over a shot of his wife, who has received Gettys's threatening letter. His promise to protect the poor is applauded by

37

Bernstein; the poor themselves are not shown (nor do they appear outside the newsreel—an ironic comment on Kane's isolation from the objects of his apparent concern). The fact that Leland is shown over the words "the workingman," and has run in high society since childhood, has a similar ironic effect, but nevertheless asserts Leland's commitment (however abstract) to the problems of the laborer. To the same end, Leland is shown applauding Kane's promise to keep his promises. This theme reaches its conclusion in Susan's monologue, when Leland returns the "Declaration of Principles" to Kane together with the torn-up severance check—a gesture that asserts Leland's own integrity as much as it reminds Kane of how far he has fallen; but its climax occurs just after Kane has lost the election. An extreme low-angle shot gives the illusion that Kane's leg (in the foreground) dwarfs Leland's full figure (in the background), so that Leland—who is speaking about the workingman— physically represents the little man shaking his fist at the economic giant:

> LELAND: You talk about people as though you owned them. As though they belong to you. As long as I can remember, you've talked about giving the people their rights as if you could make them a present of liberty, as a reward for services rendered. . . . You used to write an awful lot about the workingman—
>
> KANE: Aw, go on home.
>
> LELAND: He's turning into something called organized labor.[6]

In this shot Leland is seen not as a drunken drama critic but as a spokesman for the underprivileged, whom Kane treats as if they were his feudal subjects. Throughout this speech (in which Leland shifts slightly forward) Kane walks toward him, as if he had been cut down to size. When the discussion shifts from politics to love, Leland's remarks are seen to strike home in a less abstract manner. Kane had been sarcastic about setting back "the sacred cause of re-

form," but he answers Leland's attack about his integrity as a friend and lover with a stern toast "to love on my terms. Those are the only terms anybody ever knows—his own." Since both men know that their friendship is about to collapse, Kane's refusal to fight for the relationship (not by making wisecracks about Chicago, or by coldly proposing an isolationist toast, but by answering Leland's frank emotion in kind) clearly demonstrates his unwillingness to accept the terms in which love here presents *it*self: the need to open up, the chance to get hurt, the equal staking of loss and gain. In the last lines of this scene, one can hear a shield slam into place.

However useful Leland's insights are, they do not explain his friend by themselves. The audience has been prepared to take with some skepticism Leland's evident oversimplification: "He married for love. Love—that's why he did everything. That's why he went into politics. It seems we weren't enough. He wanted all the voters to love him, too. All he really wanted out of life was love. That's Charlie's story. How he lost it."[7] Even if that last line does bring Bernstein's explanation to mind, and the following lines mention Kane's love for his mother, the fact that the film continues—that other voices and revelations are called for —assures one that Leland does not have all the answers. If he did, the mystery would be a tame one, and the film's structure only a series of pigeonholes for flashbacks.

The thematic transition to Susan's interview is begun by Leland. When he says that Kane built Xanadu for Susan, and Thompson argues that he must have loved her to do that, Leland changes the terms of the discussion from love to Susan's theme, control: "He was disappointed in the world, so he built one of his own, an absolute monarchy. It was something bigger than an opera house, anyway."[8] By suggesting that Kane built both Xanadu and the Chicago Opera House not only for love but also out of a need to control the world and its responses to him (he has, after all, nothing of "importance" to control after abandoning

politics, and becomes a domestic tyrant out of necessity), Leland enlarges his concept of Kane's political motivations (tying the love theme into the fantasy of "lording it over the monkeys"), but fails to redefine the limits of his bias.

Of all the people in Kane's life, Susan is the slowest to arrive at self-determination. Her relationship with her husband is one long struggle for control; appropriately, her section of the film contains some of the strongest low-angle shots, portraying Kane as an aging tyrant. She introduces her monologue with the words, "Everything was his idea, except my leaving him"—and they sum up the dynamics of the marriage. Susan wins her battles by withdrawal, not aggression: she attempts to kill herself, fumes privately over a jigsaw puzzle, drinks too much, and finally divorces him. When she tries to engage him directly her voice becomes shrill and whining, sometimes losing all control in a sarcastic screech; she has none of Kane's assured sense of dominance (presented here and elsewhere as something of a façade). Her introductory overview of their courtship does not mention love, although it does hint at the theme of giving of oneself rather than of one's possessions ("I didn't want a thing")—but goes straight to the battleground: her music lessons.[9]

First-person narration is particularly straightforward in Susan's section, in part because hers is a more self-centered personality than the other narrators': a good match for Kane, if she were more self-sufficient. Welles calls special attention to the first-person labyrinth by reshooting her première—shown first, as the audience had experienced it, in Leland's monologue—from Susan's point of view (with the camera backstage). Where the images of Bernstein and Leland tend to drop out of their renditions, Susan has an important role in all the scenes she relates: her lessons, her première, her reviews, her jigsaw puzzles, her arguments with Kane, her exit. Several points she scores against Kane can be scored against her as well: neither gives very deeply, or considers the other's feelings. Even so, the substance of

her verbal attacks fits in closely with Leland's, and gives the labyrinth an unfortunate sense of coherence. During the picnic she attacks him for giving selfishly (his picnic rather than her trip to New York; things rather than affection), for attempting to "buy" her into giving him something. His furious response indicates that she has struck home, and Welles counterpoints these shots with an overheard song, "It can't be love," driving the point even harder. But Welles's acting here portrays not simply an ogre but also a man who has genuine difficulty expressing tenderness. The converse of this dynamic occurs in Susan's bedroom, where Kane's fumbling "Please don't go" reveals the "You can't do this to me" underneath it, and Susan goes in for the kill: "I see, it's you that this is being done to. It's not me at all. Not what it means to me." Her "What about me?" whine had been introduced by Leland (in the "lovenest" showdown); implicitly repeated here, it clinches the audience's judgment of Susan's self-centeredness, and undermines the reliability of her impressions of Kane. Just as Bernstein presents a witty Kane, Susan presents a self-centered antagonist.

Susan goes beyond Leland, however, in her familiarity with Kane's domineering nature and in her emphasis on the manipulative, controlling aspect of his love-bargains. As she puts it in the picnic tent: "Whatever you want, just name it and it's yours—but you gotta *love* me." (Leland, for instance, fails to emphasize one of Kane's major reasons for refusing to accept Gettys's bargain: that no one is going to be allowed to tell him what to do.)

Even Raymond's sequence, for all its brevity and callousness, presents a personal view. Its theory, that Kane was manipulable and not to be taken seriously, reflects not only Raymond's cynicism but also his sense of superficial formality. This servant's-eye view of Kane emphasizes the destruction done to Susan's room. The sense of sheer mess and violence contrasts vividly with the hushed cluster of attendants. In the final shot Kane walks in front of a mir-

41

ror that, because it faces another, reflects his image over and over again. The arrangement of these mirrors is triumphantly formal, bringing out the *Marienbad* in the gangsterish Raymond (and the Expressionist in Welles); it also creates the grandest of Kane's personal icons, climaxing the theme of his image. An endless reflection is the only "single" image capable of corresponding to this man—not just because of its multiplicity, but because of its inherently paradoxical structure. The final image of Kane—the one in the furthest and smallest mirror—is inconceivable. Behind every image (including the one on film) there is another. The jigsaw puzzle Thompson offers as an alternative metaphor for Kane's enigmatic character pales beside Raymond's mirrors, for the former implies that a solution is possible, while the latter suggests—as Borges did in his essay on this film—that the labyrinth is "centreless."[10]

The facing mirrors climax another series of images, one that is closely related to that of Kane's personal icons. At many points in the film, Kane is shown in a frame. While his mother discusses his future with Thatcher, Kane is seen through the window, playing in the snow (almost as if the window were a "thought balloon"). During the office party, while Bernstein and Leland discuss his business coup, Kane's reflection is seen dancing in the windowpane behind them. And his framed portrait hangs in Bernstein's office. This imagery calls attention to the film's narrative structure, which frames Kane in biased monologues. Xanadu's mirrors proclaim the result: frames within frames, and the "real" Kane inaccessible, even to the frame that borders the motion picture image.

Orson Welles, writing about the film just after it had been released, reduced the various viewpoints to questions of love (thus greatly oversimplifying the picture's concerns) and implied that both mirrors and puzzle were valid approaches:

They tell five different stories, each biased, so that the

truth about Kane, like the truth about any man, can only be calculated by the sum of everything that has been said about him.

Kane, we are told, loved only his mother—only his newspaper—only his second wife—only himself. Maybe he loved all of these, or none. It is for the audience to judge. Kane was selfish and selfless, an idealist, a scoundrel, a very big man and a very little one. It depends on who's talking about him. He is never judged with the objectivity of an author, and the point of the picture is not so much the solution of the problem as its presentation.[11]

As in a jigsaw puzzle, all the gathered information (including the newsreel and Rosebud) can add up to a complete picture; nevertheless, Welles asserts the integrity of the labyrinth, and identifies its central technique as first-person narration. Kane remains the center of a complex of impressions.

Eisenstein argued that montage is conflict—that out of the juxtaposition of different images a concept could arise, whether in the mind of the audience or in the secret dynamic of the film. Although much of the film operates on revolutionarily non-Eisensteinian principles (as Bazin has demonstrated), the narrative structure itself does work like montage. Each view of Kane has a dialectical relationship with every other, and the contrasts prompt the audience to conceptualize Kane themselves. The imagery of icons and frames, together with the ambiguous time sequence of the opening death scene, is reminiscent of the distancing/involving narrative devices employed in such novels as *Moby-Dick, Heart of Darkness, Absalom, Absalom!*, and *Wuthering Heights*, whose common assumption is that the work's central mystery must be generated rather than explained.

Not surprisingly, Welles's original intention, on going to Hollywood, had been to film *Heart of Darkness*. It seems clear that he re-created Conrad's achievement in a new

form: evoking his isolated, dark, and powerful Kurtz through a cluster of Marlows, each of whom creates Kane either in his own image or in relation to his personal concerns.

As has already been mentioned, his plans for *Heart of Darkness* called for an uniquely extensive use of subjective camera—a technique finally employed in *Lady in the Lake*. The camera would see everything through Marlow's eyes. Welles was to have played both Kurtz (a role he would no doubt have handled brilliantly) and Marlow (whose reflection would have been glimpsed in mirrors).[12] Nevertheless, the subjective camera (which Welles was forced to abandon for technical and budgetary reasons) is an overliteral approach to first-person cinema. What Welles employed in *Kane* was not the first-person eyeball but the first-person mindscreen.

Each section of *Kane* is dominated by the *mind* of its narrator, each of whom presents an apparently third-person view of the world informed by a first-person bias. These worlds betray their egocentricity as well as their prejudices throughout, so that the narrating mind is felt as an offscreen presence. The camera eye, which is the organ of the audience's curiosity, moves about in the narrator's subjective world: a narrative method that is both more interesting than subjective camera and truly comparable to first-person literature, where the narrator describes not what he sees but what he knows (whether he was present at the original event or not). Beyond this, the succession of narrators combines with a metaphoric logic of quests and frames to provide a method for dealing with what the individual narrators cannot achieve, a characterization that can be meaningfully conceptualized only as a system. In this way, as well as others that have long been recognized, *Citizen Kane* prepares the ground for the achievements of modern film narration, from the multiple mindscreens of *Last Year at Marienbad* to the ineffable apprehensions of *Shame*.

44

A Dream of the Truth:
The Offscreen Narrator

I'll let you be in my dream if I can be in yours.
—Bob Dylan, "Talking World War III Blues"[1]

Citizen Kane was not the first film to use sustained mind-screen narration, nor even the most intricate. Its originality consists mainly in its juxtaposition of extended mindscreen sequences, and in the subtlety of its means of indicating bias. To flesh out the problem, this chapter examines two earlier mindscreen films, *The Cabinet of Dr. Caligari* (1919) and *Sherlock Junior* (1924); a self-conscious cartoon, *Hair-Raising Hare* (1945); and a few of the ontological implications of the notion of an offscreen narrator.

Expressionist cinema had two occasionally overlapping intentions: to stylize the world in such a way as to portray, in Balázs's term, its "latent physiognomy" or truest, often hidden, nature, as perceived by the artist; and to reflect in both gesture and physical environment the psychological tensions experienced by the characters. In each case the image was distorted so as to express, or present as if from within, the psychological or metaphysical forces which were, for the artist or his character, the "dark" soul and truth of the world. The makers of *Caligari* disagreed, as Kracauer and Eisner have shown,[2] on which of these forces that film's distortions were intended to express: that is, on whether it was the hero or the world that was insane. The film as it stands suggests both.

Caligari opens on two men, one of whom has just told his

45

3. *Sherlock Junior* (courtesy of Raymond Rohauer): Buster looks at the audience just before he rushes into his dream version of *Hearts and Pearls*.

companion, Francis, a "true" ghost story. A woman the latter identifies as his fiancée (Jane) walks by as if in a trance. Francis then relates the harrowing story of what he and Jane have undergone, in a silent-film equivalent of voice-over. In a lengthy first-person sequence, he tells how the director of the local asylum tries to discover whether one of his inmates, a somnambulist named Cesare, can be instructed, while in a trance, to commit murder. Adopting the name Caligari, the mad doctor sets up a booth at the village fair; this serves as a front as well as a means of discovering appropriate victims, one of whom is Francis's friend (and rival for Jane's hand), Alan. Later on, Cesare abducts Jane, but is pursued (fig. 1) and dies. With the aid of the asylum staff, Francis exposes Caligari, who is promptly committed to one of his own cells. The sequence is Expressionist in décor (and, to some extent, in performance). As Kracauer describes them:

> . . . the settings amounted to a perfect transformation of material objects into emotional ornaments. With its oblique chimneys on pell-mell roofs, its windows in the form of arrows or kites and its treelike arabesques that were threats rather than trees, Holstenwall resembled those visions of unheard-of cities which the painter Lyonel Feininger evoked through his edgy, crystalline compositions. In addition, the ornamental system in *Caligari* expanded through space, annulling its conventional aspect by means of painted shadows in disharmony with the lighting effects, and zigzag delineations designed to efface all rules of perspective. Space now dwindled to a flat plane, now augmented its dimensions to become what one writer called a "stereoscopic universe."[3]

Within the context of the film as Janowitz and Mayer, its writers, originally conceived it—in which Francis is sane, Caligari represents insane authority, and Cesare is the victim of what amounts to a conscription—these sets express

47

the latent physiognomy of contemporary Germany. The narrative mode is third person, with an emphasis on Francis's point of view. The first director assigned to the project, Fritz Lang, decided it would be more interesting (or perhaps more safe) to present the sequence in mindscreen, and to establish by means of a frame not only that Francis was telling the story, but also that he was insane; Robert Wiene, who completed the project, embraced these suggestions. The opening frame-sequence, however, tells the audience only that Francis is the narrator, leaving the confirmation of his insanity to the closing frame. Throughout most of the film, then, the narrative mode appears comparable to that of the dying antihero in *Double Indemnity*: a "voice-over," first-person tale that the image field appears objectively to illustrate.

At the close of his story, Francis introduces his companion to the live Cesare, the distraught Jane, and the benevolent "Caligari," head of the asylum where Francis himself is in residence. After remanding the lunatic to a grotesque cell, the doctor gives the impression of being able at last to cure him. The sets in this final sequence, however, remain Expressionist, in what is either a complex narrative gesture or a muddle. Setting aside this last question for the moment, one can at least assert with some confidence that the apparrent nature of Francis's narration has been redefined. Its mode is, clearly, mindscreen; but it is, as a mindscreen, more like Anna's in *Cries and Whispers* than like those in *Kane* or *Double Indemnity*. What the décor expresses—along with the camera movements, cuts, and story logic—is the instability of Francis's mind. The image incorporates the narrator's distortions; it is thoroughly subjective. Francis's tale turns out to be an elaborate fantasy about his fellow inmates, a vision of the world as he imagines it to be—rather than an objective (or sane yet personal) view of a truly mad world.

The problem, of course, is that the Expressionist distortions are not confined to Francis's monologue, and that this

analysis would apply more conclusively if they were. The only way I can see to make sense of *Caligari* as it stands is to ascribe the subjective bias to the filmmakers—or, more precisely, to the "potential linguistic focus" of the film itself. The distortions inherent in *Caligari*'s world—a mad world within which a madman tells a story—are of course the responsibility of the filmmakers, but may be taken to suggest that the film as a whole is a mindscreen. In this sense the narrating mind, keenly attuned to latent physiognomy, and presenting the world as it sees it, remains offscreen and relatively impersonal.

Kracauer's fine reading of *Caligari*, which most critics have simply accepted, emphasizes the politically subversive content of Francis's tale, and argues that the failure of the framing sequence to restore "natural" perspective gives the narrator's paranoia (however unintentionally) a sense of appropriateness, a basis in contemporary reality. But the film need not be read only in psychological or political terms. In a useful analysis, Frank McConnell calls attention to the way in which *Caligari* makes the audience aware of its own kinship with Francis: a kinship that depends on our willingness to accept the reality of fantasy. McConnell demonstrates that much of the imagery in Francis's monologue alludes to the syntax of precinema—that it has the feel not only of "a frozen cartoon" but also of the world of the magic lantern. One shot, early in the monologue—"a painted carousel revolving against a painted backdrop"—is explicitly self-conscious:

> What you are about to witness, that first shot says, is a series of images which are not only highly artificial, but which include artificiality and illusion as part of their central content—which will ask you, as spectator, to decide for yourself how far you are prepared to trust their artificiality, and therefore how much belief in your own real world you are willing to sacrifice in order to sustain and preserve your enjoyment of the story about to be played out.[4]

49

In this sense, the final frame, while it gives the impression of releasing the audience from Francis's dream, refuses to release us from our own. *Caligari* raises the issue of *our* insanity—not only that of our politics (the discussions are simultaneous, and they depend on the same imagery). Paradoxically, since the film knows its world is delusory and accepts the terms that give it being and meaning, it gives the impression of being more sane than we, who are willing to abandon the true in search of truth. All three readings of *Caligari*—Kracauer's politics of Expressionism, McConnell's psychology of Romantic self-consciousness, and my own analysis of narrative subjectivity—are mutually reinforcing; indeed, a variety of films from *The Balloonatic* (1923) to *Weekend* (1967) demand to be considered from each of these points of view, and suggest the inseparability of metaphysical psychology from the semiotics of narration (not to mention politics).

Self-consciousness is something of a pejorative term; it implies that one is so aware of his own nature and situation that he is unable to *do* anything, at least gracefully. The prototype is of course Hamlet, who is aware of himself not only as a failed revenger but also as a pseudo-playwright in a failed revenge tragedy.[5] However, as the distinguishing characteristic of a major tradition in the novel (from *Tristram Shandy* to *Gravity's Rainbow*),[6] in the theater (from *Hamlet* to *Rosenkrantz and Guildenstern are Dead*), and in film, self-consciousness is associated not with the inability to function in the given world, but with the attempt to know the world and self more deeply and thus to function in a way that would otherwise be impossible. At the heart of this narrative mode is the internal awareness that narration is going on, that its world is in some sense the product of a mind; at the heart of the audience's response is the awareness of complicity. The world of the self-conscious artwork is the world in which artist and audience confront each other across a proscenium both know to be "true" but deliberately agree to consider "false"; however, as neither is

50

allowed to forget the fiction of fiction, both continually probe the truth of their encounter, as well as the truth of the lie that accepts its falsehood. The dynamics of this confrontation give rise to the illusion that the work is aware of itself, directs itself, conceives itself: that a self-conscious film, for instance, can be its own mindscreen.

Let me appeal at this heady juncture to Bugs Bunny. The best laughter is, after all, laughter at ourselves—the sort provoked by a sudden realization of the familiar absurdity of our own position. Because self-conscious film so often reminds us of our position in life as well as in the movie house, its comic potential is extraordinary. *Les Caribiniers* (1963), like *Endgame*, may be the work of a "bitter Fool," but one can always turn to Buster Keaton or Bugs Bunny for the laugh in its purity. In their light, even this knotty mode is lucid.

Chuck Jones's *Hair-Raising Hare* (story by Tedd Pierce) burns our candle at both ends, even in its first image. Out of the rabbit hole emerges a short candlestick—one McConnell might identify as the ancestor of the projector's carbon arc—in the hand of a peering Bugs who inquires, "Did you ever have the feeling you were being *watched*?" The bunny is known for his asides, of course; in most of his films, he nonchalantly inhabits the credits, lounging on his block-printed name and pulling the subsequent title-card down like a shade, or screen. So his audience is prepared to be addressed and to be reminded that they and the work see each other. But this first shot goes beyond such Elizabethan conventions, as the image enlarges to reveal that Bugs *is* being watched through the televisor of an Evil Scientist, who looks a great deal like Peter Lorre. The film image (criterion of reality) turns out to be a televisor image, an internal fiction that alludes to the film world's actual means of presentation, and therefore—while appearing to let us off the hook (it is not *we* who are watching him)—in fact sets us up for an elegant, complex *gotcha!*

The Evil Scientist, who intends to feed Bugs to a furry

51

monster (imagine Yosemite Sam's whiskers, eight feet high, whose only features are saucer-eyes, claws, and sneakers), lures him to his castle by means of a mechanical female bunny. (In another joke, his parody of a Universal horror film's castle features the flashing sign: EVIL SCIENTIST. Like the image of Peter Lorre, this gimmick asserts that the film's reference points include other films. These bon-bons of self-consciousness are in the spirit of Godard's "Arizona Jules," or Groucho Marx's "I thought they burned that" when he sleds in on Rosebud.) The monster chases Bugs through the castle—at one point, past a mirror. When the monster looks in the mirror, his reflection runs away; to paraphrase Godard, the reflection has reality. At another point, the monster's eyes (and later, Bugs's) peer out through the eyes of paintings, and the frame does not protect them from assault (as one might, by this time, have expected).

Finally, Bugs is trapped. He pushes against a door with all his strength, but it is clear that the monster will burst through. "Is there a doctor in the house?" he hollers, and a silhouette appears against the screen, as if someone in the audience were standing up, and says, "Yes, I'm a doctor." This is an extreme form of the aside, the imitation of interchange between character and audience—but what happens next is masterful. Bugs adopts his characteristic lean, produces a carrot out of nowhere, and in what is both a caricature of his own image and an affirmation of its power, asks, "Eh, what's up, Doc?"

There is only one place to go from here, and that is to let the monster in on the secret. In a climax that anticipates that of Beckett and Keaton's *Film* (1965), Bugs asks the monster, "Did you ever have the feeling you were being watched? Look out there, in the audience . . . " Confronted at last with something more horrifying than himself, the monster screams, "People!" and runs directly away from us, through layer after layer of—take your choice: castle wall or film space; whatever it is, it rips like a colored screen. The gimmick has come full circle (we are faced with the other

end of the candle), but there is one thing left to do, and that is to establish one's relation to this labyrinth, a way to live in it. As Bugs contemplates the hole in the back of his world, the robot bunny (or her double, since the first "fell to pieces" when Bugs kissed her) unwinds into view. "Mechanical," he says disparagingly, not to be taken in by representation. Then she kisses him, and with a loud "So what if it's mechanical!" he bounds after her like a robot himself. And that's all, folks.

The comparison with Beckett's *Film* is worth pursuing. The self-consciousness of that film is asserted by its opening and closing shots, which are extreme close-ups of Keaton's aged eyelid—perhaps a functional echo of the shot that Porter indicated could be used to open and/or close *The Great Train Robbery* (1903), in which a cowboy blasted his gun straight at the camera. All the other shots are subjective camera: some, which are smeary, show what Keaton sees; the others, which are clear, show what "the other Keaton"—self-perception—sees. This "other self," which at first appears simply to be "the camera," spends most of its time hiding behind the old man, who is himself obsessively covering or evicting anything in his apartment that might look at him or his briefcase of personal photographs. When the old man realizes that he has been observed all along by this other self (whom we too see at this point), he hides his face, and eventually the image goes black. (*Film* raises the possibility, then, that subjective camera can function as mindscreen in the context of a self-conscious film.)

Hair-Raising Hare is a self-conscious film without internal mindscreens—without, that is, the illusion that any of its images originates in the mind's eye of a particular character. But to the extent that its "potential linguistic focus" is aware of itself *as film*—an awareness that both includes and is alluded to by Bugs's own awareness—it projects the fictitious autonomy of mindscreen narration: it appears to

53

imagine itself—or perhaps more precisely, includes an awareness of its being a visual narration.

The converse of this kind of structure is seen in Cammell and Roeg's *Performance* (1970), where the characters are aware of themselves as performers, but not in a film, and where the two key mindscreen sequences (introduced by the image of a hole's being bored into a character's head) present not what each character fantasizes but what the film, from a "clairvoyant" point of view,[7] understands and embraces. It is not necessary, in other words, to limit the application of "mindscreen" to sequences that present what a character sees, or relates, in his mind's eye. Yet to extend the term from that base, it is necessary to explore more deeply what is meant by "mind," by "presentation," and by "sight." Even a brilliant use of conventional mindscreen, like the flash-forwards experienced by the hero of Roeg's *Don't Look Now* (1973), suggests ambiguities of time, of mindspace, and of film syntax that are impoverished by being termed merely "subjective."

Film, as a world in itself, has limits analogous to those of the external world: limits that are inseparable from the fact that it is a language. As a reading of Wittgenstein's *Tractatus* will convince one, the limits of one's language are the limits of his world.[8] Language and thought, self and world—all, as systems, appear to be limited wholes. No system can include what is outside its own limits: language acknowledges the ineffable, but cannot define it. Nevertheless, some of the things that cannot be explained or "known" within or by the system display themselves as aspects of the system's coherence. As Wittgenstein puts it, "They *make themselves manifest.*"[9] The eye, for example, is a limit of the visual field, not a part of it.[10] One does not see the eye that sees (except in a mirror—but the image of an eye is of course not the eye itself). But the fact that there is an eye is evident from the fact that the field is a visual one. Dorothy's apparently third-person figure in Oz is like the

image of the eye in the mirror; the dreaming mind, like the physical eye, is offscreen: a limit of the dreamed world.

Mindscreen, as a term, attempts to articulate this sense of the image field as a limited whole, with a narrating intelligence offscreen. This intelligence—to recapitulate— selects what is seen and heard; it is a principle of narrative coherence. The film is its visual field, made accessible to an audience through the technology of projection. The narrator need not appear onscreen, but manifests himself in the narrative structure (as do the internal narrators of *Citizen Kane*). *The Wizard of Oz*, then, presents a limited whole (the dreamed world of Oz) whose dreamer is offscreen—within a larger, limited whole *(The Wizard of Oz)* whose makers are offscreen, but who are different from Dorothy in that they are not fictitious. Nevertheless, the dream of Oz and the film of Oz-and-Kansas relate to their respective limits in the same way; each is equally unable, and for the same reasons, to transcend the bounds of its being. Because the same can be said of the human mind, and of the known or knowable universe, the question of self-conscious narration takes on metaphysical proportions rather urgently. One of the few gestures available to the metaphysically self-conscious filmmaker is to create an intermediary consciousness between himself and the audience—one the work can struggle to become aware of, or to become, and which it can come to consider (giving up the quest) the limits of its world. No more than Bergman can film what he means by "God" can Godard film what he means by "truth"—but each can dramatize the struggle and its limits, acknowledging the bond that he and his language share.

Whether or not a film is logically positivist, its attempt to manifest self-consciousness raises these issues. Self-consciousness functions at the edge of a system's coherence, and invariably involves the question of limits, whether it does so in a joking mood (as in *Never Give a Sucker an Even Break* [1941] and *Hair-Raising Hare*) or overwhelms both itself and the audience in frustration, despair, and tension

(as in much of Bergman, or—to switch media—Beckett and Faulkner). To the extent that a mindscreen sequence (or film) depends for its coherence on the existence of an offscreen narrator, it too raises these questions. The audience "reads" a mindscreen by recognizing it as a limited structure—that is, by fantasizing a storyteller. Let me repeat that I have been speaking of *fictitious* storytellers, some of which are identifiable as characters within the fiction (Francis in *Caligari*) and some of which are personae of the film's "potential linguistic focus" (the arc rods in *Persona*). It is possible, in these terms, to consider the film a self, and its mindscreen first-person. But only if the film, as part of its declared and often structural intent, attempts to conceptualize the limits of its mindscreens, and to relate those to its own limits, is it necessary to call a first-person film self-conscious. The two modes, then, are independent, though they often appear together. Neither *Citizen Kane* nor *Don't Look Now*, despite extensive use of mindscreen, is self-conscious—although the audience may be goaded, by the resemblance of the internal narration to films, to interpret the total system in self-conscious terms (in which case one must speak of a self-conscious audience). Nor is *Last Year at Marienbad*. And *Hair-Raising Hare*, although self-conscious, has no mindscreens. It seems appropriate, however, to conclude this chapter by considering a film that is replete with both modes: Buster Keaton's extraordinary *Sherlock Junior*.

Dreams, like movies, endow one with temporary freedom. Films that capitalize on this similarity, such as *Sherlock Junior* or *The Wizard of Oz*, have to be distinguished from the other major tradition of dream-films, the Surrealist, whose masters (Buñuel, Cocteau, and occasionally Bergman) employ dream-conventions to convey a heightened view of reality—one that is less interested in fantasy-fulfillment than in the connections between the workings of the unbridled mind and the aesthetic structure of truth. It is worth noting, however, that Breton's *Manifesto on*

Surrealism came out during the same year as *Sherlock Junior* (1924), and that there are moments when Keaton's film straddles both traditions, coming up, if you will, with the best of all three worlds.

Sherlock's establishing shot presents the seats of a movie theater, which is doubtless the last thing its audience expected to see on a movie screen. In the back row of the otherwise empty theater, next to a pile of papers he is supposed to be sweeping away, Buster reads a book that is revealed in close-up as *How To Be a Detective*. The owner-manager tells him to get to work, and Buster takes off what one had perhaps not expected to be a false mustache. He sweeps out the theater, adjusts the sign for the current film, *Hearts and Pearls: or, The Lounge-Lizard's Lost Love* (which, like *Sherlock*, is five reels in length), and after some business with the trash-pile, buys his girlfriend (played by Kathryn McGuire, "the girl in the case") a $1 box of candy, whose price he pencils in as $4, to impress her. While he is giving her the box, along with a tiny engagement ring, his rival (played by Ward Crane) sneaks into the house and steals her father's watch, which he pawns for $4, three of which go to purchase the biggest box of candy he can find. When the theft is discovered, Crane slips the pawn ticket into Buster's pocket. The father tells him never to return, and Kathryn gives back the ring. Consulting his detective book, however, he decides to shadow his suspect, and follows Crane across town—until Crane notices him and locks him in a boxcar, from which Buster escapes by means of a water tank. "All wet" as a detective, he goes back to the theater "to see what he could do to his other job." Meanwhile, Kathryn (the better detective) investigates the pawnshop, discovers the thief's identity, and heads back home with the news.

Buster starts one of the projectors and goes to sleep. His dreaming self gets out of his body to watch the film (Keaton appears in double-exposure, his solider form dozing against the projector, his transparent form moving around). One by

one, the characters of *Hearts and Pearls* turn away from the audience, dissolve, and turn back as the characters of Buster's own life: Kathryn, her father, his hired hand (now a butler) and the rival. At this point Keaton is making a nice point about the way most people read films in terms of their own lives (identification), but he is also identifying movies with dreams (wish-fulfillment), and this particular dream with a movie (self-consciousness). The dreamer takes his hat (leaving a solid hat on the wall) and goes out of the booth to take a closer look at what his rival is doing with Kathryn. Outside the booth, he appears solid.

He walks up the aisle, then stands to one side of the screen. When his jealousy becomes too strong, he rushes into the picture. Crane promptly throws him back out into the audience. Buster charges back in, but the image has shifted, so that he finds himself outside the front door of the house. There is another cut, and Buster is in a garden; his screen position has not changed, but the setting has. Throughout this sequence the image has included the screen, the proscenium, the musicians, and much of the audience, with the camera rear and center, more or less where the projection window ought to be (fig. 3); indeed, as the final scene of the film demonstrates, this *is* the view from the projection booth, and the image is the dream-field of the projectionist. It is a mindscreen, then, but it is also a joke on film syntax. This becomes clear when Buster starts to sit on the garden bench but lands on the pavement of a busy street, then starts to walk and almost falls over a cliff. He is trapped in a montage. The brilliance of all this is that Buster is taken along with the cuts, like a spectator, but physically affected by the landscapes (endangered by a train, frozen in a snowbank, drenched by the ocean), like a character. He is caught in a film, but in a manner possible only to the most involved spectator—the spectator who believes totally in the truth of the filmed world: in some sense, the dreamer. Cuts leave entire, integrated worlds behind them; Buster must, then, be considered imperfectly integrated into the filmed

world at this point, since the cuts do not leave him at the doorway (which was the landscape he entered). Another level of involvement is called for, and with it a twist of the mindscreen.

The montage dumps Buster in the garden again, and the image irises out. The camera tracks in, until the "false" screen fills the "real" one. Buster's image has disappeared. We understand, then, that Buster's dreaming mind has opted for a different approach, a way to get into the house and win the girl. To do this he must become perfectly integrated into the image: become a character. He must no longer appear to be the dreaming spectator; the audience must, in fact, accept his dream as its own. Appropriately, "the film within a film" expands to replace "the film." Dream becomes film in a radically clear way, just as the film becomes dream. The entire visual field is still a mindscreen, and still Buster's, and his image eventually appears within it, but the audience's responsibility has shifted. From now on, the audience must interpret the visual field in terms of Buster's offscreen mind's eye, even though the image looks no different from that of any third-person film. Similarly, there is no inner screen or surrogate audience to remind us of the image's self-consciousness; we are encouraged, in fact, to forget about it and accept the inner film, one dream being as valid as another (and that of course being the most radically self-conscious judgment possible in this context).

The story of *Hearts and Pearls*, as revised by Buster, mirrors that of his disastrous afternoon, with the difference that Buster, without losing his endearing qualities, has become the brilliant detective, Sherlock Junior. Crane and the butler steal the father's string of pearls, and the father sends for Sherlock. The butler rigs the house with an exploding billiard ball, a booby-trapped chair, and even poison, but Sherlock—through a combination of dumb luck and a glance in a well-placed mirror—outwits him. By the next day, as a title informs us, he has completely solved the mys-

tery, with the exception of identifying the thief or finding the pearls. With the aid of his assistant, Gillette (the theater-owner), Sherlock dresses in front of what appears to be a mirror—then walks through it. He opens a safe, which turns out to be a door to the outside, and walks into the street. (These jokes invoke not only "the reality of the reflection," but also the interface of vacuum and volume,[11] a dialectic expressed to perfection in *Sherlock*'s climactic chase sequence.) He sets about trailing Crane, and eventually discovers the hide-out. Gillette, who has accompanied him in disguise, helps him drape a dress over the outside of one of the windows before Sherlock walks inside. In the film's most Surrealist moment, Crane shows Sherlock a bizarre cage in which a detective is dying. Sherlock, however, grabs the pearls and jumps through the window, rolling to the ground outside in the old-woman disguise. When the criminals realize who the "woman" is, Sherlock escapes again by leaping through the open suitcase and midsection of Gillette (who is now disguised as a peddler-woman), and even through the solid fence against which Gillette is standing. (Both these stunts are accomplished without montage.) Sherlock runs down the street in the general direction of another hide-out, where Crane has informed him Kathryn, in imminent danger of assault, is being held by the butler. Gillette pulls up alongside him on a motorcycle; Sherlock gets on the handlebars. They hit a bump, Gillette falls off, and Sherlock continues: miraculous, unaware. Volumes become vacuums; trucks pass beneath an interrupted bridge, and their tops make an even road; street repairmen finish their blasting just before he speeds through the site[12]—the whole sequence is a masterpiece of fluid geometry—and through it all, Sherlock pilots the motorcycle from the handlebars, until he crashes into a woodpile outside the second hide-out, is hurled feet-first through the window, kicks the butler through the opposite wall, and saves the girl. Sherlock and Kathryn rush off in the gangsters' car, blow up their pursuers with the pool ball, and end up in

a lake. When they start to drown, Buster wakes up in the projection booth.

Throughout this sequence the dream quality is a function of what happens (wish-fulfillment, with occasional bizarre developments) rather than of how it is filmed. There are no visual indicators that the field is being dreamed. This is one of the problems in mindscreen analysis, of course—film itself is an imagined visual field, comparable, as a choreography of the real, to dreams—but it is also the primary reason that some films in their entirety can be discussed as mindscreens. The narrator of a mindscreen is offscreen; the indicators of his presence are contextual. Even in *Caligari* as we have it, the Expressionist décor cannot, on its own, be taken as a conclusive signifier of first-person narrativity (since it continues till the end of the film). *Citizen Kane*, too, has a consistent visual style from first to last (the newsreel excepted), and does not confine such devices as the blacking-out of heads or the use of deep focus to the mindscreens of certain characters. One understands that Buster is dreaming (i.e., narrating the dream) because one sees him go to sleep at the beginning of the sequence and wake up at its end; yet both framing shots are third-person. (The double exposure of the opening frame, like the vignette shot in *Life of an American Fireman*, is an exception, and a clumsy one; its literal portrayal of the onscreen narrator has proved unnecessary, and even Keaton, by the end of this film, abandons it. The transition from third- to first-person occurs *during* the shot of his going to sleep, and it is the first half of this shot that, having no fictitious narrator, constitutes the true opening frame.) When Buster wakes up, the mindscreen stops. But the self-consciousness continues independently.

The self-consciousness of *Sherlock Junior* depends not on its being about a movie projectionist, nor even on its largely taking place in a movie theater—although these are, of course, reflexive devices—but on the way it reminds us of *our* being in a movie theater (and therefore of its being a

film), of *our* acceptance of the reality of the dream, and of the option that we share with Buster: to wake up. We are reminded at every turn that this world is a film, and that the points of contact among "reality," film, and dream are complex and ambiguous.

Buster wakes, of course, into what he thinks is reality. The audience wakes from the same dream, but into two levels of reality, between which it must choose. To continue to enjoy the fiction, the audience must believe in Buster's level, and wake with him from Sherlock's—but there is a moment when the audience is aware of itself as being on Keaton's level. To enjoy the self-consciousness of this final sequence, one must be able to deal comfortably with all three levels, to believe—and disbelieve—in all three worlds. (Buster has made this point by discovering a way to integrate himself into the image field of *Hearts and Pearls*—to become a believing character in the fiction, rather than a deluded spectator; analogously, Keaton moves up his camera to allow the inner film, populated by its dream characters, to fill the "real" screen.) During what follows, the audience's decision to rest at Buster's level is challenged, and we end—like him—scratching our heads.

Kathryn enters the projection booth and lets Buster know what has happened since their last meeting. Buster is overcome by his real-world shyness and looks to the dream world to find out how to behave. (Sherlock had not been shy.) On the theater screen outside the booth, the hero (no longer Crane) reassures the heroine (no longer Kathryn); Buster reassures Kathryn. Buster mimics the hero as he places a ring on the heroine's finger, and then kisses her, but is puzzled at how to mimic the leap through time (and experience) that endows the screen couple, suddenly, with a pack of children. The audience is being asked to consider what it learns from films, here, and is being treated to a restatement of the joke on montage (the paradoxicality of film time and film space), but it is also being forced to evaluate or conceptualize the limits of film reality. This conclud-

62

ing exchange is made up of reverse-angle shots, which alternate between the screen couple in their frame and Buster and Kathryn in theirs: the window of the projection booth. Each couple is unmistakably identified as being on screen, one in a film world and the other in a filmed world. Having been doubly taken in, the audience has the option of being doubly awakened.

4. *Coming Apart* (courtesy of New Line Cinema): Joe examines the
stiletto heels of a casual acquaintance. His mirrored camera (out of
view) obliquely faces the large mirror behind the couch.

"Coming Apart":
The Mind as Camera

The nature of cinema is to transform the world into
a discourse.
 —Christian Metz[1]

HALDEMAN: But we are now at a point where fact
and fiction are becoming badly confused.
 —*The White House Transcripts*[2]

Hair-Raising Hare is about a character who knows he is in
a film; *Sherlock Junior* is about a character whose experi-
ence reminds the audience that he is in a film, and also
about a surrogate of that character who lives in a film that
is somehow of his own making. The position of Sherlock is
different from that of Bugs Bunny in that some manifesta-
tion of Sherlock—the dreaming consciousness (Buster) that
makes itself manifest in the structure of the dream but does
not appear in person—is *responsible* for the filmed world
(the revised version of *Hearts and Pearls*).

 Between them, these films involve three distinct (but
not mutually exclusive) approaches to self-consciousness.
The least difficult is that of the awake Buster, who con-
siders himself a person in a real world—a world that the
audience is prompted to regard as a film. In *Hair-Raising
Hare*, which is the most Pirandellian of the three, the hero
is aware of being in a film, and of existing in relation to a
world outside his (that of the audience, which is fiction-
alized to the extent that it participates in the encounter).

When Jacques muses, in *As You Like It*, that "All the world's a stage, / And all the men and women merely players," he performs a function similar to Buster's: he alerts the audience, without being entirely aware of his position.[3] Buster's mindscreen of *Hearts and Pearls*, however, is both more personal and more paradoxical than either of the other structures, since Sherlock's limited consciousness has potential connection with what is in *this* context the extra-systemic consciousness of Buster. While Sherlock is not (like Bugs) aware that his world is a dream, the offscreen mind of Buster is clearly, on some level, aware that his mindscreen is both dream and film (hence the jokes on montage and paradoxical space). The self-consciousness of the Sherlock sequence, then, is a latent fact of the image rather than a preoccupation of its characters, and it is this approach to reflexivity that strikes me as having the greatest dramatic potential. There are limits, after all, to the aesthetic interest of "Look, Ma, I'm in a movie!" Self-consciousness becomes most effective when it is used instead to intensify or redefine the classic confrontation, basic both to comedy and to tragedy: "Look at the position in which I have placed myself." When a character blames his bind on someone else, whether he rails at the gods or simply at some variant of Laurel ("Well, Stanley, this is another fine mess you've gotten us into"), one understands that he is simply dodging the issue. (If he's *not* dodging, the situation is neither comic nor tragic, but pathetic.) In this chapter I should like to take up the question of self-conscious tragedy, in terms of a film that very few people have enjoyed: Milton Moses Ginsberg's *Coming Apart* (1969).

This may be a case of "a good *idea* for a film," or of a good film that repels its audience; I can only go on my own feeling that it is interesting, serious, and an apt example of the rhetorical and psychological networks associated with the overlap between mind and mindscreen. The general critical response, however, is typified by this excerpt from Andrew Sarris's pan of the recent film, *Inserts* (1976):

66

When a movie makes even Milton Moses Ginsberg's *Coming Apart* of a few years back seem artistically controlled, it is time to let the mind wander, and mine did.[4]

It is my contention that *Coming Apart* certainly is "artistically controlled" (despite the self-indulgence of its first half-hour, with its flaky cameos) as well as psychologically and politically revelatory. It deals effectively with the issues of sexism, materialism, narcissism, self-destructiveness, and self-consciousness—in each case without failing to emphasize the antihero's responsibility for his own situation.

Ginsberg's film strikes me as ethical rather than exploitative—a clear working-out of the implications of what Roger Poole, a few years later, was to call "ethical space." That space, in this context, is the visual field, structured by the intentions of the character who photographs and lives in it, and also by the unself-conscious actions of the other characters, who are unaware that they are being photographed. Describing a silent confrontation between Czech citizens and Russian soldiers in a park during the occupation of Prague, Poole says:

> An ethical grammar of the visual would begin by connecting the signifier of the acts in space with the signified which is the intention of the actor. Obviously this is not and can never be achieved by quantitative analysis.
>
> In the park in Prague, two sorts of space intersect. There are two sorts of space because there are two sorts of intentions plainly visible in the photograph. The intentions structure the space in two different ways.
>
> When the two sets of intentions, the two sets of signs, confront each other in hostility, then ethical space is set up instantaneously.
>
> The space in the Prague photograph is an achieved intentional structure, something held in place, something willed.[5]

67

While this analysis applies decisively to the phenomenal field of the apartment in Ginsberg's film, and to the visual field held between mirrors (one of them false—an extension of Raymond's mirrors in *Citizen Kane*), it also applies to the mindscreen of its central figure, and to his responsibility (within the fiction) as the primary structurer of that space.

Coming Apart is about a man who realizes only gradually that his mind is offscreen, as if he were Buster and Sherlock at once. For Joe Glazer, the psychiatrist, what begins as a research-oriented exercise in snooping ends in a fragmentation of consciousness; for the audience, what appears to be a pornographic home movie develops into a deliberate statement on the nature of voyeurism. For each, the self-consciousness of a narrative device becomes the main instrument of his own self-consciousness.

The psychological and ethical structure of the visual field is revealed gradually, as is the nature of the narrative device, but within the first few reels the audience has been given enough clues to be able to understand the origins of the footage it is seeing. A psychiatrist (played by Rip Torn) sets up shop in an apartment building in New York City. He is estranged from his wife and has chosen this building because his former mistress (Monica, played brilliantly by Viveca Lindfors) lives here—although it becomes clear that Monica wants nothing to do with him. He has a research grant, on the strength of which he dismisses most of his patients and buys a compact 16mm lip-sync movie outfit, which he disguises as kinetic sculpture and sets up in the apartment. This "sculpture" looks like a foot-high cube with a mirrored front. Joe usually leaves it facing his couch and the wall-sized mirror behind the couch, so that most of the living room is within the unmoving camera's range (fig. 4). A remote control switch is usually left on a table to one side of the couch, just out of view. (One becomes aware of this switch because of the number of scenes that end with Joe's hand going offscreen left, or begin with his hand's pulling back from that direction.) Joe uses this

camera "to photograph things as they happen," because, as he tells a juvenile model who visits his apartment, he is "interested in reality." The audience sees all the unedited footage photographed by this camera, and nothing else.

He begins by photographing the women he brings up to his place, recording their bizarre stories (as in a scene that begins, "How did you say you got those burns?"[6]) or intimate behavior. In the process he produces a portrait of himself, and a chronicle of his own nervous breakdown. One learns about Joe not only by watching his behavior, but also through interpreting his decisions of what to film. He tends to switch off the camera when he is losing arguments, for example. The reasons he turns it on are more intricate.

The false name he sometimes adopts, GlassMan, expresses both his own neuroses and the metaphoric significance of the two-way mirror on the front of the hidden camera. He calls himself GlassMan because he would like to consider himself transparent, but manipulates mirrors—because he aspires to sincerity, but depends on pretense—because he lives a double life: Superman of the human spirit (brilliant, selfless psychiatrist) and mild-mannered (withdrawn, contemptuous) reporter (peeping Tom). At all times, the audience is aware of Joe's awareness that he has the camera turned on: that the women with him are living while he is acting (when his guests lie or pose it is not for the sake of the camera). Always looking over his own shoulder, he becomes a voyeur in his own life. He has an edge on all these people, and on a very private level he uses it, withdrawing into his sense of secret power: that his is the greater knowledge, the final control over the situation. Like Fellini's Guido in *8½*, he films his life from an interior distance, manipulatively, "because he doesn't know how to love." Since Joe's casting problem is considerably simpler than Guido's, *Coming Apart* begins where *8½* ends, but without the latter's uplifting sense of acceptance and integration.

The principal relationship recorded by the analyst's camera is his affair with a former patient (JoAnn, played

by Sally Kirkland), about whom he writes a clinical paper (presumably after examining some of the footage). She is a major element in his self-destruction in that she makes him see how he has used her sexually and exploited her confidence (although she never knows about the hidden camera). In one scene she points her 35mm camera at the wall mirror's image of their nearly nude bodies[7] and pretends to take a picture of their love-play; he becomes furious, probably because she has unintentionally made him aware of what he is himself doing at that moment. He suffers an alienation effect that points out his true alienation from his own existence. He destroys her through a combination of sexual exploitation, contempt, and violation of their previous therapeutic relationship. He drags her away from her former lover to talk about how wonderful Monica is, for example, or urges her to have all-night sex bouts with his fellow analysts, with the result that she is too fatigued to keep her job. When she becomes dependent on him, he throws her out.

All this time the audience sees only what Joe has decided to record, in a continuous-present equivalent of a *Kane* monologue. The first part of the film orients the audience to this narrative device (and loses both direction and energy in its catalogue of strange ladies). The second part records Joe's affair with JoAnn and his attempt to win back Monica. A harrowing party near the end of this section makes clear just how involved Joe is with problems of false surface (of which the two-way mirror on the face of his camera is the physical expression): a seductive girl in a clown disguise turns out to be a homosexual male deeply attracted to Joe. The removal of the clown disguise makes Joe happy, but the removal of the girl disguise leaves him compromised and angry (and ready to turn off the camera).

In the third section of the film things come apart. One has been prepared for the main elements of Joe's breakdown by his reaction to JoAnn's camera joke, and by the Jefferson Airplane songs that, when a character happens to

70

play them, constitute the film's only music. (The pretense is consistently maintained that no lab work or sound mixing was employed on this footage.) Joe is a Plastic Fantastic Lover, a rapist by instrumentation, a phony. His involvement with this filming has gone far beyond any original research interest; the camera has become part of his consciousness, a life process and a compulsion. He begs God to make him stop—what? Filming, or behaving as he does: it makes little difference at this point. In two brilliantly conceived sequences Joe turns on the camera when he is alone and tries to explain himself to it: does a little dance (at groin level), then sits, meditates, and says, "No, the thing is, I can imagine myself out there, looking at the film," and the camera begins to malfunction. Successive cuts show his face in various stages of contortion from the apparently painful things he is saying, but the sound track is feedback. Of course feedback is a perfect metaphor for this situation, because the uninterrupted electronic (or consciousness) circuit is being turned on itself, like a microphone pointed at its own speaker, or a TV camera at its own monitor. This mutilated sequence is perfectly expressive of what Joe would say if he could. Later he shouts at the camera (having removed its false mirror), "What do I have this—this *machinery*—on for!"

It is at this point that he has his deepest and most selfish confrontations with the women around him. First, he throws out JoAnn. Later, his wife comes to ask him for a divorce; she has received a letter from one of GlassMan's lovers. He turns the camera on and off during her denunciation of him. At one point she screams, "Why do you have such contempt for everybody!" and he smirks, his face averted; one is reminded of his quiet laugh when JoAnn had earlier attacked, "There's no *mystery* about you—none!" His camera, of course, is his mystery, his secret self, his manipulative "integrity," his defense. In one really stunning scene he sits on the couch with Monica, who is telling him to get out of her building. He is staring, completely withdrawn; he

71

gives no sign that he is even aware of her (until he starts to cry, late in the scene): but the audience realizes that he has switched on the camera, that that is his secret response. Perhaps he weeps at the habit of insincerity that has made this his only method of communication, of being in his life. Soon afterward, he shows the camera to one of his girlfriends; it is a confession, and he looks exhausted. She asks him to turn it off so they can construct a fiction and then turn the camera on, to make a "movie within the movie." He refuses and says, "Let it run." This is the closest he comes to an acceptance of life; even if his *cinéma vérité* is plastic fantastic, it is a life force to him. In the final scene, JoAnn returns to the abandoned apartment, intending to wreck it and shoot herself. In the process she apparently trips the remote switch and starts the camera. She looks into its mirror, since for her it is always a *one*-way mirror, then smashes the glass (her reflection) with her gun butt. "Plastic Fantastic Lover" is on the record player. From the glass in its workings and the other upsets it has suffered, the camera speeds up: the image and soundtrack slow down. JoAnn throws something at the large mirror that has filled most of the frame for the last hour and a half, and it shatters. Tableau; titles.

Unlike most films, which prefer to suggest that some magical process has allowed the audience's eye to wander where it will in their worlds, *Coming Apart* calls special attention to the presence of the camera in its scenes. Instead of letting the mechanics of filmmaking go as conventionally unnoticed as the transparent "fourth wall" of rooms on the stage, *Coming Apart* deliberately turns the "fourth wall" of Joe's apartment into a consciousness, whose metaphoric nature and moral implications are both complex and lucid.

The actions of the film occur between facing mirrors, one of which is false. Although the psychiatrist pretends to be committed to the relationships he carries on between the mirrors, his mind is more deeply engaged *behind* the false one. The hidden eye of the camera responds to his selecting

intelligence, to the extent that the act of deciding to photograph a scene becomes at least as important to him as whatever he does with his visitors, and in some cases is his primary response to (or defense against) the demands they make on him. In the scenes where he attempts to explain himself to the camera, it is clear that the camera has become an important part of his mind—that he and it are one continuous system, capable of generating feedback (a signifier of extreme reflexivity). Where Joe begins by teaching the camera how to observe life intermittently from behind a glass mask, the camera ends by shattering Joe and teaching him its own life process: to run on and on, uncritically recording everything in front of it (an aesthetic of reality).

Because Joe makes the film that the audience sees (and creates the means for recording the final scene, in which he does not appear) *Coming Apart* is a first-person film. The brilliance of its narrative method lies in the fact that the film is being recorded and presented, however indirectly, by Joe's mind—a mind with the power to photograph the objects of its concern. Joe inhabits his scenes as do the various narrators of *Citizen Kane*, with the difference that this mindscreen is unmistakably presented *as film*.

By making the audience so aware of the camera's role in the image and plot of his film, author/director Ginsberg has not only created an intriguing metaphor for the workings of the self-conscious mind, but also extended the reference of that metaphor to the ethical position of the audience itself.

An audience is responsible for what it sees; it makes a decision to look at the film's world. In most narrative films, however, the convention of the camera as an organ of one's shifting ideal attention tends to suppress any Brechtian self-consciousness on the part of the viewer. One can deny that he is eavesdropping on Marion Crane's lunchtime tryst in *Psycho* (1960), for example, or that he is passive—remains in his seat—while she is being murdered, only by clinging to the convention of the nonphysical camera that puts his attention, but not himself, at the scene of the crime. If one is

sexually excited by these scenes, or repulsed by them, in either case the moral responsibility can be put off onto Hitchcock for making these things happen and making one look at them. Yet one could have looked away, or left the theater, and Hitchcock's nicest ironic gesture is to spare his audience this awareness.[8] This is not to say that there is not a very complex play of moral consciousness in his work, but rather that the audience's complicity in choosing what to look at is usually left unstated (*Rear Window* [1954] is a relevant exception).

Without anticipating our later discussion, it might be worth noting here that Godard's approach is specifically the opposite of Hitchcock's. His section of Chris Marker's compilation film, *Far From Vietnam* (1967), shows several minutes of Godard's fiddling with his camera and meditating, voice-over, about the role of the committed filmmaker. Godard makes one see that a political filmmaker deals not with the ideal consideration of political events, nor even with documentation, but with his camera. He begins with his situation: manipulator of photographic imagery, in France. Only from this base can he hope to consider the nature and implications of the Vietnam war; only by extreme stylization can he keep this awareness of situation in his imagery. The audience is made uncomfortably aware of its decision to sit in a movie theater and watch a film about Vietnam, at the very moment when Vietnam is a real war in a real place; they are far from Vietnam, dealing with film, and that is their moral, political, aesthetic situation. For Godard, the limitations of that situation are the basis of his art.

The narrative device of *Coming Apart* presents a fictional situation that is no less unsettling and brutal than *Psycho*'s and applies to it the self-conscious gaze of a Godard. The audience, which may have come to look at film art, or naked bodies, finds itself instead looking at a physical representation of its own voyeuristic detachment. The "fourth wall" of the boudoir is a two-way mirror, reflecting in on the fictional situation and providing a mask for the watch-

ful outer consciousness. By pointing out Joe's decision to film what the audience sees, Ginsberg makes the viewer aware of the moral implications of seeing, of deciding to see, and vividly dramatizes the contradictions of a peripheral relation to life—a relation that the audience shares with Dr. GlassMan.

Coming Apart, then, ably supports Metz's assertion that "the nature of cinema is to transform the world into a discourse." The film exposed by Joe's camera is his record of the world—a visual presentation of what his mind decides to notice: in short, both mindscreen and discourse. As a subjective account of reality, it is defined by what it leaves out as much as by what it includes—and it is an account, no matter how spontaneously or unpredictably its present-tense events develop. To photograph is, as has been suggested before, both to notice and to tell. To look at a given event, or in a certain direction, or even to cease looking, is to bias that rendition: to describe the world as one chooses to see it. The activity of Joe's camera does not simply illustrate but *is* his narration, and to the extent that his mind narrates this world, the screen is the retina of his consciousness. As a mindscreen, this field apprehends and describes simultaneously (in a visual analogue of what Gertrude Stein called "listening and talking at the same time"); its biases are inherent in its vision, so that the image calls attention to its subjectivity as authoritatively as any first-person sentence, or as the dream-field in *Sherlock Junior*.

When Joe says, "Let it run," he may be interpreted as attempting to convert his discourse back into a world—to arrive at a phenomenological perspective. Bugs manages this at the end of *Hair-Raising Hare*, when he marches off mechanically after the robot bunny. Such existential acceptance is possible for Joe, however, only when he acknowledges his responsibility as narrator: Bugs accepts his world, but Joe has to accept himself. His aesthetic of reality is at first an evasion of this responsibility, and only when he allows himself to be both Sherlock and Buster is he able

75

to emulate Bugs. Analogously, one could argue that *Coming Apart* extends the experiment of *Citizen Kane* not only by making the world safe for deep focus, and by complicating the imagery of facing mirrors, but also by insisting on the discursive nature of the presented world.

From "Rashomon to Marienbad:"
The World as Mindscreen

> At the level of detail we can value most the mo-
> ments when narrative, concept and emotion are
> most completely fused. Extended and shaped
> throughout the whole picture, such moments
> compose a unity between record, statement and
> experience. At this level too, sustained harmony
> and balance ensure that the view contained in the
> pattern of events may be enriched by the patterns
> of our involvement. When such unity is achieved,
> observation, thought and feeling are integrated:
> film becomes the projection of a mental universe
> —a mind recorder.
>
> —V. F. Perkins[1]

The unity Perkins describes is perhaps most evident in
mindscreen cinema, where the narrator's statement is both
record and experience, and where the world unfolds for
both audience and narrator in that continuous present
which is the literal time sense of film.[2] One of the most
decisive limitations on film is that, like the world, it may
allude to the past, or present it as memory (an activity that
takes place in the present), but has no past tense. The
subjectivity of the past is especially clear in films like
Citizen Kane or *Hiroshima, mon amour*, where what might
appear to be third-person flashbacks are identified as past-
oriented mindscreens. When a filmmaker insists on flashing
back to "another time," he goes against the inherent

77

5. *Last Year at Marienbad* (courtesy of Astor Pictures): X (right) watches A (center) watch a stiff melodrama, somewhere in an elegant resort that may be Marienbad, sometime during a year that may be this one.

present tense of the image, and in fact does not abandon present for past, but renders that past (or future) as something present, so that unless time-scrambling is part of the film's programmatic intent (as in Stanley Donen's *Two for the Road* [1967]), the sequence can become muddled. It is in this sense that mindscreen cinema participates in one of the central concerns of modernism (exemplified in the work of Stein and Joyce), which is to present the world as it unfolds to, and is determined by, the present-tense consciousness of its characters. Although there have been numerous points of contact between literature and film—and not just on the Faulkner-and-Hawks level, but also on that of Joyce's interest in Eisenstein and Ruttmann, or Brakhage's in Gertrude Stein—one of the most intriguing is the collaboration between Alain Robbe-Grillet and Alain Resnais. Robbe-Grillet, immersed in the work of Faulkner, Sarraute, and Beckett, and fresh from his own experiments in radically subjective (but appearing on the surface to be entirely objective, almost photographic) narration; and Resnais, who had (through his collaboration with Duras) advanced mindscreen cinema to the point where it could present a subjective vision without having to surround the sequence with voice-over or whirly opticals—came together to produce a film that was as much at the forefront of contemporary literary experiment as of contemporary film: the notoriously enigmatic *Last Year at Marienbad* (1961). There have been several periods when literature, painting, and film have been contemporary with each other—notably the 20s, of course, as a film like *Ballet mécanique* (1924) attests—but *Marienbad* is the most conspicuous sync-point of recent times, not because of the respective callings of its writer and director, but because of the contemporaneity of its approach to the problems of narration, particularly those of subjectivity and time. Its central device is the mindscreen, and its declared time sense is the continuous present. It differs from a film like *Coming Apart* (which is, in its own way, contemporary with the Minimalist

aesthetic in American painting, and with the sexual/polit-
ical/structural self-consciousness of much recent litera-
ture) in that its mindscreens are not self-conscious, and that
its editing owes more to Eisenstein than to Bazin. (To find
a work that incorporates the systemic intentions of both
these films, one must look to the later Godard.) Between
them, *Marienbad* and *Coming Apart* divide and extend the
experiments of *Citizen Kane* (much as the Russians and
Germans extended the work of Griffith in the 20s): *Marien-
bad*, with the relativity of its multiple mindscreens and the
complexity of its time sequence, and *Coming Apart*, with
its deep-focus aesthetic and commitment to classical ethics.

For our immediate purposes, however, the most impor-
tant distinction between the two films is that *Marienbad*
is not self-conscious. Although it presents the subjective ex-
perience of its central characters as visualized by their off-
screen narrating minds, there is no suggestion that a motion
picture camera plays any part in recording this imagery, or
that the world thus presented is actually a film. Conse-
quently, the audience is encouraged to enter the characters'
minds in a radically direct way, but not to relate their
mindscreens to some further, systemic, offscreen narrator.
To be sure, any mindscreen has an offscreen narrator, but
not every mindscreen presents itself as film, or alludes to
the part it plays in some larger film.

What *Marienbad* does present are the interrelated mind-
screens of at least two characters, X and A. Much of the
difference between *Marienbad* and *Kane* depends on the
fact that these mindscreens do not follow each other in
sequence, but alternate almost haphazardly, with no sil-
houetted audience-surrogate like Thompson to announce
the transitions or attempt to assemble the puzzle. *Marien-
bad* is also more radically subjective[3] than *Kane*, freely dis-
torting the image to show not the "real" event that a char-
acter *selected*, but the felt event as it is meditated upon or
lived through. What is emphasized is the subjectivity—al-
most the solipsism—of private experience, and the difficulty

80

(if not the mendacity) of the attempt to share lifespace. Through its direct visualization of the thought processes of its characters, and its refusal to unscramble these mind-screens from "what happened," *Marienbad* asserts that mental imagery has no less presence (or subjective validity) when it originates in fantasy than when it is more conventionally coordinated with physical events in objective time and space. In this film, what a character sees in his mind's eye is as real to him as what he sees with his physical eye. Because the filmmakers have left out the conventional symbolism that distinguishes private reality (fantasies, dreams, memories, lies) from shared reality, *Marienbad* achieves a subjective realism (however stylized) at the expense of conventional coherence.[4]

Marienbad's plot is simple. A woman (A) and her escort (M), who are resting at an elegant hotel, encounter a man (X). X insists to A that they had met last year at the same, or a similar resort, and had fallen in love. She had agreed to leave M and become X's lover if he would wait a year. The problem is that she does not remember him. After a long persuasion (lasting the length of the film) A accepts X's story, and goes off with him. Although Robbe-Grillet's suspicion was that X is making up his story as he goes along, and Resnais has said that he directed the film as if the lovers had met and A had in fact forgotten him,[5] the film deliberately refuses to clear up this mystery, any more than it establishes whether the current setting is Marienbad or Fredericksbad, "this year" or "last year." Once the viewer accepts that these mysteries are not going to be cleared up, he can accept the film's contradictory events on their own ground, which is that of the characters' interrelated mind-screens.

The film opens with a series of track shots, implicitly identified by the voice-over as the movements of X's body or attention through the hotel's baroque corridors, comparable to the opening of *Rebecca*, but with the "I dreamed" suppressed, and the tense relentlessly present: "Once again

—I walk on, once again, down these corridors, through these halls, these galleries. . . ." (This voice-over narrative, swamped by organ music, is not detached from the mind-screen. Both image and monologue are interior and simultaneous.) The sequence concludes by bursting in on a stiff performance of a play involving an actor and actress, attended by the hotel's overformal clientele—among them X, whose mind may have been wandering while he watched the play, a play whose tone is similar to that of X's monologue and whose plot is virtually identical to *Marienbad*'s. There is no need to go into a complete analysis of the labyrinth; the above example gives a fair idea of the film's narrative complexity. The entire film may be a fantasy in X's head, inspired by the play before him, or he may himself be an element of a similar fantasy going on in the mind of A, who is also in this audience (fig. 5). It is more likely that the film itself is a labyrinth incorporating the mental experience of several characters and answerable to no imposable time sequence. X may be inventing the past, or the whole plot, or may be living this year as if it were the year to come; all this sequence tells is that X's attention wandered the corridors of Marienbad while, or before, X attended a play. Both images are equally vivid to him, and because his subjective experience (which includes both events) is directly presented on the screen, both corridors and play are equally vivid to the audience.

The viewer is not completely at sea, however, since certain scenes are clearly (but not conventionally) "unreliable." As the filmmakers explained to *Cahiers*:

RESNAIS: In any case, if you study *Marienbad* closely, you see that certain images are ambiguous, that their degree of reality is equivocal. But some images are far more clearly false, and there are images of *lying* whose falsity is, I feel, quite evident. You mustn't think that while shooting we amused ourselves and left the spectator to sort it out.

ROBBE-GRILLET: The use of décor is characteristic. When the room has an extraordinarily complicated baroque décor, or the walls are heavily encrusted with wedding-cake ornamentation, we are probably watching a rather unreliable image.[6]

The scene in which the balustrade crumbles, for example, is probably A's fantasy, just as the frenzied track through the corridors into one overexposed image after another of A's welcoming arms is probably X's. Indeed, recognizing the more subjective origin of certain images is essential to any comprehension of the film's dramatic structure.

One of *Marienbad*'s most interesting moments occurs in the bar of the grand ballroom, where X succeeds in making A see one of his own mental images. He describes her in her hotel bedroom, choosing a pair of shoes. Short shots of this very bright image are intercut with shots of the dark barroom; their relative lengths shift until the bedroom is the dominant image and the barroom only an intermittent flash. When X appears in that bedroom (dressed as he is in the bar), A backs away from him; the image is so vivid to her that she also steps back physically in the barroom, knocking over and breaking a glass. The point is not that she has "remembered" the incident, nor even that he has guided her fantasy, but that their mindscreens have overlapped. The viewer is unable to determine whether he is seeing the bedroom as A sees it, or as X sees it while he is describing it (so that the shots of A's barroom face would be taken to indicate that she is seeing *something*, but not necessarily what the viewer sees), but has the feeling that all three are seeing the same image. Between the moment when the glass breaks and the moment when M appears, offering A a new drink, a half hour of film intervenes, at the end of which A has a vision of X's destruction (the collapsing balustrade) and screams; her scream is completed in the barroom. Although the viewer could conclude that the events of that third of the film are supposed to have

flashed instantaneously through A's mind now that X has begun to convince her of his story, those events are so similar to what goes on in the rest of the film and contain so many intersubjective flashes of their own that, unless one wishes to believe that the whole film is A's fantasy, he must simply assume that the labyrinth has turned in on itself, demonstrating its independence from clock time and the total interdependence of its mindscreens.

Even when it depicts a fantasy in the mind's eye, then, the mindscreen remains a medium of first-person visual narration. It is not simply an intense mode of point-of-view, even when placed in sequence by some third-person "potential linguistic focus," but is, within its own limits, first person. It presents a personalized world, one that both incorporates the emphases and distortions of its organizing intelligence and expresses the mind's relation to its materials. The emphases may be subtle, as they are in *Citizen Kane*, or obsessive, as in much of *Marienbad*; the distortions may operate by exclusion, as in some sections of *Coming Apart*, or by excessive invention and rearrangement of incident and detail, again as in *Marienbad*—but the central point is that a mind is expressing its view of the world through these images. In Wittgenstein's sense of the word, a mindscreen *shows*[7] that it has consciousness. It is both an agency of visual telling and an expression of mind in the world; in short, it is the eye as I, the Vision of vision. In *Marienbad*, these private narrations so determine the audience's experience of the filmed world that one does not feel the urge (as in *Rashomon*) to probe the mindscreens for "what really happened"—the mindscreens *are* what happened: in fact, what happen.

I do not wish to be taken as implying any denigration of *Rashomon* (1950) by that last remark; in fact, Kurosawa's film is structurally a fundamental link between *Marienbad* and *Kane*, and deserves some discussion at this point.

Rashomon concerns the search for truth and for ethical order. The ambiguities, falsehoods, and selfish acts that

frustrate and motivate this search are dramatized on three sites: the forest, where a bandit ties up a samurai, rapes his wife, and probably kills him; the court, where the participants tell their versions of the forest scene; and the Rashomon gate, where two of the witnesses (a priest and a woodcutter) explain to a peasant, who is waiting out a heavy rainstorm with them, their versions of the court scene. The structure, then, is of an inquiry within an inquiry, and all three sites raise problems. As the bandit presents the story, the woman found him attractive and the husband put up a good fight; as the woman presents it, her husband rejected her unfairly, she was unconscious during the battle, and her sense of dishonor led her to attempt suicide (without success); as the husband presents it—via a medium—he killed himself with his wife's dagger, out of *his* sense of dishonor. The trial involves three further testimonies: those of the woodcutter, who found the body; the priest, who passed the couple on the road; and a deputy, who captured the bandit after the latter fell from the "murdered" man's horse.

Each of these testimonies is presented in mindscreen, as in *Kane*; the difference is that their stories contradict each other, not just in subjective implication, but in matters of fact. (The bandit, for instance, immediately denies falling from the horse, and presents a completely different account of his capture.) The audience is not, then, seeing the actual past, as selected, but a version of that past, recounted and probably invented in the story's present. As it develops, the woodcutter's testimony at the trial is false; goaded by the peasant, he reveals that he was a witness to the forest scene (and that he had stolen the woman's dagger afterward). According to him, all three characters had behaved badly: the bandit cowardly, the woman viciously, the husband dishonorably, and all of them selfishly. But because the woodcutter leaves out the detail of the stolen dagger, his story becomes suspect too. Each of the four major narrators, then, engages in a combination of selec-

tive perception and lying, in the service of his own self-image. It is possible to reconstruct "what really happened," at least approximately, but one must begin by distrusting the presentational field—by realizing, in other words, that what appears to be flashback is mindscreen. (I do not mean to suggest that there is no such thing in film language as a flashback—only that many of the sequences considered flashbacks are actually mindscreens, and that film has, strictly speaking, no past tense. There are many films—Huston's *The Man Who Would Be King* [1975], for instance—where the audience is allowed to feel that it is witnessing *the* past, and listening to privileged commentary [voice-over plus mindscreen]; my point is that such sequences depend on the past tense of the voice-over, or some other contextualizing device, to locate the present-tense image in fictional time, and that such "willing suspension of disbelief" can itself be suspended to good effect.) *Rashomon* is not so much about the relativity of truth as it is about selfishness, from the ego-supportive fictions of the narrators to the outrages they commit.

It is at this point that one understands the function of the Rashomon gate, which lies in ruins. The story is set in a period of economic and moral decay; the old values, like the gate, go disregarded but are still called upon for shelter in times of need (the rainstorm). People are selfish. The priest is having a crisis of faith; the woodcutter is overwhelmed by all the lies he has heard (and told); the peasant is a cynic bent on personal survival. The peasant is also the audience-surrogate for much of the film, distrusting what he is told and demanding to hear more. After all the stories have been related (mindscreen within mindscreen), the three discover that a baby has been abandoned nearby. The peasant steals some of the swaddling, and when the woodcutter denounces him, the peasant attacks in kind—divining the theft of the dagger. He then breaks up the fire around which they have been huddling (probably as much of a search-for-truth symbol as the baby is an embodiment

of hope and value) and cackles off. The priest holds the child, declaring that he has finally lost his faith; when the woodcutter tries to take the child, the priest accuses him of wanting to steal the remaining clothes. The woodcutter explains that his intention was to raise the child in his own family. The priest realizes that he himself has finally proved imperfect, begs the woodcutter's pardon, and declares (more or less as the sun comes out) that he has regained his faith in humanity. The burden of the film, then, is positive but not perfectionist or intolerant. Truth, like selflessness, does exist somewhere. The film opens and closes with a shot of the gate, inevitably reminding one of the "No Trespassing" sign and *K* gate that frame *Citizen Kane*.

Rashomon follows *Kane* in its general structure: a series of past-oriented mindscreens linked by a present search for truth. It anticipates *Marienbad* in that the content of those mindscreens is often "false." (The interesting thing is that the subjectively narrated image looks no different from the "real" image; its unreliability is contextual.) As in *Kane*, there is a perceptible difference between the subjective and objective sequences; the inquiries take place in "reality." By the time one reaches *Marienbad*, however, such easy distinctions prove impossible. To use a Gestalt metaphor, the subjective world-view in *Marienbad* is both figure and ground. It is relatively simple, once one has come to terms with *Marienbad*'s world-as-mindscreen, to appreciate the later achievements of Bergman and Godard, in which one is asked to consider the world as a self-actualizing visual structure—the self-conscious mindscreen of the world-as-film.

PART TWO

Self-Conscious Mindscreens
in Bergman and Godard

"All right, wise guy, where am I?"
—Daffy, in *Duck Amuck*

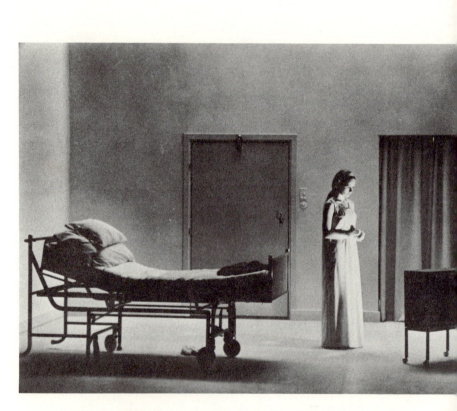

6. *Persona* (The Museum of Modern Art Film/Stills Archive, courtesy of United Artists Corporation): Elisabeth watches a news report of the self-immolation of a Vietnamese monk. Soon she will retreat and cover her mouth.

Bergman:
An Introduction

The photoplay tells us the human story by over-
coming the forms of the outer world, namely,
space, time, and causality, and by adjusting the
events to the forms of the inner world, namely,
attention, memory, imagination, and emotion.

— Hugo Münsterberg[1]

One of the things I find most disappointing about Berg-
man criticism is that so much of it is at the expense of
Godard. John Simon, for instance, calls the latter "a de-
railed fanatic"[2] in the midst of an otherwise profound and
gentlemanly study, and Robin Wood feels the need to
praise *Shame* (1968) by attacking *Weekend* (1967).[3] On the
other hand, Richard Roud goes out of his way to call
Bergman's films "adolescent, pretentious, silly, and visually
undistinguished,"[4] which is an insupportable judgment.
The reader will no doubt already have gathered, through
my praises of such diverse films as *Hair-Raising Hare* and
Citizen Kane, that my tastes are fairly broad. Aside from
the fact that I really enjoy both Bergman and Godard, how-
ever, I have a conviction that any film theory worth ad-
vancing ought to be able to deal with a variety of masters.
For the remainder of this book, then, I would like to ex-
plore, and if possible clarify, what I consider the major
works of these major artists, not just in terms of mindscreen
or of self-consciousness, but in search of a more compre-
hensive understanding of film narration.

91

My point is not simply that film can "speak" in the first person as well as the third, and that its narrative structures can achieve reflexivity, but that the presence of these modes and voices indicates that the audio-visual field is at least as flexible and articulate as that of the novelist or poet, and that the interplay of mind (of the artist, of the audience, and of the film) is a decisive element of the visual structure, equivalent in authority—but not in method—to the pronoun system (pronominal code). The "I" signifier and the "mind's eye" signifier differ in that the former is included in its sentence, while the latter is contextual. Both, however, involve an interplay of mind that can range from identification to reflexivity, and both signify the existence of a personalized narrator. In both cases the audience is led to conjure up an image or concept of a systemic presenter (usually fictitious) whose words or "vision" are contained in the work but who exists elsewhere—at a desk, for instance, or offscreen. Locating this narrator in presentational space, the audience and artist generate something of a Kantian structure: the image is phenomenal, the informing intelligence noumenal. Film is a dream, and a language (system of signification), and a world, alluding in two major directions—to the "physical reality" recorded (or "redeemed"[5]) by the camera, and to the "metaphysical" narrator—but including neither. The audience is encouraged to imagine (reconstruct) both offscreen worlds: the three-dimensional one, of which each shot gives a partial view, and the mental one, of which the mindscreen is the evidence.

The implicitly metaphysical nature of the offscreen narrator should not be taken to suggest that all self-conscious mindscreen films lend themselves to transcendental analysis. The self-consciousness of the "potential linguistic focus" can be semiotic or political, as in much of the work of Godard, or purely formal, as in much experimental film. But it can also prove to be an exceptionally apt vehicle for metaphysical statement, as well as for psychological drama,

92

and it is to these ends that Bergman has most intriguingly explored the potential of mindscreen narration. To be sure, there is a difference between the offscreen and the ineffable, but their metaphoric points of contact are highly suggestive. One of the central devices of Bergman's metaphysics is the identification of the offscreen mind of the narrator with the transcendent mind of God, each of whom, like the artist, dreams (creates, presents) a world. The analogy persists even in his "nonreligious" films, and makes of the mindscreen a uniquely profound and multivalent signifier. Indeed, the principal difference between Bergman and Godard is not traceable to their respective neuroses, but is an outgrowth of their respective conceptions of the nature of the world-systems whose mindscreens they present as self-conscious. Between them they sketch two exciting and perhaps definitive options for the future of the mode, and perhaps for the immediate future of film narration, if not of postmodernist consciousness. It is to their respective achievements, then, that I propose to turn at length.

Bergman has been Expressionist, Surrealist, and "literary" by turns, in an experimental onslaught on the visualization of intense states of being. He has Dreyer's feel for faces and Strindberg's for dream-invasions, Beckett's talent for reductive abstraction and O'Neill's for creating volatile characters and caging them together until they crack. Perhaps the only way to describe him that includes all these interests is to call him a metaphysical psychologist.

The visualizations he has chosen for his many concerns have varied in effectiveness. *Music in Darkness/Night Is My Future* (1947), for example, begins with a Surrealist vision of the miniaturized hero swimming in an aquarium, surrounded by monstrous fish; *Cries and Whispers* (1972) proves much more disturbing with its simple blood-red fadeouts. Two examples that are perhaps closer in spirit are the figure of Death in *The Seventh Seal* (1956), who is symbolic in an appropriately medieval sense, and the love-

93

starved corpse of Agnes in *Cries and Whispers*, who is a nightmarishly believable extension of the suffering character. The Bach that comes out of a radio in *The Silence* (1963) demands to be interpreted as a symbol of the fossilized presence of creativity as well as a language that soothes where words fail; when Bach's music is played over the hospital radio in *Persona*, it is again contrasted with a failed language (melodrama) but resists further interpretation, taking its dramatic importance not from what it "stands for" but from what it is and its effect on the listener. His symbols of fate run to similar extremes, even from one film to the next; the spinning rear-view mirror ornament of *A Passion/The Passion of Anna* (1969) is succeeded by the beetle-infested madonna of *The Touch* (1970). Although the former is realistic and the latter could hardly be more farfetched, Bergman manages to manipulate both symbols with great power. Conversely, he is able to use the island that figures in most of his recent films as a "dream" landscape in *Shame*, a "real" landscape in *A Passion*, and both in *Hour of the Wolf* (1968).

The career of so prolific and innovative an artist naturally reflects many kinds of growth, both emotional and technical. To say that these changes can be organized into "major periods," and to attempt such compartmentalization of the work of a living artist, is presumptuous and self-defeating if taken to extremes. Lines could be drawn between his work as apprentice and as master, or believer and nonbeliever, or stage director and TV director, with equally pointless facility. What I attempt here, for only the most general purposes of discussion, is to break down his work into four (going on five) periods, divided on the basis of visual style, intellectual content, and chronology.

The first period is a long apprenticeship, running from his script for Sjöberg's *Torment* (1944) to *Summer with Monika/Monika* (1952). (Bergman agrees with this division, and calls it his "spotty-faced period."[6]) In general,

these early films study sexual frustration and fulfillment in relation to a contemporary urban environment. Their lyrical realism is influenced by that of Carné, the director of *Port of Shadows* (1938), but Bergman's debts to Sjöström (noted for his stylistic economy and for his experimental intercutting of dream and reality), Stiller (a master of sophisticated comedy and the emotive use of landscape), and his immediate mentor, Sjöberg, are also evident. Bergman is, by his own admission, not much of a reader, but as a prolific stage director he has had extensive exposure to the literature of the nineteenth- and twentieth-century theater. It is important, then, to acknowledge the influence of Strindberg, Büchner, Ibsen, Pirandello, Brecht, Camus, and even Beckett on the existential, psychological, neofeminist, and self-conscious aspects of his work. Throughout this first period he battled through these influences, learned from a variety of actors and cinematographers, and tried to convince Svensk Filmindustri to let him do what he wanted. Many of these films tell two or three interrelated stories, in the manner of the later *So Close to Life/Brink of Life* (1957), and reflect a weakness for melodrama.

With *The Clown's Evening/The Naked Night* (1953), Bergman entered what many critics consider his major phase. The films of this period—which includes *Journey into Autumn/Dreams* (1955), *Smiles of a Summer Night* (1955), *The Seventh Seal*, and *Wild Strawberries* (1957), and concludes with *The Face/The Magician* (1958)—both confirmed his international reputation and won him wide popularity. Most of them were photographed by Gunnar Fischer. In these films Bergman established his unique voice, artfully integrating metaphysical ponderings with tragicomic studies of loneliness, love, professional fulfillment, and death. These "big issue" films are often brooding and melancholy, characterized even in their comic moments by religious anxiety. Their pronounced fear of death is inseparable, however, from their celebration of life, and

a figure like Bibi Andersson is often on hand to mock, seduce, or playfully distract (and under it all, revere) the central, moody worrier.

These films take place in a variety of landscapes. *The Seventh Seal*, for example, vividly recreates both the objective and subjective worlds of medieval Sweden. While on the one hand it tells the historically credible story of a knight and his squire who return from the Crusades to a land ravaged by plague (a deliberate parallel to the modern sense of impending nuclear disaster), on the other it has them encounter not only Death himself, but Joseph, Mary, and their baby as well. The knight, who worries aloud about God and death, finds fulfillment in a momentary reunion with his wife and in a simple, refreshing meal of strawberries and milk served him by the life-loving Joseph and Mary, members of a small acting troupe. The literal manifestation of these symbolic figures gives the film the feel of a medieval drama, and paradoxically supports the knight's acceptance of the limited, mortal world. In this way *The Seventh Seal* achieves a remarkable fusion of philosophies. Love, mortal beauty, and artistic vision justify life even in the absence of God and under the shadow of Death; this existential affirmation is reached in a world thickly populated with metaphysical presences and answerable to many of the theater conventions in an age of faith.

Wild Strawberries, the best film of this period, continues on a more intimate level Bergman's defense of love in the face of death. This film is a memoir of one day in the life of a famous doctor—a day in which he understands how he has isolated himself from his loved ones and tries to repair the damage. Symbolic dreams and rather stagey memory sequences (both mindscreen) are woven into a realistic account of the doctor's long drive to the site of his receiving an honorary degree. This drive is both a physical journey and a spiritual quest, integrated in such a way that neither the symbolism nor the intimate realism suffers at the other's hands. Because the "fantasy" sequences tend not to

be stylistically consistent with the rest of the film, the viewer does not get confused, but for this same reason the film fails to achieve the profoundly unsettling quality of Bergman's later work, in which the lines between "dream" and "reality" are gracefully sabotaged.

The third period, which runs from *The Virgin Spring* (1959) to the trilogy of *Through a Glass Darkly* (1961), *The Communicants/Winter Light* (1962), and *The Silence* (1963), coherently examines the problem of faith in God. *The Virgin Spring* marks the beginning of his collaboration with the brilliant cinematographer, Sven Nykvist (who had assisted in filming *The Clown's Evening*), a collaboration that immensely expanded the visual range of Bergman's work. In these films, religious anxiety is at its peak; God has died for Bergman, and some way must be found to give life meaning. *The Virgin Spring* tries to distinguish between Christian and pagan, but leaves only a muddled impression of general barbarism. *Through a Glass Darkly* tries for a big finish (human love vs. spider god) that is, from this distance, unconvincing. These anxious films are conspicuous for the absence of dream sequences; their waking worlds take on the tensions that dreams can be used to release (as in *Wild Strawberries*). The intimacy they achieve, prefiguring the domestic, destructive claustrophobia of *A Passion*, has a feeling of relentlessness.

In these works, three major themes from the earlier periods are tightly interrelated: the silence of God, the importance of loving communication, and the violence of sexual desire. (It is characteristic of Bergman that these three problems are most energetically focused in the face of death; it is also characteristic that a later film most artfully sums up the interests of an earlier period. Thus the greatest film of this phase of his concerns may well be *Cries and Whispers*, as the greatest of his anthology films may be *Brink of Life*.[7]) The key theme, God's silence, is brought into relief by an intense examination of mortal communication. Even in these most flagrantly "religious" films,

Bergman is primarily concerned with human relationships, and it is unfortunate that a large part of his audience has missed this point.

The Silence portrays a world in which God is not a significant presence and people must struggle to talk with each other. It is the story of two sisters who are traveling through a country whose language they do not know. The elder is a dying translator, sexually obsessed with her sister; the younger, whose ten-year-old son accompanies them, fights off her sister with compulsive heterosexual liaisons. When the elder is not eavesdropping, masturbating, or destroying herself with liquor and cigarettes, she tries to learn the local language, and teaches the bookish boy a few of the words she learns; in contrast, the relationship that the younger sister establishes with a local waiter is antiverbal and brutal. While the sisters torture each other, tanks drive by their hotel and the boy roams through its corridors with his cap gun, encountering dwarves who dress him up as a girl and a considerate but doddering hotelkeeper who dangles a sausage at him before eating it.[8] The boy's response to this violent, wordless, comic sexual wilderness is to hang on his beautiful mother and to read. Whether he will be able to break down the silence—that is, establish meaningful and loving communication with himself and others—is left ambiguous,[9] but there is little hope that any serious attack on *God's* silence will succeed.

Many of the trilogy's themes continue to be expressed in Bergman's fourth and, I believe, major phase, but the emphasis on God undergoes a remarkable transformation. In the key films of this period, meditations on the nature of God, and on how to live without him, are linked with investigations of the self-consciousness of film.

God emerges from the trilogy not merely inscrutable, but defective. Even in the earlier films, of course, he was no prize. In the miracle of the Virgin Spring, for instance, he presents himself as an object of belief, but can hardly be considered one of reverence; the daughter is an inadequate

martyr, and the father's chapel is a monument to the stupid and selfish violence of all concerned, the bloody gods included. There is, so to speak, still a frog in the loaf. The god that appears in *Through a Glass Darkly* is a lascivious spider, and it is hard to say whether the heroine's mental illness biases her view of God (so that she sees him "through a glass, darkly") or does in fact allow her to see him "face to face." For the remaining members of her family, God is love: the withdrawn, self-centered father opening up to his son. *The Communicants* analyzes a priest's loss of even this hard-won "certainty" of God's presence, and prepares the ground for *The Silence*.[10] In the following works, however, God's silence—and in some cases, absence—is accepted, and Bergman concentrates more exclusively on the problem of the mind in conflict with itself. When a metaphysical framework does emerge, it does so more subtly, and concerns itself less with the problem of God's existence than with that of his unsympathetic, self-centered, and even pathetic character. In several of these more psychologically-oriented— and self-conscious—films, the unseen, perversely creative mind of God is indistinguishable from that of the artist.

These later films have several themes in common, of which perhaps the most striking is the struggle for power. Although *Persona* is the key film of this period, it is *Now About These Women/All These Women* (1964), a witty, ironic, and bitter comedy, that announces the transformation of Bergman's concerns. The central character is a sexually exploitative master cellist whom a composer-critic attempts to dominate by threatening *not* to complete a biography that might earn the cellist immortality, unless the cellist performs the critic's music in an upcoming concert. As it turns out, both critic and mistresses find a new darling after the cellist's death, and the master is forgotten. In its own playful way this film deals with the problem of the isolated artist, his control of the people who love him, and the attempts of a less creative spirit to dominate him. It is not God but the artist who is of central importance here,

as in the other "comedy" of this period, *The Rite/Ritual* (1969), an attack on critics and censorship.

The closer one comes to the present, the more difficult it becomes to draw these lines. Bergman himself links *Persona* with the trilogy, calling them his "chamber works," because in them, "with an extremely limited number of voices and figures, one explores the essence of a number of motifs. The backgrounds are extrapolated, put into a sort of fog. The rest is a distillation."[11] With its two-woman figure, *Persona* is closely related to *The Silence*; yet both these films, and most of his later work—from *Hour of the Wolf* to *The Touch* and *Scenes from a Marriage* (1974)—center on the conflict between two inseparable adults. The films before *Persona*, however, and after *A Passion*, do not deal in the same ways with the problems of the artist or with the nature of self-conscious cinema; for my purposes here, these are the important differences.[12]

What distinguishes the best films of Bergman's fourth period is their intense exploration of subjective reality, and their uniquely self-conscious landscape. Although many of Bergman's characters have been actors—notably in *The Clown's Evening*, *The Seventh Seal*, and *The Face*—none of his works before *Persona* so directly calls attention to its own nature *as film*; none uses such Brechtian devices as the actor-interviews in *A Passion*, or searches so deliberately for the mind of the artist who might be controlling or dreaming its world. This new abstractness is accompanied by a radical simplification of the films' physical environments. Most of them take place on the island where Bergman himself lived at the time, a relatively bare, rocky place dotted with small homes, a place where light, sky, and ocean are elementally stark. Taken as a group, these films reveal a gathering intensity unlike anything else in his work. The clarity of their moral scrutiny, the brilliance of their performances, and the extraordinary range of their cinematography make them compelling. Their symbols have undergone a paradoxical development, too: although they are

far more complex than any in the earlier films, they are also more direct, more reduced. Their manner of presentation is less exotic, with the result that these films appear more realistic even as they become more self-conscious and metaphysical. This strikes me, in short, as the period of maximum integration in Bergman's work; in it he perfects a tone that allows him to be metaphysical and reductive, symbolic and realistic, introspective and prophetic, not by turns but in every word and image.

Persona falls between two trilogies: the one already discussed, and the extraordinary sequence of *Hour of the Wolf, Shame,* and *A Passion.* The metaphysical and psychological trailblazing of this masterpiece, to be discussed at length below, made it possible for Bergman to limit the variables and increase the intensity of the films in this second complex, all three of which pit Liv Ullmann and Max Von Sydow against each other in parallel universes of marriage, probing to their depths the problems of love, control, insanity, and death. For all their inscrutable privacy, for all their mystery to each other, these people are bound together; they are each other's fate, wrestling in an unresolvable dialectic of female and male, creation and destruction, love and contempt, ignorance and imagination, sanity and frenzy. For the synthesis one must look back to *Persona,* where layman and artist, mortal and deity, merge, and the dialectic of identity mysteriously clarifies the dialectic of the cinematic image itself.

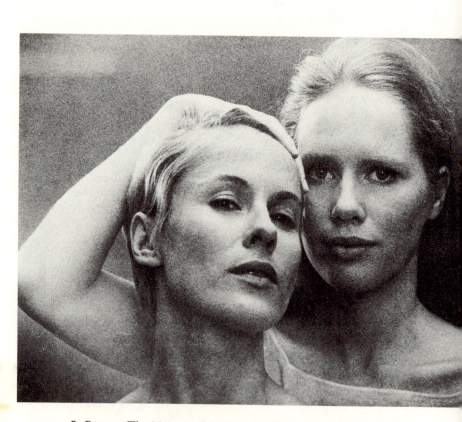

7. *Persona* (The Museum of Modern Art Film/Stills Archive, courtesy of United Artists Corporation): Facing a mirror that is also the screen, Elisabeth draws back Alma's hair so that their facial resemblance will be clear. There is, however, no clarifying whose mindscreen this is, although it is most likely Alma's.

"Persona"

In the ways that Bergman made his film self-reflex- ✓
ive, self-regarding, ultimately self-engorging, we
should recognize not a private whim but the ex-
pression of a well-established tendency. For it is
precisely the energy for this sort of "formalist"
concern with the nature and paradoxes of the
medium itself which was unleashed when the
nineteenth-century formal structures of plot and
characters (with their presumption of a much less
complex reality than that envisaged by the con-
temporary consciousness) were demoted. What is
commonly patronized as an overexquisite self-con-
sciousness in contemporary art, leading to a species
of auto-cannibalism, can be seen—less pejoratively
—as the liberation of new energies of thought and
sensibility.

—Susan Sontag[1]

Bergman has insisted that most of his artistic decisions are ✓
intuitive rather than intellectual. In his interview with
Charles Samuels, for instance, his tone is extremely con-
vincing on this point:

My impulse has nothing to do with intellect or sym-
bolism; it has only to do with dreams and longing,
with hope and desire, with passion. Do you under-
stand what I mean? So when you say that a film of
mine is intellectually complicated, I have the feeling
that you don't talk about one of my pictures. Let us

talk about the pictures, not as one of the best, or the most disgusting, or one of the stinking ones; let us talk about attempts to come in contact with other people.[2]

Even to make a film as conceptually intricate as *Persona* is largely a matter of storytelling, not of philosophizing. If any ideas emerge from Bergman's stories, they do so because they are elemental to his emotional imagination—because they are part of the way he sees human relationships. His works do not set out to propound theses, yet because their imagery is rich and their characters are often able to put their tensions into words, these films are uncommonly suggestive, both emotionally and intellectually.[3]

"Persona" is the Latin word for mask.[4] That word integrates the film's multiple concerns with extraordinary economy, for *Persona* is the story not only of two women who switch roles and are in a sense alternate masks of an unknown character energy, but also of the mask of photographic imagery worn by the movie projector's white, primary light. It is also a study of role-playing, of acting, of the nature of personality, and of the nature of God: of the masks adopted by a woman who decides to be a nurse; by an actress who decides to play that woman; by another actress who plays an actress; by that actress in the adopted roles of Electra and later of silent patient; and by man, who adopts the role of dynamic chatterbox in response to the role of pathetic inscrutability and vampirism adopted in his turn by a silent God.

Bergman's account of the genesis of this film emphasizes the intuitiveness of his decisions:

BERGMAN: *Persona* is a creation that saved its creator. Before making it, I was ill, having twice had pneumonia and antibiotic poisoning. I lost my balance for three months. . . . I remember sitting in my hospital bed, looking directly in front of me at a black spot—because if I turned my head at all, the whole room began to spin. I thought to myself that I would

never create anything anymore; I was completely empty, almost dead. The montage at the beginning of the film is just a poem about that personal situation.

SAMUELS: With cuts from earlier Bergman films.

BERGMAN: Because whenever I thought about making a new film, silly pictures from my old ones came into my head. Suddenly, one day I started thinking of two women sitting next to each other and comparing hands. This was a single scene, which, after an enormous effort, I was able to write down. Then, I thought that if I could make a very small picture—perhaps in 16mm—about two women, one talking, the other not . . . it would not be too hard for me.[5]

By comparing the script with the finished film, one can discover just how much was improvised, abandoned, or refined during the making of *Persona*. (The decision to repeat Alma's long monologue about Elisabeth's feelings for her child, for instance, and to merge their faces, was made during the final editing.) The film was put together on the basis of what, during the actual shooting, seemed to "work." As Bergman put it, "Exactly what happened and why I don't know."[6]

The three images that seem to have been basic to him from the start are those of the women comparing hands (their strangely complementary personalities), the conflict of speech and silence (likely to have been influenced, as Sontag has noted, by Strindberg's short play, *The Stronger*), and what he called in an interview with John Simon "the film's impatience to get started"[7] (those flashes from earlier films, which are in the same spirit as the screenplay's notation that the ending of *Persona* should somehow include its being removed from the projector and "packed into its brown carton"[8]). These three germinal "scenes" go to the heart of the film's intentions: to be the story of these two women, and to be self-conscious. *Persona* is about film—

its "own" (ultimately imitative) awareness of being a film and Bergman's awareness that he is making a film—as much as it is about the relationship between Alma and Elisabeth. The decision to make Elisabeth an actress, and thus to introduce a metaphor that could relate these intentions, seems to have come later—although it is latent in Bergman's decision to echo *The Stronger* (which concerns a power struggle between an actress and her lover's wife, and raises the question of identity-transfer). With that decision came the means to portray the artist's exploitative, bloodsucking relationship with the people around her (or, if Bergman is indirectly talking about himself, around him) and to extend observations about professional role-playing to more general levels, including the level at which the projector's light masks itself with an image and that at which one's anonymous sense of identity adopts the more permanent role of a *persona*lity. Out of the dialectic of silence and speech, and this cluster of mask metaphors, came what may have been a completely unconscious extension of the concerns of the first trilogy, and particularly of *The Silence*.

Persona begins with the striking of an arc between the two carbon rods of a motion picture projector.[9] The flow of current between these oppositely charged rods generates the light that is aimed through the film and onto the screen. Each frame of film cuts out, or masks, portions of this light, filtering out some of its colors and interrupting (totally, in the case of a black "object") the transmission of a white field. Perhaps my ultimate point about this film is that Alma and Elisabeth make contact like these carbon rods—that they are identical yet oppositely charged, and that their dramatic intercourse is a filtered representation of the light that courses between the rods. The arc light is differentiating and limiting itself into an image—in other words, adopting a persona. That persona includes the relationship of the two women and every intermediate level of filmic representation. The first five shots get the arc struck, show a turn-

106

ing disc (perhaps the shutter), move film through a sprocket wheel, and direct the arc's light through the lens. The sixth shot is standard leader, from the START frame through the countdown to 3. (The numbers grow larger as the camera moves in on them.) The seventh shot is again of the projector's moving parts; in the eighth shot, the filmstrip's image can almost be made out as it whirs through the gears. In the ninth shot, the camera zooms in on the projector gate and watches the upside-down image of a female cartoon figure washing her face. (This image would appear right-side-up on the screen, after it had passed through the projection lens.)

At this point it becomes necessary to return to Bergman's personal explanation of this opening sequence:

> While I was working on *Persona*, I had it in my head to make a poem, not in words but in images, about the situation in which *Persona* had originated. I reflected on what was important, and began with the projector and my desire to set it in motion. But when the projector was running, nothing came out of it but old ideas, the spider, God's lamb, all that dull old stuff. My life just then consisted of dead people, brick walls, and a few dismal trees out in the park.
>
> In hospital one has a strong sense of corpses floating up through the bedstead. Besides which I had a view of the morgue, people marching in and out with little coffins, in and out.
>
> So I made believe I was a little boy who'd died, yet who wasn't allowed to be really dead, because he kept on being woken up by telephone calls from the Royal Dramatic Theatre. Finally he became so impatient he lay down and read a book. All that stuff about The Hero of our Time struck me as rather typical—the overstrained official lying on his sickbed. Well, all this is trivial. But that's how it works—and suddenly two faces are floating into one another. And that's where

the film begins. As for the interpretation, you can in-
terpret it any way you like. As with any poem. Images
mean different things to different people.[10]

One of the things Bergman used to run through his pro-
jector when he was a child was an old Pathé fragment of a
chase involving a policeman, a murderer, the devil, and a
ghost; he remade this farce in *The Devil's Wanton* (1949),
and cut snatches of the remake into the opening of *Per-
sona*.[11] The cartoon figure washing her hands is appar-
ently another of these primitive filmstrips. It makes sense
to me in another way, however. What is starting up here is
not just Bergman's filmmaking imagination, but a self-nar-
rating projection system. The light achieves itself, then de-
fines an image—and it begins with a primitive cartoon, one
that bears some resemblance to the work of the pioneer
animator, Emile Reynaud, who painted his images directly
on "film" and projected them by means of mirrors. Even if
it is not specifically to Reynaud (or even Winsor McCay),
the reference to the earliest days of cinema is clear. The
image is constructing itself from scratch, historically as well
as ontologically "beginning at the beginning."

In the middle of this shot, the projector breaks down. For
a moment the image freezes—then starts again, continuing
its inane motions. The interruption of this cartoon's move-
ments corresponds exactly to the freezing, burning, tearing,
and regeneration of the image that occurs after Alma has
cut Elisabeth's foot, and is an emblem for the entire movie.

In the next shot, we see a spinning film reel. The eleventh
shot shows the filmstrip leaving its sprocket wheel, just as
Persona will some eighty minutes later. These eleven shots,
in other words, are an overture to the film, a capsule al-
luding to all its major movements. After this little film has
run itself out, Bergman ups the ante, sophisticating his
image from hand-drawn precinema to motion picture pho-
tography: the twelfth shot shows a child's hands making

washing movements. This image is more sophisticated than the cartoon, in terms of film history; it more closely approaches the narrative norm, as a reproduction of kinetic, physical reality: that is, the hands are "real," the washing is—as pantomime—mimetic. (Still, one is reminded of the shot of a "real cat" in *La Jetée* [1962].) The next shot both advances and retreats, showing (after a completely white frame) the pantomime patterned after the Pathé fragment. This is, historically, less sophisticated than the extreme close-up of hands (which is, in addition, photographed on a more modern-looking film stock); but it is also a further advance toward a complex storytelling image. This sequence, which has some resonance with the themes of resurrection and death explored a few minutes later, shows a man fleeing from a skeleton that jumps out of a trunk and from another figure in a black cape. The man's dive into bed is followed by another white frame, into which fades a spider—apparently meant to evoke the spider god from *Through a Glass Darkly*, but also prefiguring the themes of entrapment and bloodsucking (in other words, Elisabeth on all counts). The spider does not walk off-frame but disappears; Bergman has cut to the white frame again, the unmasked light.

The next shot shows the slaughtering of a sheep ("God's lamb"); the blood running from its neck suggests a ritual slaying. Next the camera zooms toward the sheep's eye as the slaughterer eases his grip. The next shot is a close-up of that hand cutting at the sheep's internal organs with a knife; this is followed by an irised close-up of hanging entrails, which are apparently being read in search of an oracle. The next shot is a white frame. The next three shots are of a hand being nailed to what I assume is the Cross. In other words, having constructed *film* from scratch, Bergman goes on to bring *religion* from one primitive stage to another. Part of this sequence recurs when the image breaks down after Alma has wounded Elisabeth—suggesting not

only that the image has had to reconstruct itself out of these original materials, but also that that wounding finds a parallel in the Crucifixion.

The next shot is of a brick wall; over the soundtrack, appropriately enough, come church bells. This image dissolves to a mid-shot of a forest in winter, setting the mood for the morgue scene that follows. The next shot shows a spiked, iron fence, running diagonally downward from screen left, with what appears to be a church in the background. By the next shot, which has a snowbank in the foreground and a spiked fence and brick church in the background, one recognizes that these four shots are of one location. The sophistication of these fragments, then, has grown to include not only the sequential cutting seen in the silent comedy, and in the three shots of the nailed hand and the four of the butchered sheep, and such optical devices as the fade-in on the spider, but now both montage and live sound. Taken as a whole, the opening sequence is, of course, itself a montage, but it is important to notice that a grammar of film techniques is maturing—on an *interior* level—from fragment to fragment, as the image continues to sophisticate (or limit) itself. The cut from the nailing shots to the church shots clarifies a second theme of this sequence, which is (as suggested above) that of the evolution of Western religion. This theme is made explicit in the following sequence, where the tolling of church bells is replaced by the ringing of a telephone—a call that awakens the dead (almost like the knell to Judgment in *Macbeth*).

The shot of the snowed-in church is followed by an extreme close-up of the nose, mouth, and chin of a horizontal, elderly person; the outline of this portion of the face is almost identical to that of the snowbank. An association between death and winter is clinched in the next shots, when the viewer becomes aware of the larger setting. The chin shot is followed by a close-up of the entire face, which is that of an elderly woman. The church bells are replaced by a

110

sound of dripping. Next comes a mid-shot of a boy lying on a table and covered by a sheet; he is lined up with the bottom of the frame. Footsteps are heard on the soundtrack, but the dripping continues. The next close-up, of a hand dangling over one of these tables, establishes that one is in a morgue, and that the sounds one is hearing are going on in "real time," probably in the corridor, or another part of the room. In other words, the sequence is slowing down, acquiring a more conventional continuity—readying itself to tell a story. Appropriately, it uses "live," action-synchronized sound. The next three shots show the first dead woman, then a dead man, then a corpse's folded hands. The next shot is of a corpse's feet; on the soundtrack, a telephone rings. The phone rings a second time, noticeably louder, over the next shot, which is an overhead close-up of a dead woman's face, as if one were standing at the head of the table on which she is lying. Then, in an extraordinary cut, the eyes are open. (One does not see them opening; it is as if they have opened by cutting, or as if the *image* has opened its eyes.) During this shot the phone rings for a third time, even louder. In the next shot the phone rings again, and the boy awakens—or is resurrected. He tries to go to sleep, but is unable to get comfortable and sits up.

This boy, who acted in *The Silence*, then turns over and begins to read the same book he was reading in that film (*The Hero of our Time*); the cover flap even marks the page at which, presumably, he stopped reading when he "died." To some extent, this boy is Bergman, dizzy and bedridden, nagged by associates and afraid he would never be able to work again. Although Bergman's explanation here is that the film is forming itself in his mind, it appears that the film is also forming itself *to itself*—taking shape not only in the director's imagination but also in the mind of the work. Although Bergman may be alluding to his own mindscreen in the next few shots, what he presents us here is a character who is part of *Persona*'s mindscreen.

As has already been pointed out, Bergman has said that

this sequence manifests *"the film's* impatience to get started." That is the closest he comes to suggesting that the film has a "life" of its own distinct from his own impatience to conceive a film. If the viewer has been sensitized to the self-conscious nature of these opening shots, he may be moved to identify this boy not just as the actor, but as the *character* from *The Silence*: a character who has been resurrected from the space between these two films.[12] (It is the book, and the general similarity of situation, that argue for this identification; obviously one does not consider that the male lead in *Hour of the Wolf* is the same character as the male lead in *A Passion*, even if both are played by Max Von Sydow.) That boy, it will be remembered, had been attempting to sort out his feelings for his mother and aunt, two women who were, in a sense, opposites in mortal combat: one communicating with words, the other with her body; one hanging on the other, draining her for details of her sexual experiences, the other struggling to achieve her independence if not her identity; one ill, one physically healthy. The parallels with *Persona* are striking, although Elisabeth does not perfectly match the elder sister (the younger sister is the "wordless" one). The boy, who had tried to learn from both women in *The Silence* (and thus perhaps to act as a vehicle for Bergman's exploration of a silent God, or of ways of living in a world from which that God had departed), looks up from his book in *Persona* and discovers a new mystery, a face that shifts between those of two remarkably similar women—a face that is looking at him as if it were a withdrawn mother; or an inadequately apprehended, resurrecting, mystical presence; or an artwork in the process of formation. Out of focus, the face shifts from Alma's to Elisabeth's and back again, while the boy extends his hand toward it. What he appears to encounter with his hand is an invisible wall that exactly corresponds with the movie proscenium: perhaps a physical analogue to the self-conscious mindscreen.

At this stage of the discussion it becomes necessary to

make some general points about self-conscious narration if the originality of this image is to be fully recognized. A useful definition of the self-conscious novel is offered by Robert Alter: a novel (or in this case, a film) "that systematically flaunts its own condition of artifice and that by so doing probes into the problematic relationship between real-seeming artifice and reality." He goes on to insist on the "consistent effort to convey to us a sense of the fictional world as an authorial construct set up against a background of literary tradition and convention"[13] and, one might add, ontology. *Coming Apart, Hair-Raising Hare*, and *Sherlock Junior* all fall within the limits of such a definition; the audience is continually reminded that it is watching a film and refers its reactions and judgments to this premise. I believe, however, that a useful distinction can be set up between two types of self-conscious narration, in both literature (including drama) and film. In one mode, the self-consciousness is "authorial," as Alter puts it; in the other, the self-consciousness is attributed to the work itself. Thus Joyce and his readers are extremely aware of literary artifice and convention—of the connection between Bloom and Odysseus, or Stephen and Hamlet—throughout *Ulysses*, but there is no suggestion that the "potential linguistic focus" of that novel is autonomous. Beckett's *Unnamable*, however, gives the definite impression of being a self-actualizing system of words, struggling—along with its narrator—to name *itself*. In this sense, the overcoat of *Ulysses* is cut from the same cloth as the scarf of *Hair-Raising Hare*; such self-consciousness might be termed "third person," since there is no indication that the system is narrating itself. Rather, the self-consciousness is attributed by the audience directly to the author, and enjoyed in his company. This remains the case even when Bugs, or GlassMan, reveals *his* awareness of the artifice; he is a character within the system, and not *the* system. In *Persona*, however—as in its most complex predecessor, Dziga Vertov's *The Man with a Movie Camera* (1928)—there is an impression of the mindscreen's being

113

generalized, so that the film's self-consciousness appears to originate from within. Without being identified with a specific character, nor with the filmmaker, the "potential linguistic focus" takes on the characteristics of a mind-screen. The film becomes first-person—speaks itself.

However overdiscussed it may be, *Last Year at Marienbad* is the key film in this development, not because it is self-conscious (which I maintain it is not), but because its internal mindscreens do not *demand* to be identified as those of X and A; *Marienbad* legitimatizes the mindscreen as a way of presenting the world, even if an audience that accepts all its contradictions is (according to Robbe-Grillet and Resnais) misinterpreting the film. A post-*Marienbad* audience is capable of accepting Buster's dream of *Hearts and Pearls*, and of recognizing it as a first-person structure, without having to return to the frame of *Sherlock Junior* for reassurance. A post-Beckett audience is capable of recognizing *systemic* autonomy without having to assign that self-consciousness to a character within the fiction. In *Coming Apart*, the offscreen mind is GlassMan's; the narrative he assembles is first person, but the film is authorially self-conscious. *Marienbad* is a third-person film with extensive and overlapping first-person sequences. The newsreel in *Citizen Kane*, with the shots that direct the audience's attention away from the newsreel toward the men in the projection room, is authorially self-conscious (as is the in-joke that identifies the years of Kane's ascendance with those of the cinema: 1895-1941). But in *Persona* the arc-rods approach and retreat from each other autonomously, the light sublimates itself into a story, and the frame makes its own limits manifest to the boy in the morgue, who is as much an element of the fiction as he is a representative of the author. That frame is a self-conscious mindscreen, and it gives the impression of speaking in the first person.

I am not, of course, suggesting that the film is alive—only that it imitates mindedness. Ervin Laszlo offers a useful distinction between "natural" and "artificial" systems,

114

as opposed to that between "living" and "nonliving" systems:

> Many things that we used to call nonliving (or inorganic) manifest organizational characteristics which they share with living things. They take in and put out substances or energies; they maintain themselves amidst changing circumstances; and some even grow and evolve into different and more complex shapes. A candle flame maintains its form amidst a flow of energies and substances, yet one would not call it living except in a poetic metaphor. So does a waterfall, a storm center, a city, an ecology, a university, a nation, and even the United Nations. . . . My term for this highest level of organizational invariance is "natural system." (In this use "natural" contrasts with "artificial" and not with "social." Any system which does not owe its existence to conscious human planning and execution is a natural system—including man himself, and many of the multiperson systems in which he participates.)[14]

A film is an artificial system. It cannot be self-conscious, nor even conscious. But it can imitate consciousness (which Laszlo defines as "the ability of a system to be *aware* of its own · subjectivity"[15]). Huckleberry Finn's words imitate consciousness, just as *The Unnamable* or *Persona* imitates self-consciousness. The locus of this consciousness in reflexive cinema is the mindscreen, just as in literature it is the pronoun "I." Both "I" and the mindscreen allude, on their simplest levels, to subjectivity; they can be manipulated to give the impression of presentational autonomy, and of self-awareness.

The mindscreen, then, can be systemic, and need not be attributed to the narrative intentions of a character within the fiction, like GlassMan or X or Buster. In the presence of such a mindscreen, one speaks of a first-person, self-conscious film, and identifies the offscreen mind with the "po-

tential linguistic focus" of the work itself. To reverse the formulation: when the "potential linguistic focus" of the film is self-conscious, the field of *its* mind's eye is properly called a mindscreen, despite the evident fact that the system is artificial. Whether it be termed noumenal, or paradigmatic, or simply offscreen, this "mindedness" is involved in the audience's response to the image. In this context, every frame in *Persona* makes manifest a dialectic—perhaps the most characteristic one in modern art—in which the self-conscious artist and the self-conscious audience engage across the self-conscious mind of the work.

The shot in which the boy turns to his book ends with his staring directly at the camera and moving his hand back and forth across the entire foreground of the image we see. The next shot is taken from the exactly opposite position, as if the frame itself had turned around. Now the camera is behind his back, watching his hand move back and forth across a flat, invisible surface, on or behind which is the unfocused image of a woman's face. The implications of this framing are far-reaching. It is not just that the audience sees the boy reach up to a flat surface and then, through a reverse angle shot, is allowed to see what is on that surface; it is also that the frame of the image of *Persona* itself is identified with one (or both) of these surfaces. Bergman makes one feel this by having the boy so literally—and with the appropriate wide-angle distortions as he nears the camera—touch the surface of the lens and limits of the frame. The audience senses, for the duration of this shot, that it is being looked at, or at best is hiding behind a two-way mirror (more or less as in *Coming Apart*, but with the other mind behind the "mirror" being that of the film, not simply that of GlassMan).

In the reverse shot, the boy appears to be touching a surface on which an image is attempting to define itself. The viewer who has seen *Persona* before is able to recognize that what is being enacted on that screen is a miniature of the story of Alma and Elisabeth, whose identities move in and

116

out of focus, sometimes fusing with each other. This face is Bergman's metaphor for their relationship: the face of which "Alma" and "Elisabeth" are partial, complementary manifestations—the anonymous energy of which they are the interchangeable masks. This face is also the mother that neither can entirely be (Elisabeth is withdrawn from her child; Alma has had an abortion and is afraid that in describing Elisabeth's maternal failings she is describing her own tendencies); the boy is perhaps the abandoned child of that mother. This face is also comparable to that of the God who has resurrected the dead with his church bells, telephone, and silent gaze, as has been suggested before— and of course, the central image of the film organizing itself in Bergman's head. Most important, this face is also the image achieved by the rods of the projector—their metaphor for themselves, and Bergman's for the ontology of film. This whole sequence expresses, among other things, the dialectical nature of the film image: pure light at war with representation. The film continues to reduce and filter itself, to fill its frame with detail and dialogue—to analyze this face into Alma and Elisabeth, to give them characters and jobs and lovers, to set them against each other in a fictional context; but when they conflict in a way that for some reason jams the flow of that fiction, that hard-won reduction is yanked away and the image returns to white, then reconstructs itself from many of these early fragments until it arrives at an *unfocused* image not of Alma (on whose face the film had jammed and ripped) but of Elisabeth: a larger working-out of one of the morgue sequence's unfocused face-shifts. Finally, the dialectical nature of film *narration* is being clarified here: the mindscreen is undergoing a transition, in this sequence, between attempting to insist on its self-consciousness in the pure state and generating the elements of a fiction out of that self-consciousness (a nonpolitical variation on the position in which most of Godard's later films find themselves).

The boy, in other words, faces something like a film

screen, on which *Persona*'s dialectic is enacted. He is that "film's" audience, outside the story of Alma and Elisabeth. Whether character or artist, he belongs to a frame that is somehow opposite both to the fictional world and to the theater audience, as if the theater screen were somehow three-sided, since we find later in the film that Elisabeth can look at us too—in fact, can photograph us. This Chinese box (or Klein bottle) of a landscape, it must be remembered, is all framed by the sequences of projection, so that in its simplest terms the plot of *Persona* is as follows. The film starts itself, achieving light; that light filters and sophisticates itself until it is able to portray the morgue sequence; beyond this point it complicates and limits its imagery still further, creating a fiction about two women. When Alma breaks some kind of rule, the film is thrown out of joint, reverts to its primitive imagery, then works its way back to the fiction (that is to say, the most intricately defined of its signs). The plot continues until the intercourse between these women is concluded, at which time one of its fictional images (Alma's getting on the bus that will take her back to the hospital) fades to become once again the face on the boy's "screen." The image withdraws from the fiction to the morgue—and of course to the hospital room in which the ailing Bergman lies conceiving his fiction,[16] so that he does rather have the ability to look at his film and at us, as both we and his creation have the ability to look at him— and from there returns to the projector, where the film runs itself out of its sprocket wheels and the arc is extinguished. In the film's last image, the rods move away from each other, and the light dies.

Most criticism of this film has confined itself to the fiction, but such a limitation ignores *Persona*'s unique structure. That said, it remains to discuss the fiction, after which the film's self-consciousness can be dealt with more coherently.

After the face on the morgue's "screen" has shifted between Elisabeth and Alma several times—a process in which

it appears to close its eyes—the boy looks straight into the camera, both at the audience and at the film, and the titles start. Intercut with the titles are images, some from *Persona*, some from other films, with the titles on white backgrounds in a way that echoes and extends the technique of intercutting white frames that was used in the pre-credit sequence. The faces of Alma and Elisabeth appear too, in focus. The last image is from the "silent film"; it appears, in a joking mood, to introduce the title "Svensk Film-industri." Startingly different music sets the titles off from the pre-credit sequence, but one does feel that the film is intruding on the titles in its "impatience," while rather playfully allowing the audience a breather.

At this point the fiction fades in. Alma walks into her supervisor's office and is told about her new patient, Mrs. Elisabeth Vogler. Alma is a young nurse, engaged to be married, dedicated to the profession. Mrs. Vogler is an actress who appears to have become catatonic. While playing Electra on stage, she had gone silent for more than a minute; the next day she had refused to move or speak, and had gone on to remain silent for three months. Meeting her patient, Alma is impressed with Elisabeth's will power, and wonders whether she will be able to handle the case.

Early in the film it becomes clear that Elisabeth's silence is voluntary, prompted by at least three motives. One night Elisabeth turns on the TV in her hospital room and sees newsfilm of a Vietnamese monk burning himself to death (fig. 6); she retreats in horror to the opposite wall and covers her mouth. This suggests that her silence is in part a response to the pain and evil in the world: an almost saintly vow of silence and protest, a gesture that expresses her despair of improving the world and her determination in any case not to make matters worse. If she does not speak, she cannot lie; if she withdraws, she hopes she will not be held morally accountable for what others do.

The second reason for Elisabeth's silence is guessed at by

the doctor, and calls attention to the "ontology" motif. As the doctor puts it, Elisabeth is trying not to "seem," but to "be." Like Karin and Maria in *Cries and Whispers*, she is a prisoner of her own isolation, her fear of relationship. Elisabeth's career as an actress—a professional adopter of roles—is not very different from her private life:

> DOCTOR: I understand all right. The hopeless dream of "being"—not seeming but "being." At every waking moment, alert. The gulf between what you are with others and what you are alone. The vertigo and the constant hunger to be exposed. To be seen through. Perhaps even wiped out. Every inflection and every gesture a lie, every smile a grimace.[17]

Elisabeth chooses silence as a way of avoiding all role-playing, including that of personality. Her refusal to "seem," however, does not really solve this problem. Throughout the film it is clear that Elisabeth is displaying a definite personality, and not a very nice one at that. In terms of film imagery, Elisabeth's search for "being" is comparable to a photograph's attempt to become unfiltered, undefined light—as it is comparable to the artist's desire to be profound, and the protestor's insistence on perfect virtue. The doctor's insights appear to be confirmed by Elisabeth's facial reactions, almost those of an animal that has been found out. The doctor goes on, not only to express her ironic admiration for Elisabeth's gesture, but to destroy it in two further observations. One is that "your hiding place isn't watertight; life trickles in from the outside, and you are forced to react." (This "flaw" is of course responsible for much of the drama of the film, which would have been much less interesting had Elisabeth entirely failed to react to Alma.) The other is to point out that Elisabeth's silence is merely another kind of acting: she has adopted the role of Silent Being, and will in time abandon this one as she has all the others.

The third reason she has gone silent is less abstract than

the first two: Elisabeth enjoys being in control of people, making them react to her. Her "passivity" is provocative, dominating. This role allows her to be supercilious and superior, and is intended to protect her from being judged (since she "does" nothing that might be held against her). All three of these reasons are variations on her fear of living, of defining herself, of taking responsibility for her actions and emotions; all three find their perfect complement in Alma, whose persona at the beginning of the film is her own personality.

Alma, who is at least as formidable as her patient, has allowed herself to become "a real person." She has limited herself to having one life, and feels she would be incapable of acting. At one point she says that Elisabeth could play her like a role, and that says a great deal about their relationship. Elisabeth's withdrawal allows her to assume many false lives, but leaves her with little sense of "real" self. Alma intends to commit herself to the profession of nursing, to marry her boyfriend, to have children, and eventually to grow old; she admires the single-minded dedication of old nurses she has met. She has some doubts about these decisions after Elisabeth has shaken her up, but her life-plan and identity at the beginning of the film are well under control. Where both women are sensitive to the suffering of others, Alma is professionally committed to helping people, while Elisabeth (who is moved more by a TV film of Vietnam or a photograph of Nazi persecution than by the pain of people she knows) covers her mouth. Elisabeth may withdraw because she has a better sense than Alma of the *totality* of human suffering and feels helpless before it, but the audience is still left with the impression that Elisabeth brings more pain into the world than she takes out of it. For example, when Alma switches on a radio melodrama in the hospital room, Elisabeth laughs at the bad acting—but also perhaps at the content of the dialogue, which is crying out for "forgiveness" and demanding, "What do you know about mercy?" She goes on to be extremely

moved by a Bach selection from another station, but the audience is liable to conclude that the voice on the radio was not very different from the calls of her abandoned child, or even the prayers of the faithful, addressed from a great distance to a mocking, silent God.

For God has refused to adopt a particular identity; he is inscrutable, unlimited, able to do anything. Man, on the other hand, is born into a body, lives one defined life, works within his limitations, and drops dead. To some extent, these are aspects of the relationship between Elisabeth, who is afraid of life and retreats into inscrutability, and Alma, who is "not as smart," "not as talented," but whose emotions are deeply felt, who is able to level with others, who takes chances, who gets hurt, who fights in the open. Her attack on this "God," which breaks the film wide open, is entirely comparable to the Crucifixion. (Jesus was, after all, a role.)

Most of these tensions are set up in the first ten minutes of the film. At this point a narrator (Bergman himself) appears on the soundtrack; he explains that the two women have gone to the doctor's summer house by the sea, where Elisabeth can rest under Alma's care. It is clear that Elisabeth has no desire to return to her family (as her responses to an intimate letter from her husband, and a photograph of her child—which she tears up—have shown). The two women read in the sun, cook, wear similar outfits, go on nature walks—and talk. That is, Alma talks. Elisabeth's silence at first provides Alma with the only good listener she has ever had, and brings her out; later it becomes manipulative and unnerving, and Alma finds herself talking to fill up the silence (or, to borrow a term, the Silence). Alma tells about her lovers, her conscience, her professional aspirations—and in a justly famous monologue, her orgy on a beach and the abortion that followed. Her candor continues until Alma discovers, by reading an unsealed letter written by Elisabeth to the doctor, that Elisabeth has no deep feeling for her, is willing to repeat her confidences to the doc-

122

tor, and is in fact having fun "studying" her. Alma retaliates by leaving a piece of broken glass where Elisabeth is liable to step on it; the "accident" occurs, and as Alma watches Elisabeth's expression of pain, the film jams and tears.

As John Simon has observed, one of this film's principal visual themes is that of "halving and doubling."[18] Bergman, who has said that he chose Liv Ullmann for the role of Elisabeth because of her facial resemblance to Bibi Andersson, continually emphasizes that the two women are complementary personalities. They are so similar that they could be considered two masks on one common face. Even while they are still in the hospital Bergman cuts, for example, from Elisabeth's crying silently in bed to Alma's meditations about herself and her patient as she lies in bed. Early in their stay at the doctor's house, Bergman dresses them in similar straw hats and shows them comparing hands (the germinal image). Perhaps the most startling moment comes several scenes later, when Alma and Elisabeth, each dressed in black and smoking cigarettes, are photographed from the side while sitting at a table, so that Alma blocks Elisabeth's face but not her arm and shoulder. The effect is to produce a distorted single figure—since the clothes appear to merge—with two arms of dissimilar sizes, an oddly turned chest, and Alma's head. Later in the shot, when Alma turns slightly, the composite figure is seen to have both their heads, but still only two arms and one trunk. In several other scenes, Bergman uses light, framing, or blocking to cut each of the women in half; sometimes he joins the halves in an attempt to visualize their impossible mutual face. Such experiments as the nearly cubist figure created in the scene above prepare the audience for the climactic moment when the half-faces are, through optical printing, literally fused.

The progress of the women's relationship during this first half of the film depends on two major movements: the increasing intimacy of Alma's revelations about herself (an

123

experience that seems, almost like psychoanalysis, to make her aware of her own complexity and value, even as it breaks down many of her defenses), and the gradual intrusion of the world of dreams. It is difficult to say whose dreams these are, although at first they appear to be Alma's; by the second half of the film one is prepared to believe that these are dreams of the work itself: another level of the film's consciousness, as if, asleep, it were revealing the nightmare elements of its vision. In each case, these dreams deal directly with the film's thematic center: the two women's "secret sharing," their uncanny joinedness. In the first "unreliable" moment Alma, who has drunk too much, hears a voice whisper that she ought to go to bed. From the soundtrack, it is difficult to identify this voice as Alma's interior monologue or Elisabeth's whisper, but the screenplay identifies the voice as Elisabeth's. Alma then repeats the line out loud, as if she had just thought of it (or been prompted). That night Elisabeth comes into Alma's bedroom. The setting reminds one of horror films; Elisabeth advances through a mist, her ghostly nightgown waving, almost like a vampire on a nocturnal visit. Alma rises to meet her. They face the camera as if it were a mirror, reminding one of the complex nature of the screen in this film; Elisabeth draws Alma's hair back from her forehead, as if to demonstrate how similar their faces look (fig. 7). Then Elisabeth moves her mouth toward Alma's neck, in an echo of Edvard Munch's painting, *The Vampire*. The next morning, Elisabeth mutely denies having spoken to Alma or visited her room. The fact that the screenplay prevents the whisper as Elisabeth's could indicate that Elisabeth is lying, and that the events of the night before "really happened," but it seems more plausible to identify the whisper and visitation as dream movements. On the other hand, to consider these (and the more complex sequence that occupies most of the second half of the film) *Alma*'s dreams would be, I think, to unbalance and limit the picture; it would simply become the story of a nasty patient and a spotlighted, schizophrenic

nurse. Much of *Persona*'s excellence lies in its decision not to pinpoint the origin of these visions, but to offer them as *in some way* "happening"—as if the film itself had in these moments shifted the territory of its exposition from the surface of the story to its eerie undercurrents. As Robin Wood puts it, "If we are watching a dream, it is as much Elisabeth's as Alma's";[19] it is perhaps more precise to build on Wood's line and observe that the mindscreen is that of the film's "potential linguistic focus," rather than that of Alma, but that Alma and Elisabeth participate in, or share, its "dream." In the first "dream," the women achieve some kind of telepathy; in the second, they study their faces in the camera/mirror; in the later, climactic sequence, the hint of vampirism emerges as outright bloodsucking, and the face-halves merge.

Elisabeth's letter hurts Alma into hatred—the hatred of an intimately exposed, sincere person for the violator of her trust, and perhaps by extension the hatred of mortals for a mockingly superior, pathetically withdrawn deity. Each set of emotions is extreme enough to account for the breakdown of the image. The Crucifixion is supposed to have provoked earthquakes and metaphysical disasters, as a contradiction in the ontology of the universe was brought to its climax by a physical attack on the body of its God. Such a scene would be almost too overwhelming in its implications to visualize. In terms of the women's relationship, the issue is not one of ineffability but of an emotional overload as well as an indirect confrontation with the fiction's own logic. Alma is demanding, through violence, Elisabeth's full attention to Alma's pain—her acknowledgment of Alma's humanity—and has abandoned the restraints and defenses of her role as nurse. At this moment and for the first time, all the masks are off—Alma, no longer a nurse or a chatterbox, has let down her own and ripped off Elisabeth's pose of harmless, passive superiority—and the film image itself is, accordingly, unmasked.

By wounding Elisabeth, Alma has insisted on making a

direct, physical communication. She has defended her own humanity, her ability to be hurt, by demonstrating that her inscrutable companion can be hurt too. (In many ways this scene makes me think that Jesus was killed not because he was a nonviolent troublemaker whom no one recognized as a god, but because he *was* considered a god, trapped in a body that for once made mortal revenge possible.) Occurring in a frame whose logic is precisely that of masking, this unmasking short-circuits the ontology of the image. (One is reminded of the "feedback" sequence in *Coming Apart*.) The breakdown occurs only once because it would be poor storytelling to repeat the device at every major escalation of the women's unmasking; the moment of its occurrence may even have been chosen at random (as was the moment at which the cartoon image broke down), although the Crucifixion insert that follows suggests otherwise. But when it does occur, this sequence declares the film's self-consciousness in the clearest possible terms, and suggests to the audience that the limits of that self-consciousness do involve the problem of unnamables. Like Beckett's Unnamable, who can say the word "I" but not the self that transcends that word, *Persona* can allude, in words and images, to the fact that it is a mask—can in fact fully dramatize the nature of the mask—but cannot *directly* present the mind behind the mindscreen, the metaphysical intelligence that here masks itself (even if that mind is its own).

It is difficult to suggest to an audience that it is watching a system's (rather than a character's) mindscreen—although *Persona* is notably successful in doing so, particularly in its opening poem; and it is impossible, if one accepts Wittgenstein's analysis, to include the mind itself in the image (one must be content with signifiers and surrogates). An attempt to express the logic of the system, to transcend the mindscreen in an attempt to confront the mind, must result in incoherence and breakdown. This analysis requires no mystical overtones; Elisabeth need have no relation to Godness. As it is encountered in this film, the mindscreen

itself is an expressive, limited system, whose dreaming mind—whether it be that of Bergman, or of some character, or of the work as it narrates itself—is from the point of view of that system, metaphysical. It cannot be included in the image. Even if Bergman is, as he suggests, the conceiving offscreen mind, the audience does not see his mind. The boy in the morgue is a metaphor for the dreaming artist, a fiction within the system. His morgue screen, too, is a metaphor for the mindscreen that really is operative: that of the film. The nearest that mindscreen can come to confronting itself, short of the intricate metaphor of this unmasking scene, is to reduce itself to white: the visual equivalent of perfect, articulate silence. It is up to the viewer to intuit the consciousness behind the mindscreen; the most that the film itself can do is to draw attention to its own "awareness" that it is a mask.

After the image burns away, leaving a white frame, the "silent film" returns; a devil stares directly into the camera, then is eclipsed by another white frame. The next shot shows a chase, and in the next a skeleton jumps out of a trunk. Over the white frame that follows, a cry of pain is heard; it leads into the next shot, which is of the nailed hand. The final shot of this sequence probes the blood vessels of a moving *eye*, before the image fades out, and Elisabeth—out of focus—fades in. Then there is a cut to sharp focus. Nothing can stop this story from telling itself.

In the next sequence, Alma and Elisabeth have a physical fight that ends with Alma's frightening Elisabeth into speech. Hurt and furious, Elisabeth storms off. Alma chases her along the beach, crying, "You won't forgive me because you're proud! You won't condescend! I won't—I won't!" Alma is not simply answering herself as if she were Elisabeth; she is speaking as if they were one person. From this point on, the processes of role-switching and "secret sharing" intensify until the two women's personalities become inextricable.

After shouting these lines, Alma falls to the rocky beach,

sobbing. The metaphoric significance of this gesture can be appreciated if one returns to an earlier scene, in which Alma had read the following words to Elisabeth:

> All the anxiety we carry with us, our blighted dreams, the inexplicable cruelty, our anguish at the thought of death, the painful insight we have into the conditions of life on earth, have slowly crystallized out our hope of heavenly salvation. The cries of our faith and doubt are one of the most terrible proofs of our desolation and awareness.[20]

Under Alma's voice, the camera had photographed the rocky, crystallized landscape, which thus became an image of existential despair. Elisabeth had nodded her agreement with these words, while Alma had rejected them. Now, fallen and sobbing, Alma feels her own faith "crystallize out" in the face of Elisabeth's haughty silence. The paragraph she had earlier rejected has become a perfect expression of the religious and emotional landscape to which Elisabeth has brought her.

Alma remains on the beach a long time. Soon after she returns, the film's major "dream" sequence begins. (Both Simon and Wood have performed excellent analyses of this part of the film;[21] as I have little to add to their observations, I will be brief in what follows.) Photographed from overhead like the woman in the morgue, Alma is awakened from an uneasy sleep by the arrival of Elisabeth's husband, who at first appears to be blind. Under Elisabeth's prompting, Alma plays the role of Mrs. Vogler, soothing the husband and making love to him. (It should be remembered that Alma used to see herself as incapable of playing another person.) Alma's acting, however, is more than pretense, for while they are in bed she spontaneously expresses what appear to be Elisabeth's emotions: "Leave me alone—I'm cold and rotten and bored—it's all lies and cheating!"

It was in the middle of these "dreams" that Bergman

originally placed the projector's breakdown. In the screen-play, he meditates:

> At this point the projector should stop. The film, happily, would break, or someone lower the curtain by mistake; or perhaps there could be a short circuit, so that all the lights in the cinema went out. Only this is not how it is. I think the shadows would continue their game, even if some happy interruption cut short our discomfort. Perhaps they no longer need the as-sistance of the apparatus, the projector, the film, or the soundtrack. They reach out towards our senses, deep inside the retina, or into the finest recesses of the ear. Is this the case? Or do I simply imagine that these shadows possess a power, that their rage survives with-out the help of the picture frames, this abominably accurate march of twenty-four pictures a second, twenty-seven metres a minute.[22]

In the scene that Bergman originally imagined as surviv-ing this breakdown, and which in the finished film directly follows the scene with Mr. Vogler, Alma finds Elisabeth looking at a photograph of her son. Alma's monologue, in which she describes Elisabeth's experience of motherhood, is shown twice; the first time, the audience hears Alma but watches Elisabeth, and the second time one hears and watches Alma. Throughout each rendition, Nykvist's camera cuts steadily closer to the face onscreen. At the end of the "second" sequence, Alma cries, "No—I'm not like you . . . I'm Sister Alma . . . I'd like to have—I love—I haven't"— and at that climactic moment, their faces—each halved by the lighting, both unified by the scene's repetition—merge.[23]

The content of Alma's monologue is almost as significant as these visual devices. She divines (like a medium, in the screenplay) that Elisabeth took on motherhood as a role, to complete her repertory, but became frightened of preg-nancy and its responsibilities—the permanent aspects of the role—after it was too late. She grew to hate her child and

rejected it after birth, but the child refused to abandon *her*. Some of Alma's lines appear to have a double meaning; they can be taken to refer both to Elisabeth's fear of intimacy and to the relationship between a withdrawn God and his devout creation:

> You began to hate the child and hope it would be stillborn. . . . It was a long and difficult delivery; you suffered for several days. . . . At last the boy was taken in by relatives. . . . The boy was seized by a strange and violent love for its mother. . . . Your meetings with him are cruel and clumsy. . . . You want to hit him for not leaving you alone. You think he's repulsive with his ugly body and his moist pleading eyes. You think he's repulsive and you're afraid![24]

Alma becomes terrified at the apparent accuracy of her insights, because she feels she may be describing her own feelings—in other words, that what she used to think of as "Sister Alma" (who wants children, although she had had an abortion, etc.) no longer exists, or applies. The soul (*alma*) has broken into God's refuge, only to find its own image. Even abandoning the religious metaphor as farfetched, one finds in this merge a vigorous expression of many of the film's other themes: the relationships among artist (Elisabeth), creation (*Persona*), and audience (Alma); between the shifting faces on the morgue "screen"; between the anonymous self and its masks; between the oppositely charged, sublimated carbon rods; between silence and speech; and between the white frame and the representational photograph. Each grouping of opposites is seen to be comprised of complements: figures on either side of a mirror, each of which is equally two-dimensional.

In the next scene, Alma is in her nurse's uniform; she sits across a table from Elisabeth. Silhouetted by the light from the window, their heads flow together; Alma says, "I'll never be like you—I change all the time." Then Alma pounds on the table, regains control, and begins to speak

as Elisabeth moves her lips. Her words, although they have many exciting poetic undercurrents, are fragmented into nonsense: "Say defend nothing . . . Not now no . . . A desperate perhaps . . . Many words and then nausea." Bergman's comment on this scene emphasizes the degree to which *Persona* operates at the edge of silence: "[Alma] has been driven nearly insane by her resentments so that words, which are no longer useful, can no longer be put together by her. But it is not a matter of psychology. Rather, this comes at the point inside the movement of the film itself where words can no longer have any meaning."[25]

At this point Alma cuts her forearm with her nails and offers the blood to Elisabeth, who sucks greedily. One is reminded of Elisabeth's nocturnal visit to Alma's bed—a scene that, during the shooting, apparently concluded with Elisabeth's sinking vampire fangs into Alma's neck.[26] Elisabeth is many kinds of predator: an actress studying Alma, in order to learn new gestures to use when she returns to the stage; an "empty" person, taking—as Bergman put it—"some blood and meat, some good steak"[27] from a richer human being; a voyeuristic God getting vicarious stimulation through the loves and risks of mankind—in short, an undead that feeds on the blood of the living. The gorged Elisabeth tries to pull away, but Alma forces down her head, then lets her go and begins to beat her savagely. The image goes black.

In the next scene Alma, still in uniform, enters the hospital room where Elisabeth lies in bed. Comforting her exhausted (and unbattered) patient, Alma urges her to speak: "Try and listen to me. Repeat after me: Nothing. Nothing. No, nothing." Church bells are heard in the background. Elisabeth speaks the word, and a close-up of her face dissolves to the image of the two women looking into the mirror in Alma's bedroom. The image fades to white.

Alma wakes up and finds Elisabeth packing. When she is alone Alma closes up the house. Just before leaving, Alma pulls back her hair in the mirror, imagines "her" dream

image of Elisabeth standing beside her and stroking her hair, then smiles as the vision fades. As she leaves the house, there is a cut to Elisabeth, made up as Electra, and another cut to a film crew (apparently Bergman's). Inside the camera one sees Elisabeth, no longer made up as Electra and apparently at work on a new film. Only her head and shoulders are visible as she lies on a bed; she is upside down, like the woman who awakes in the morgue and like Alma at the beginning of the long "dream" sequence. In this image *Persona*'s self-consciousness becomes labyrinthine, and the links between death and resurrection, between the artist's fear of sterility and his waking into a new creativity, between the world of fiction and the world of dreams, and between Silence and role-playing, all fuse.

The bus arrives to take Alma back to the hospital; the camera pans to look at the ground. Superimposed on that ground, the face from the morgue fades in, and in the seconds before the dissolve back to the morgue is completed, one sees the boy still feeling the screen in front of him—the screen that for those few seconds contains the vestiges of the fictional image, the pebbly ground. Then the fiction fades completely; the boy continues to move his hand across the almost transcendent face until it fades to white; he has just time to begin to retreat as the film runs out of the projector. In the final image the arc light is extinguished, and the opposite yet identical rods, whose intercourse is completed, pull away from each other, leaving the screen in darkness.

"Shame" and the Structure of Horror

It is not that Bergman is pessimistic about life and the human situation—as if it were a question of certain opinions—but rather that the quality of his sensibility, when he is faithful to it, has only a single subject: the depths in which consciousness drowns.

. . . It is here, I think, that one must locate the ostensibly political allusions in *Persona*. Bergman's references to Vietnam and the Six Million are quite different from the references to the Algerian War, Vietnam, China in the films of Godard. . . . [These] are, for Bergman, above all, images of total violence, of unredeemed cruelty. They occur in *Persona* as images of what cannot be imaginatively encompassed or digested, rather than as occasions for right political and moral thoughts.

—Susan Sontag[1]

In *Shame*, Bergman has two projects: to show the horror of war, and to analyze the difficulty of coming to terms with horror itself. At the film's European premiere he described his intent as "to show unpretentiously how humiliation and the rape of human pride can lead to the loss of humanity in the victim himself. As an artist, I am horror-stricken by what is happening in the world. . . . I hope that in *Shame* I have been able to convey the intense fear I experience."[2] There can be little question that he suc-

133

8. *Shame* (courtesy of United Artists Corporation): Jan (far left) cries as Jacobi and Eva reenter the house after making love.

ceeded here, or that *Shame*'s mastery extends beyond its "right political and moral thoughts" (even if Sontag suggests these are not at issue); to me, it ranks with the best of his work, alongside *Persona, Scenes from a Marriage,* and *Wild Strawberries.* Despite the fact that so much of its intent is thoroughly and unforgettably realized, however, there is something extremely *un*realized about its treatment of the second project. The horror is dealt with, but the knowledge of the horror transcends the limits of the system, and thus of the artist's resources. I do not mean to suggest, however, that these failures represent defects, either in Bergman or in *Shame.* To appreciate the extent of the problem, one must open to question the nature of this film's mindscreen.

The mindscreen of *Persona* is self-conscious; its light "establishes itself and thickens."[3] Rather than narrate itself, *Shame* calls attention to the fact that it is being dreamed by a separate offscreen mind, but cannot name the dreamer. This mind—which might, but need not, be identified as that of Bergman or of God—is able to have an emotional response to its fantasy: shame. Since it belongs to this offscreen mind's overview of its dream, this emotion locates itself "outside" the work, in the title. Like his characters, this dreamer is overwhelmed by the horror of "unredeemed cruelty," and is as unable as they to escape the moral consequence of all it has seen. In this respect, *Shame* is like the dream of *Hearts and Pearls,* divorced from *Sherlock Junior* and hopelessly in search of its Buster.

The simplest and starkest of Bergman's films, *Shame* is the story of Jan and Eva Rosenberg, two musicians living on an island, who are victimized and humiliated by a war. As each art and grace and defense is stripped from them, their marriage deteriorates. Jan's essential cowardice and cravenness evolve from the point where he is unable to shoot a chicken to the point where he murders a soldier for a pair of boots; from a whining, dependent intellectual, he deteriorates into a loveless brute intent only on personal

survival. Eva, who is much stronger than he, holds onto her humanistic values, although she adapts her morals to the changing situation. (Her act of infidelity with Jacobi, the local power-figure, is the decisive precipitator of—or excuse for—Jan's brutality [fig. 8].) Although both of them respond with sensual energy to a good bottle of wine (one of the last) and good music, Jan's interest in civilized values falls away with civilization, while Eva continues to want to have children or to be able to talk with her husband even after the war has humiliated them beyond endurance. War brings out the worst in them both, but only Jan becomes a killer.

All of this pertains to the first project, and contains no suggestion of mindscreen narration or self-consciousness. Bergman's second project is to suggest to the audience that this world is an object of knowledge; his characteristic method is to hint that the film is a dream, and the visual field a mindscreen. *Shame* opens with Jan's telling Eva of a dream he has just had, and closes with Eva's doing the same to Jan. Jan begins:

> I dreamed we were back in the orchestra, sitting beside each other rehearsing the Fourth Brandenburg Concerto, the slow movement. . . . And everything that's happening now—it was all behind us. We remembered it like a terrible dream, and we were grateful to be back. I woke up crying—can you imagine?[4]

To Jan, of course, the world into which he wakes is real; but his words have planted the notion that everything "happening now" might from some perspective be "a terrible dream." Eva takes the hint, and at the halfway point of the film, while they are waiting to be interrogated by Jacobi's forces, she says to Jan:

> Sometimes everything seems like a long strange dream. It's not my dream, it's someone else's, that I'm forced to take part in. Nothing is properly real. It's all made

136

up. What do you think will happen when the person who has dreamed us wakes up and is ashamed of his dream?[5]

These lines do not violate the integrity of the fiction; their dream metaphor makes sense as an expression of Eva's bafflement at having her life turned upside down. But they also function as an authorial hint, a moment when the dreamer confronts, in disguise, exactly what he is doing. It is comparable to the scene in *Through the Looking-Glass* where Alice dreams the possibility that the Looking-Glass world is being dreamed by the Red King, and Eva can be forgiven her impulse to give the dreamer a good shaking.

After the couple have lost their home, their intimacy, and their self-respect, Jan buys their way onto a small boat that may be able to take them to "the neutral zone." Instead, the boat strands them in a calm. The water is full of dead bodies, floating in their life jackets. The "captain" lowers himself overboard while the passengers are asleep. The boat drifts off course, and the film ends with a feeling very like that of Kafka's "Country Doctor": they will never reach land, they are trapped in the end of a nightmare. In the closing scenes of the screenplay, Bergman made it explicit that nuclear weapons had been dropped; in his original concept, the film ended with the passengers' drinking "poisoned" rainwater. This effective ending was abandoned, so that the film now ends with the following extraordinary monologue, spoken by Eva:

I had a strange dream, it was absolutely real. I was walking along a very beautiful street. On one side were white, open houses, with arches and pillars. On the other side was a lovely park. Under the big trees by the street ran cold dark-green water. I came to a high wall, that was overgrown with roses. Then an aircraft came roaring down and set fire to the roses. They burned with a clear flame and there was nothing particularly terrible about it, because it was so beautiful.

137

I stood with my face against the green water and I could see the burning roses. I had a baby in my arms. It was our daughter, she was only about six months old, and she was clutching my necklace and pressing her face to mine. I could feel her wet open mouth against my cheek. I knew the whole time that I ought to understand something important that someone had said, but I had forgotten what it was. I pressed the baby close to me and I could feel that she was heavy and wet and smelled good, as if she had just had her bath. And then you came on the other side of the street and I thought that you would be able to tell me about the important thing that I had forgotten.[6]

Besides its lyrical power and its thoroughly dreamlike quality, this speech perfectly dramatizes the dilemma of Eva's humanism. Her longing for a child, for a beautiful life, for intimacy with a strong and understanding husband nearly exhausted, she attempts to make sense out of the end of the world; and on this note of hopeless, defiant incomprehension the film drifts to its fade-out.

This vivid and mysterious recitation, coming as it does in the stillest part of the film, accompanied only by the slow motions of a deathship on a cold, gray sea, casts a dreampall over the whole of what has preceded it. At the end of the fade, the audience wakes up. What the system's dreamer does, we cannot know.

Again it is McConnell who raises the issue most clearly:

. . . "politics," if it makes sense at all, must signify its most general meaning, "life in time." No sign system, either language or the succession of images which is cinema, can escape from the fundamental contradiction of all sign systems which try to deal with "politics" in our sense—the contradiction being that they are attempting to signify what no system *can* signify, the higher system which is its cause.[7]

138

The higher system, in this case, is the dreamer. His, too, are the rules of this war.

Shame is, in the first place, a fantasy in the mind of Bergman, who is literally making up these people and all their troubles. In the second place—if one were to accept the fiction as "real in its world"—it is a nightmare in the mind of a silent God. This possibility is suggested most forcefully in Jan and Eva's discussion, over the '59 Liebfraumilch, of whether they ought to have children. Jan says that he is not as selfish as Eva thinks; he can change his character, he is not "a determinist." Eva does not know what the word means, but the camera does—and pulls dramatically in on Eva's face as she asks Jan what he means. A determinist, of course, is someone who believes that God is in total control, that everything is foreknown and foreordained. One is reminded at this point of Śaṅkara's Hinduism: the solution to the problem of the world is to realize that the world is a product of God's imagination; one is freed from delusion by acknowledging it.

However this mind is identified, the suggestion remains that the dreamed world cannot know him. There is a concealed "I" in this film, whose dream is the visual field that appears on the theater screen. His response comes outside the film, in the "waking world" of the title (any other hints of his presence being sublimate): a periphery that must strike the inhabitants of the mindscreen as transcendent. Much of the brilliance of *Shame* appears in the ease with which it integrates—or implicates—the offscreen dreaming mind into its larger structure, without violating the fictional integrity of the dream. *Shame* is able to suggest the presence of an offscreen "I," to suggest its awareness that it is a narration, exactly because it does not name that dreamer.

How do the two projects, then, relate to each other? Why all this talk of dreaming in a film about war? To understand this, one must return to Sontag's observation that acts of "total violence" occur in Bergman's films "as images

139

of what cannot be imaginatively encompassed or digested."
One discovers throughout *Shame* a theme of refusal to
know. In the midst of her affair with Jacobi, for instance,
Eva tells him, "I've never been unfaithful to Jan before.
I'm scared when I think of it. So I never do think of it."
A few minutes later, Jan looks out the window, sees them
together, and realizes what has been happening. The cam-
era, like Jan, is inside the house, and the window is
whited out. This is not a simple instance of overexposure;
Nykvist could have covered the window with a neutral
density filter and shown what Jan sees. The horror is de-
liberately not shown, and this makes it all the more pain-
ful. The burden of knowledge is refused, Bergman suggests,
because it *has* to be.

As Jan and Eva make peace with the terrible things they
do, the responsibility of coming to ethical consciousness is
shifted to the offscreen mind: it is he who must wake up
and be ashamed. But to blame one's behavior on God, or to
give him the burden of consciousness, is both immoral and
self-defeating. As Emily Dickinson acutely observed:

> Of Consciousness, her awful Mate
> The Soul cannot be rid—
> As easy the secreting her
> Behind the Eyes of God.[8]

It is for this reason that *Shame* refuses to *look* like a dream,
to fill itself with Surrealist imagery, self-contradiction, and
other subjective image-codes. This mess of a world, Berg-
man insists, is potentially real; if it happened, it could look
just this way. There is a formal reason, too, for refusing to
encode the image as a mindscreen—for refusing to include
a *Sherlock Junior* frame—and that is, as McConnell sug-
gests, that the extra-systemic *cannot* be included. The
hints of the dreamer's presence are just hints, addressed by
the dreamer to himself, within earshot of the audience;
Eva is only guessing. Whereas personal responsibility *can*
be confronted, the noumenal mind cannot. As Bergman de-

fines the structure of horror, it involves the problem of incomprehension, and it is in this initial incomprehension that the character's refusals originate. Yet Bergman endows every aspect of his fiction, up to his own dreaming persona, with the potential for self-knowledge and its attendant ethical consequence.

The self-consciousness of *Shame*, then, is authorial, and is a function of Bergman's suggestion that the visual field is a mindscreen—in Wittgenstein's sense, "a limited whole":

> God does not reveal himself *in* the world.
> ... To view the world *sub specie aeterni* is to view it as a whole—a limited whole.
> Feeling the world as a limited whole—it is this that is mystical.[9]

This accounts for the "unrealized" quality of the second project. For a character inside the world, God is transcendent. Analogously: as the visual field does not include the eye, the dream is unable to include the actual dreamer. Even if Jan or Eva were allowed such dramatically disastrous lines as "Hey, we *are* a dream in the mind of God," their observations would have to be taken as guesswork— at best, as a sublimation of the dreamer's self-awareness. Because a mindscreen is the visual field of an offscreen, "higher" system, some aspect of this problem is basic to the mode itself.

In *Persona* and *Shame* Bergman advances two kinds of mindscreen cinema. *Persona* gives the impression of narrating itself, of being its own mind's screen. *Shame* (which may, I grant, simply be a third-person war film whose characters talk a lot about dreaming—and much of my point is that there can be no absolute evidence for either position) adopts the more conventional form, suggesting that it is the visual field of an offscreen, fictitious[10] narrator; its innovation, and its metaphysics, proceed from its systemic rigor— its refusal to encode or contextualize the mindscreen through a frame. When a film can be mindscreen from start to finish,

yet appear throughout to be third person, it suggests not that "all films are mindscreens"—which they are not—but that the rhetoric, the look, and the connotative range of first-person film narration are wider than anyone seems to have suspected.

Godard and the Politics
of Self-Consciousness

The nine films which we made were mainly spon-
sored by T.V., "carte-blanche" given to Jean-Luc
and me to do whatever we wanted. That was. the
case with British T.V., with German T.V. And they
all refused to show the films; they banned the films,
but not on overt political grounds. Rather, the pol-
itics was in another cake. And the cake was: "This
is not cinema. You don't know what a film is; you
don't know what film is about . . ."; and in the end
you admit that. The only thing I can say is a politi-
cal film is a film which disconnects the normal
links of reality, which suddenly breaks the world
apart and gives you space where suddenly you can
think and breathe and deal with the element. . . .
The thing we intended to prove, and it's not
proven by [*Tout va bien*, 1972], is that the politics
may be a short trip to poetics which people are not
ready to accept.

—Jean-Pierre Gorin[1]

Although Gorin is speaking of the films on which he and
Godard collaborated between 1968 and 1972, his remarks
have much wider application: not only to virtually the
whole of Godard's career, but also to such political films as
Salvatore Giuliano (Rosi, 1961), *Teorema* (Pasolini, 1968),
and *Les Violons du bal* (Drach, 1974). What Peter Harcourt
describes as "the struggle between love and politics"[2] in

143

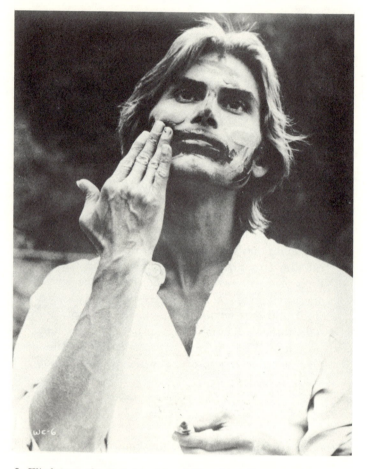

9. *Wind from the East* (courtesy of New Line Cinema): The Indian applies antibourgeois makeup, while the voice-over accuses Eisenstein of having allowed *Intolerance* to divert him from the true course of revolutionary cinema.

Godard's work from *Breathless* (1959) to *Masculine-Feminine* (1966) has developed into a struggle between making what a producer could recognize as a "real film" and disconnecting what Gorin calls "the normal links of reality" in the interest of creating a film space in which one can "think." While the economics of this conflict are liable to remain unresolvable so long as the producers do not enlarge their vision (or redefine their motives), the resources of mindscreen cinema, and the rhetorical implications of Godard's own work, suggest that the conflict is artistically useful when it is presented as a structural element of a self-conscious film.

Unlike *Persona* or *Shame*, Godard's films tend to confront not the metaphysics but the politics of self-consciousness. Both men deal with the problems and attractions of self-determination, both are Romantics, and both are well-versed in the literature of reflexivity (notably Brecht and Faulkner). But where one is a mystic, the other is a Marxist; where one is a psychologist, the other is a sociologist; where one shares with the audience his fear of (and identification with) vampires and other night-monsters, the other finds something valuable in the lifestyle of *Weekend*'s hippie cannibals; where one strives for a "well-wrought urn," the other offers the fragments of a new kind of pot.

The crucial difference between them, for our purposes, is that Bergman disguises his identification with the "potential linguistic focus" of the image, so that the mindscreen of *Persona* appears to be that of the film as a poetic object, while Godard establishes a dialogue (that becomes a dialectic) between the "potential linguistic focus" of the filmed world and his own, personal voice, so that the mindscreen of *Two or Three Things I Know About Her* (also 1966) incorporates the conflict of their attempts at discourse. Throughout *Two or Three Things*, first person collides with third, in an Eisensteinian montage of narrative modes, with the result that the film fails to present itself as a "finished" piece; the synthesis (following both Eisenstein and

145

Hegel) is up to the audience. To the extent that both artist and audience share the work of putting the film and its world into some kind of order, then, self-consciousness has, in Gorin's sense, a politics. The problems of expression and of self-definition are directly addressed, and although these problems are not "finished" by the film, their dynamics are not so hostile that the film becomes incoherent. In fact, *Two or Three Things* is both playful and powerful. It is articulate because self-consciousness *works*, because the rhetorical structure of the genre is viable, projecting a clarity whose poetics are largely independent of Aristotle's. Just as *Tristram Shandy* is more than "a COCK and a BULL," Godard's best works are each more than "Fragments of a Film."

Persona gives the impression of establishing and filtering its own light, and offers an extended metaphor of the creative process as intrapersonal dynamic. Where self-generation is presented as an achieved, formal possibility in *Persona*, it is a problem, a task, a project in *Two or Three Things*. The difference is not one of genre, but one of approach; Godard uses the self-conscious mindscreen to dramatize his own embattlement with narrative process and with the politics of filmmaking (which includes the politics of self-expression as well as those of "the means of production"). Accordingly, the central concern in virtually all of Godard's films is—as Sontag has convincingly demonstrated[3] —language. And just as verbal and visual signs occur throughout his works in montage relationship, so do first- and third-person modes of each sign system. To Sontag must go the credit for recognizing that Godard's work is not simply "personal," but first person:

> Godard proposes a new conception of point of view, thereby staking out the possibility of making films in the first person. . . . Godard, especially in his recent films, has built up a narrative presence, that of the filmmaker, who is the central *structural* element in the

cinematic narrative. This first-person film-maker isn't an actual character within the film. That is, he is not to be seen on the screen . . . though he is heard from time to time and one is increasingly aware of his presence just off-camera. But this off-screen persona is not a lucid, authorial intelligence, like the detached observer-figure of many novels cast in the first person. The ultimate first person in Godard's movies, his particular version of the film-maker, is the person responsible for the film who stands outside it as a mind beset by more complex, fluctuating concerns than any single film can represent or incarnate. The most profound drama of a Godard film arises from the clash between this restless, wider consciousness of the director and the determinate, limited argument of the particular film he's engaged in making. Therefore, each film is, simultaneously, a creative activity and a destructive one. . . . This dialectic has reached its furthest development in *Deux ou Trois Choses*, which is more radically a first-person film than any Godard has made.[4]

There have, of course, been many first-person films, in the sense that they have first-person narrators. The difference here is that Godard may be the first narrative filmmaker to preempt the "potential linguistic focus," to identify the mindscreen as his own.

It is of course obvious that most filmmakers express themselves somehow in their films, and that the "potential linguistic focus" of a third-person film (*The Informer* [1935] or *Olympia* [1938], for instance) is controlled by the filmmaker and often directly expressive of his attitudes toward his subject. And such experimental filmmakers as Deren, Brakhage, and Belson regularly produce films that are, in their entirety, authorial mindscreens. But it is rare for a narrative filmmaker to declare, up front, that he is the "speaker" of the film—that the film is at least as much discourse as it is world. Bergman, for instance, hides it, and

assigns the mindscreen to the film-as-personalized-speaker. Godard's films do not necessarily represent the best use of first-person narration, but they do explore new territory. (In this sense, *Tout va bien* is the bridge between *8½* and *Les Violons du bal*.) Their subjectivity is, as part of their structural intent, attributed largely to Godard, without the films' ceasing to be first-person fictions: that is, without the fields of their "potential linguistic focus" ceasing to be mindscreens. It should not be forgotten, however, that anybody can shove his finger in front of the lens and call attention to himself-as-filmmaker. The rhetorically, structurally interesting thing is that Godard's mindscreen—which is only one element of his films' total linguistic structure—is still just *a* mindscreen, *a* first-person "voice," and demands to be analyzed as a part of each work, not as an extrasystemic authority. This is particularly true of the films he has made with Gorin, as a member of the Dziga Vertov film group—Vertov, of course, being an innovator both in self-consciousness (*The Man with a Movie Camera* [1928]) and in documentary (*Kino-Pravda* [1922-25]). The most important aspect of his Dziga Vertov period is that in it Godard cuts himself off from the image of the self-indulgent, self-concerned artist—whose disguised autobiography is *Pierrot le fou* (1965) and whose films, however authorially self-conscious, are generally third person[5]—and allows his self-consciousness to become one aspect of that of the film. Presented as an entity on its own, engaging in its own self-definition, answerable to the political and aesthetic concerns of everyone involved in its production, a film like *Tout va bien* can imitate and justify a self-consciousness like Godard's, without being labeled "bourgeois." In the Dziga Vertov films, Godard's self-consciousness joins that of the filmmaking collective.

Two or Three Things does not admit of such Maoist analysis; it is still a film by the individual, Godard, who identifies himself on the soundtrack as "me, the writer and painter." But it is the first film in which his self-conscious-

ness finds a first-person voice *within* the narrative structure. One of the things this film suggests is that the mindscreen, as a "linguistic" field, can accommodate two (or three) "voices" at once—and further, that the filmmaker who lends his "voice" (in this case both his mind's eye and his whispered voice-over) to the internal narrative structure can produce a work that is both authorially and systemically self-conscious. (Bergman's interpretation of the morgue sequence in *Persona* has similar implications; as I said earlier, the difference is one of approach and not of mode.) In order to appreciate what Godard has accomplished in this film, however, it is first necessary to analyze the role of self-consciousness in his work as a whole. As modes of first-person narration, mindscreen and self-consciousness are inherently distinct, and rather than introduce a terminological muddle, I prefer to lift *Two or Three Things* out of sequence and save it for later discussion. The two films that map out this aspect of his *oeuvre* are the authorially self-conscious *Les Carabieniers* (1963) and the systemically self-conscious *Tout va bien.*

THE DOCUMENTARY OF SIGNS

By rejecting the films he made between 1959 and 1968 as "bourgeois" and declaring his intention to explore a new political cinema, Godard has to some extent oversimplified his own development.[6] It is true that the earlier films were made for money by crews under the domination of a self-absorbed "director," and that the conditions under which a film is made can be said to determine its moral quality and political structure; thus Godard seems justified in labeling these pictures as decadent, capitalist products, both aesthetically and economically. Much of his point in the later films is that poetics and economics cannot be separated, particularly in such an almost inevitably collective project as filmmaking. It is also true that the Dziga Vertov films have a different feel, a more rigorous sense of experi-

mental purpose than the New Wave films. But it is important to remember that the films of both periods are concerned with "the truth of fiction"; that both explore the limits of theatricality and documentary; and that the visual rhythms, color sense, and attitudes toward camera mobility and montage of both groups of films are remarkably consistent. In recognizing that such later films as *La Chinoise* (1967), *Pravda* (1969), and *Wind from the East* (1969) are radical *meditations*, concerned as much with the nature of political thinking as with the exploration of a language appropriate to political cinema, one confronts the intellectual coherence of Godard's career.

From the first, his films have attempted to establish a viable system of signs, both visual and verbal, that would be adequate to the demands of his intense moral scrutiny, as well as of his romantic excess. If, in *Wind from the East*, the audience is educated out of its desire to "identify with" and be "moved" by the illusions of representational cinema (fig. 9), in *Les Carabiniers* it laughs at the credulity of a soldier who tries to ravish the two-dimensional heroine of the first movie he has ever seen.

Each film, then, could be described as a documentary of signs. Godard's authorial self-consciousness begins with his sense, not just that he is "making a film," but that he is manipulating signs quite as much as he is looking at "the world." One of his best arguments is that convention has so come to dominate certain signs (and approaches to communication) that the modern filmmaker is unable to use them. This is not the usual modernist argument that our clichés are catching up with us; the point is that the language itself needs revitalization and reorientation, even to the extent of our rethinking the ontology of signs in general.

The use of "blood" in film offers an example of the problem. In *Bonnie and Clyde* (1967), as in countless other pictures, blood appears as an indicator of pain; in *Straw Dogs* (1971) it is an indicator of conquest; in *Weekend* (1967) it has been replaced by "red."[7] *Bonnie and Clyde's*

audience is conditioned to sympathize with the heroes—to deplore their being massacred—by being shown so much of their blood and so little of the lawmen's. Such a response is emotional rather than intellectual. A film like *The Godfather, Part I* (1972) indirectly exposes the fallacy of this sort of audience manipulation, by making the viewer recoil from the violence done to one faction of the Mafia, and rejoice in that done to another faction. "Our" side has no moral, emotional, or ideological superiority to "their" side, but we are encouraged to root for the Corleones in the same way Griffith made us root for the KKK in *The Birth of a Nation*. Even if there were some superiority involved, these techniques would still be suspect. Penn is able to awaken our antiauthoritarian impulses without giving any good reason, just as Peckinpah is able to nurture the fascist in us. Such films are "Westerns" in the hemispherical as well as the generic sense of that term: ideological products of capitalism, manipulating their audiences into emotional quagmires over false issues, while the oppressive machinery of the real world grinds on. In *Wind from the East*, Godard argues that even Eisenstein's *Potemkin* (1925) is a Western, since it depends on Griffith's techniques of audience manipulation (which were in their turn inspired by those traditions of Western literature best exemplified in the novels of Dickens, in which the reader's *sentiments* become moral criteria in an "intellectual" demonstration, so that the French Revolution is "bad" when it condemns Charles Darnay, etc. A good example of the opposite approach is the bus-ride/polling sequence in Costa-Gavras's *State of Siege* [1972], in which the repetition of the line, "It's not a question of sentiments—he never had any; it's a political question," forces the audience to examine the *way* it has been thinking about the "central" character). Many ideological conventions have become imbedded not just in the particular signs, then (as Pasolini has argued), but in the way an audience interprets signs, or expects to interpret them: it wants to identify with a character, to have an emo-

151

tional response to death- or love- or big-decision-scenes, and to be able to distinguish between documentary and fiction —in other words, to orient itself among conventions for the communication of situation and meaning—in order to understand and interpret what it is seeing. The first step in countering this tendency, then, is to address the latent self-consciousness of the audience by reminding it that it is seeing not "blood" but "red," thereby opening to question (and allowing the audience to participate in) the mechanics and implications of signification. One does not have to be a Communist to be excited by the possibility of a new set of conventions—or anticonventions—that would educate the audience rather than simply manipulate it, and make possible a new realism.

Thus when Godard photographs the skinned rabbit in *Weekend*, he sloshes buckets of red. The red represents blood, but is also presented as a *sign* for blood. Such an authorially self-conscious use of signs keeps the audience aware of and involved in Godard's own struggle with his materials—his attempt to redefine his words and images so that they will be able to advance his insights. It is, in part, the cinematic equivalent of Brecht's use of masks and verse. The frustration and impatience his films arouse in so many viewers is the first stage of what Godard no doubt would call their edification: it expresses semiotic disorientation.

Bergman's people often investigate the limits of the dream world they inhabit, attempting to justify their moral values. Godard's people seek to establish ground rules for the sign system they inhabit, attempting to relate their words and actions to the larger language (cinema[8]) in which they are expressed. The prostitute in *My Life to Live* (1962), for example, finds the value of her own pain confirmed in the image of the heroine of Dreyer's *Passion of Joan of Arc* (1928), just as the gangster in *Breathless* sizes himself up in relation to a poster of Bogart. On a more intricate level, the heroine of *Two or Three Things* explains to her son that "language is the house one lives in," and later attempts to

discover what it means to say a sentence, or to understand the difference between her images in lamplight and in darkness. What makes a film like *Les Carabiniers* so interesting is that the characters are too stupid and brutal to ask such questions. Accordingly, Godard has an extraordinary amount of fun at their expense, continually pointing out that these walking moral disasters *are* part of a film, and suggesting that their obtuseness in the cinematic arena is related to their general brutality. For a number of reasons, their lives are not worth living; surely one of these is the degree to which they are "unexamined."

LES CARABINIERS

Les Carabiniers is the story of Michelangelo and Ulysses, brothers who live on a farm with two women (Venus and Cleopatra[9]) until they are drafted by two riflemen (carabiniers). Having been assured that the rifleman's uniform is a license to plunder on a variety of levels—to leave a restaurant without paying, to rape and pillage, to shoot old men, to get into cinemas free: in short, to be New Wave gangsters—the brothers leave for the wars. They have a series of absurd adventures, pretty much in line with what they had been promised. The story of their travels is punctuated by two recurrent Brechtian devices: authentic newsreel footage of battles and corpses (which Godard terms "realism in a theatrical perspective"[10] and which acts dialectically on the viewer's double sense of the comedy of this fable [drama] and the unromantic horror of real war [journalism]—each an opposite category of photography, each conventionally demanding a different set of audience responses) and title inserts of the postcards the brothers send home to the farm, verbalizing their military experience without sentiment or insight. Back on the farm, the women (who have instructed the brothers to bring back such bourgeois spoils as bikinis) support themselves by exchanging sexual favors with a local dirty old man. The brothers

finally return, bringing only a briefcase full of photographs: deeds on the "real" goods, to be cashed in when the war is over. The war does not end in their favor, however, and they are executed as war criminals by one of their original recruiters.

Among other things, this is a war film to end all war films, for it utterly ridicules the concept of military glory not only through its plot but also by refusing to put its gory battle footage into any romantic, patriotic, justificatory context. War is not hell nor glory, nor even deplorable; it is just business.

Three scenes are particularly relevant to the question of this film's self-consciousness, apart from the Brechtian devices mentioned above: the execution of a Communist guerilla, Michelangelo's visit to a cinema, and the examination of the briefcase full of photos. Before discussing them, however, I should like to call attention to the film's unique use of sound, which is at the heart of its Brechtian approach. All of the tracks are, in themselves, realistic: the rifle shots are recorded from the proper rifles, the jeep sounds from real jeeps, and are not amplified, echoed, or otherwise dramatized by studio technology. (The paradigm, in this respect, is Rossellini's *Open City* [1945].) On the other hand they are obvious "wild tracks"; a picture of a jeep is accompanied by the sound of a jeep alone, not a jeep in a populated landscape. When rifles are discharged in a forest, one hears the rifle shots but not the forest. In a series of crosscuts between the riflemen's jeep as it approaches the farm, and the farm as the jeep approaches, one hears the jeep loudly when the jeep is onscreen, but does not hear it at all in the shots of the farm. Thus Godard deliberately refuses to build up the illusion of real-world continuity. Jerky intercuts of music feel like commentaries. The ultimate impression is one of postsynchronization, of artificiality—so that the soundtrack calls attention to its own nature as a deliberate system of signs. The jump cuts with which the picture opens, and the blackouts that occur throughout

the film, have a similar disorienting effect; one is made immediately aware of the filmmaker's manipulation of "events."

One day while Ulysses and Michelangelo, the "con-man adventurer" and the "artist,"[11] are on patrol, they are captured by and in turn capture a pair of guerillas. One of them, evidently a militant student, recites a Mayakovsky poem about "admirable fables" before she is shot. A handkerchief placed over her head flutters in the wind, and she calls "brothers . . . brothers" from beneath it: a reference to the aborted execution of the sailors of the *Potemkin*, who cry to the firing squad, "Brothers, do you realize whom you are shooting at?" (Eisenstein calls particular attention to the white rippling sail with which the sailors are covered.) When she has finished reciting, the riflemen shoot her, but they have to fire again and again until they succeed in killing her (if they do). Metaphorically, her recitation has made her invulnerable, perhaps because she is a reference to revolutionary cinema.[12]

Perhaps the most deliberately poetic device in this film is that of the catalogue. When the recruiters first arrive at the farm they engage the brothers in an unrealistically lengthy and hilarious listing of the things they will be able to steal, the outrages they can commit. The scenes during which most viewers probably give up on Godard and go home are those lengthy sequence-shots (the eight-minute traffic-jam in *Weekend*, for example) in which he exercises his singular talent for fluid *staring*.[13] Although *Weekend*'s Mozart concert sometimes had even me playing with the chewing gum on the theater seat, I generally find these long sequences his most exciting. The twelve-minute sequence in *Les Carabiniers*, in which the brothers display and identify every single photograph in their briefcase, might drive one up the wall, but it has virtues both as a comic catalogue and as a key to the characters' unique naïveté.

For purposes of this discussion, a photograph is a two-dimensional representation of an object or event in three-

dimensional space. The photos Ulysses and Michelangelo have brought back from the wars—organized into "means of transport," "monuments," "works of art," "factories," "ladies," and so on—form a short catalogue of world culture, a liberal arts education. The horizons of their greed have expanded. The women, who at first regard these "spoils" as worthless, soon begin fighting over them. The photos have some kind of magic potency for these characters, who are themselves two-dimensional representations on a movie screen (although, of course, they do not realize it). This is not to suggest that the characters cannot tell the difference between a photo and its referent, but that they find the distinction ambiguous—almost totemistic. Venus demonstrates her (or the audience's) credulity in two-dimensional images early in the film, first by modeling herself after a picture of a woman in a magazine and later by holding a lifesize photo of a brassiere over her chest so that she does appear (to us, and perhaps to herself) to be exposed. Michelangelo responds by holding a slightly smaller than lifesize photo of men's underwear over his pelvis. It is the closest they come to a sexual confrontation. The viewer is quickly able to understand the characters' paradoxical relation to photographic realism because the film he is observing is itself a two-dimensional medium. The magazine held over Venus's chest is a convincing optical illusion only when both have been photographed; by the time the audience sees her, Venus is simply a different category of photograph from that of the brassiere ad. Thus the "spoils," which often fill the screen, tend to appear to the audience as if they *were* their referents. Looking at a photo of a photo of the Sphinx, or a Rolls-Royce, or a bathing beauty, one reminds oneself of the intricacy of the sign system—or admires the car, which does not appear much more flattened than anything else in the film. Even though Ulysses and Michelangelo qualify their credulity in these signs by calling them "deeds" on the real goods, reclaimable at the end of the war, one feels that for the brothers these photos bear a relation to

their referents which is not that of postcards but the sort that paper money bears to gold. (Compare the climax of Bogdanovich's authorially self-conscious *Targets* [1968].)

If the "spoils" catalogue examines the nature of still photography as a sign system, Michelangelo's visit to a theater (which occurs earlier in the story) enlarges the demonstration to include cinema. It is the first time he has seen a movie, and he thinks everything on the screen is as real as he is. He is blinded by the darkness of the auditorium and stumbles over the other patrons. When he is finally settled, the first thing he sees is a train pulling into a station (a remake of Lumière's *Arrivée d'un train en gare* [1895], which was one of the first films publicly exhibited in France); he cowers. This is probably a reference to the behavior of Lumière's first customers, some of whom were so struck by the realism of motion pictures that they felt this train was actually bearing down on them. Next on the program is an irreverent remake (with sound) of another early Lumière film, *Le Déjeuner de Bébé* (1895). Finally, Rome-Paris Films (the producers of *Les Carabiniers*) presents *Le Bain de la femme du monde*, in which, as the title suggests, a lady takes off her clothes, gets into a tub, and begins to wash herself. Godard's homage to Lumière continues here, since there is neither cutting nor camera movement nor Mélèsian trickery, but the primary reference is clearly to *Sherlock Junior*.

Buster can jump into the screen and become part of its world because, within the fiction, both Sherlock and *Hearts and Pearls* are kinds of dreams, and to the self-conscious audience, both of them are film. Both Michelangelo and "la femme du monde" are photographs, too, but Godard, at the risk of confusing his presentation, insists on the difference between these categories of illusion. Just as Venus is not actually exposed by the magazine-brassiere, Michelangelo is not able to hop into the bathtub. The point is that *Godard* can keep these two categories separate, but the *characters* are confused. They are more taken in by movies, ads, and myths of the culture than one ought to be.

157

Godard here is far more cynical than Keaton. For him, a movie is not a dream, not a fantasy intended to carry the audience into a happier (or more wish-fulfilling) world, but a *movie*: a two-dimensional sign system having some intellectual, moral, and pictorial relation to reality, but whose principal orientation is to the here and now of an alert audience in a physical theater. So Michelangelo gets out of his seat and approaches the screen to get a better look at the "woman of the world." He feels the flat surface of the screen, stroking the image of the actress's leg. He jumps up, trying to see over the edge of the tub. (It is perhaps in contemplating the impossibility of his success that the audience first specifically thinks about two-dimensional space and the characters' naiveté about it.) At last he attempts, like Buster, to become part of the image—to embrace the woman—but the screen tears under his weight, he falls right through, and the image continues to wash itself on the wall of the theater. Buster had been weightless, an image in his own dream, a film character joining an inner film; in contrast, Michelangelo is "three-dimensional," "physical."

But Godard has started the audience thinking about its own situation in the movie theater, so that it corrects this impression of physicality, reminding itself that Michelangelo is a character in the film *Les Carabiniers*, a slightly different category of photograph from the bathing lady. One proceeds from that reminder to note Michelangelo's credulity in the presence of photographs, and concludes that the characters' being is paradoxical. In their world photographs are not so different from "physical" reality as they are in our own. The more the audience loses itself in the screen-as-dream-world, the more it is liable to make Michelangelo's mistakes, and to be seduced by directorially manipulated illusions; the more one remains aware of the director, of the theatricality of the image and of the film as sign-system, the more likely one is to be edified and instructed. In a nutshell, that seems to be Godard's message.

As the sum of his mistrust in all categories of bourgeois illusion, from fictitious imagery to economic propaganda, it is also the foundation of his political cinema, and the primary orientation of his films' self-consciousness.

TOUT VA BIEN

In *Tout va bien*—"a tale for the foolish one who still needs one," as the end title puts it—Godard and Gorin assign their self-consciousness to the "potential linguistic focus." Not only are the heroes of this film well up on image theory, so that they avoid the predicaments of Michelangelo and Ulysses, but the image field continually responds to the direction of what are not so much "the voices of the filmmakers" as filmmaking voices. The "I" in this film is not a surrogate of Godard's but a given of the film's own presentational structure.

In a 1970 interview Godard insisted that "a movie is not reality, it is only a reflection. Bourgeois filmmakers focus on the reflections of reality. We are concerned with the reality of that reflection."[14] What his concerns have produced is a genre in which the reflection can appear to take stock of its own reality, and the filmmakers can appear to participate in (rather than boss) the self-consciousness of the sign system. It is impossible to establish a hierarchy of subjectivity in *Tout va bien*; each image is equally fictional, equally "narrated." When Fonda tells the camera, "I need an image of him at work," and a shot of Montand at work appears on the screen, it is as much her mindscreen as that of the filmmaking voices, who give the impression of constructing the whole film as it unreels, in the continuous present. Like that of *Wind from the East* (which begins: "What must we do? Make a film for instance. That means asking yourself, 'Where are we now?' "), the self-conscious mindscreen of *Tout va bien* is co-extensive with the entire film. Together with *Persona* and *Two or Three Things*, these films amount to a new genre, one that makes it possible not only to

159

think with film, but also to assign "the first person" to the work.

The principal elements of *Tout va bien* are: a fiction about the effects of the May 1968 upheaval, and of a May 1972 strike in a meat-packing plant, on two liberals (played by Jane Fonda and Yves Montand); an analysis of the strike itself; a reductive eye-level camera that (except for one high-angle shot) either tracks from side to side or looks straight ahead;[15] an extremely complex and populated soundtrack; and a dialectical intelligence, given male and female voices, that is engaged in making this film. All these elements participate in the film's project of self-definition; film and strikers and liberal couple move together toward autonomy and self-knowledge. The story, which is understood to be "only a story," is intellectually stimulating and emotionally convincing. (Fonda in particular appears at home in this medium, and gives what I consider her best performance to date. It is not a fair comparison, but the fastest way to be convinced that the antibourgeois filmmakers are on to something valid is to compare Fonda in this film with Fonda in *Period of Adjustment* [1962].)

The opening sequences illustrate the good humor of this film. After the title-cards have gone by (with each take slated), the screen goes black, and two voices, neither of which is Godard's, begin the process. The male says, "I want to make a film." The female answers, "It takes money to make a film." The image lights up with a series of checks being signed: one to the cameraman, one for costumes, etc.—corresponding closely to the order of the earlier title-cards. Then the female says, "If we hire stars, we'll make a lot of money." The male agrees, and a large title flashes: YVES MONTAND, followed by another: JANE FONDA. In order to get these actors, the male decides they will need "a storyline?" "Yeah," she says, "usually a love story." They establish a country in which the story will take place (showing a contour map of France), together with landscapes and

160

cities and workers and houses—and Montand and Fonda in one of those houses. They establish that there will be "problems," and a class struggle, and "things stirring"— and that things will be stirring with the lovers, too. The idea is to make a film in which the characters will begin to think of themselves "historically"—a theme that is reiterated at the end of the film when the soundtrack declares, "Let everyone be his own historian."

Montand (Jacques) is a New Wave filmmaker who was jolted by the events of May 1968 into abandoning his "decadent" career, but still doesn't know what else to do. He bides his time, making commercials and defining himself as "a filmmaker seeking a new form for a new content." Fonda (Susan), his wife, whom he met during the 1968 upheaval, is an American correspondent in Paris. Although she begins by being proud of her news-analysis program, she discovers in the course of the film that she "corresponds to nothing." Gorin describes this film as being about "that kind of despondency that you have when you can't find your own wave of expression."[16] It might better be described as being about the search for self-actualization and for a language adequate to it; in any case, the film is far more hopeful than his comment suggests, and brings itself and its characters to the point at which they know where to find such a language.

For one of her programs on post-1968 economics, Fonda visits the Salumi food processing company to interview the manager; Montand accompanies her. A strike is in progress, and the couple is held "hostage" with the manager for several days. After this experience both start thinking hard about the nature of their political commitments and their personal relationship. Fonda finds herself unable to read her story about the strike on the air ("It's *crap*, that's what's the matter!"), and goes off to cover another kind of revolution in a suburban supermarket. Montand tries to come to terms with his 1968 experiences while preparing

another film. These later sequences of professional unrest contrast schematically with earlier scenes of professional satisfaction, in the following pattern.

"He and she will be stirring too" is a standard plot structure, rather like that of *War and Peace*. The fiction opens with Montand at work in his screening room, contracting an actress for a sexist Remington ad. Next, one sees Fonda at work, broadcasting something with evident satisfaction. Then comes a "STRIKE" sign, and a scene of two workers arguing at the meat factory. From here on, the couple's complacency is upset. After the factory sequence one sees them working again; both interrupt their work to address the camera, attempting to make sense of their respective dissatisfactions. These introspective portraits are followed by two scenes in which each attempts to define a new kind of political commitment: Montand thinks about 1968 (illustrated with mindscreens) and Fonda explores the market. The fiction ends with the two of them in a café, the future of their marriage in exactly the same kind of doubt as the future of their politics.

Like the French flag, and the title-cards, the factory has a red-white-and-blue color scheme. The boss is a complacent hypocrite. The workers are trying to achieve a new kind of strike, independent of the shop steward. Their major victory, in addition to their emerging sense of creative solidarity, comes clear in their decision to make the boss pee under conditions identical to those of the workers—a demand that reduces him to a helpless frenzy. This action, they explain to the camera, is significant and different from what might have been expected of them (which would have been simply to give the media the lowdown on how hard it is to work in a pig factory). It is a more *dramatic* action, in the first place, a theatrical demonstration (like firing him over his own intercom)—so it seems silly. But as a sign on one of the doors advises, "Stick to the truth even if it seems ludicrous." When the workers do in fact explain to the "hostages" what it is like to work at Salumi, the image

portrays Fonda and Montand as workers at the various tasks. It is unlikely that these mindscreens are supposed to represent the couple's individual fantasies of working there; what is more interesting is the suggestion that the image is illustrating a possibility implicit in the worker's words. These are hypothetical images, but they appear to be as much fantasies of the film (i.e., "unreliable" presentations by the "potential linguistic focus," or systemic mindscreens) as of Fonda and Montand. Indeed, hypothetical imagery plays a large part in this film. Alternate takes of many events occur in sequence, as if one could and could not select among them—as if the image were inherently hypothetical.

An offscreen, silent interviewer is prominent throughout the film, as in *Two or Three Things*. The workers not only explain themselves to this presence (or camera) but have access to the voice-over. For example, when Fonda interviews a group of female workers, one of them says, voice-over and in the past tense, "It wasn't right, her listening to all that in her $100 dress. . . . I felt like singing." The female filmmaker/narrator then declares, "Radical Song," and the worker faces the camera and declaims her challenge (a song without music). In this sequence, the sense of collaboration between the filmmaking voices and the characters is firmly established.

One is not surprised to find that the offscreen filmmaker/ narrators think about and discuss the image, as in the moment when they ask, in regard to the strikers who are currently onscreen, "How far will they go?"—meaning, perhaps, "to the extent that we are in partial control of the storyline, how far will we let them go, or go with them?"— and the rhythm of the track shot (which is at that moment moving through the factory offices in which the workers are arguing) "falters," jump-cutting ahead and back. What does surprise one is that the characters in the film are able to control the image field as if from an offscreen distance. After their "bad day at work" interviews, when Fonda and

163

Montand are home together, she begins bringing the question of truthful commitment around to their marriage. Trying to make Montand see that they are both to some extent involved in an oppressive emotional system, need to develop individually, and must include their concepts of their jobs in their concepts of their relationship, she faces him with "the images of us we have in our heads." The first of these is a photograph of an erect penis with a woman's hand on it. "Be aware," she says, "that this satisfies you, as an image of our relationship, less than it used to." The shock comes in the next two images, which are of him and her at work, and which the audience has seen before. In no way are these conventional flashbacks. She has grabbed two images out of the sign system, *Tout va bien*. "I need an image of him at work," she says, facing the camera, and the film provides it for her. (It is approximately the same kind of interaction with the offscreen narrators as the worker's "I felt like singing" and the announcement: "Radical Song.") Her talk, then, is absolutely self-conscious: she illustrates her points, and advances her thinking, with shots from the film. This access to the soundtrack and image field is part of the process of becoming one's own historian, which is the central concern and metaphor of this film.

It is as if Eva were to tell the offscreen dreamer of *Shame* to take off, and seize control of the mindscreen herself. This connection raises an interesting point. Speaking of Godard's Maoist period, Peter Harcourt argues:

> Like Bergman at his most rhetorical, in films like *Hour of the Wolf* and *Shame*, Godard is confusing his own inner distress with political reality. He is attempting to project outwards his inner tensions and split response to the complexities of life on to the more public world of political struggles.[17]

This is valid, as far as it goes. The point is that these films are not so much about public politics as they are about (or, more *successfully* about) the politics of self-consciousness,

which begin with the poetics of self-determination, or metatheater. The first world these films deal with is film, just as the first authentic/duplicitous machinery Glass-Man must confront is his mirror-faced camera. Joe must probe that image (the field of what he decides to face) just as the boy in the morgue must feel across the image of the double face, or Michelangelo the image of the bathing actress, or Thompson the endless Kanes in Xanadu's mirrors. To take a related example from *Tout va bien*: Before the factory is overrun by police, Montand and Fonda are released. Each separately tells the audience, voice-over (the image field is black), "We finally got out." Their being able to let us know this, from an offscreen vantage point, is an index of their *ontological* liberation. (A Joe who could not confront his camera would be as mindless as Godard's Michelangelo.)

Tout va bien is the least arty of Godard's films, and the most efficient and convincing of his Dziga Vertov films. What Poole calls "an ethical grammar of the visual"[18] is explored in *Wind from the East* ("It's not a just image, it's just an image"), but in *Tout va bien* finds a far more accessible focus. Its mechanics are evident in the supermarket sequence, an homage by Gorin to Godard's interminable track shots.[19] (The fact that Godard did not direct this sequence—nor most of the film—is not as relevant as one might think; what is under discussion here is not so much "what Godard has accomplished" as what the poetics of such work imply in general.) Photographed at cash-register height, this scene is a clear and beautiful demonstration of the process of revolution in 1968/1972 France. The camera tracks (just in front of the cash registers, looking through them at the customers and aisles and goods—and Fonda, who walks back and forth at approximately the camera's pace) from one side of the store to the other and back again, over and over, as if marking the stages of the new strike. (This shot is comparable to the cavalry's massacre of the workers in *Wind from the East*,

with its methodical pans and tilts, or the village concert in
Weekend.[20]) The repeated track movements (earlier associ-
ated with the scrutiny of the meat factory), the rigid layout
of the store, the mechanical movements of customers and
cashiers, and the high noise level establish the supermarket
as a kind of factory. The people are buying the goods. A
group of students run in and declare that all the goods are
free; the customers riot, snatching as many things as they
can. The students also engage in a discussion with a Com-
munist (selling his books like vegetables—"just reduced!"),
whom they reject as out of touch. Finally the police charge
in and beat up both students and petit bourgeois. It is a
miniature of 1968, but it is also a process, and the camera
is calm in its presence (although its tracking pace acceler-
ates toward the end). This is just as didactic as the strike
sequence in *Wind from the East*, but it strikes one as both
stronger and more assured. Perhaps it is the authority of
a filmmaker with the right image.

Soon the filmmaker/narrators return. Over alternate, si-
lent shots of Montand waiting for Fonda in a café and of
Fonda waiting for Montand in the same position at the
same table, they say, "In this film we'll leave him and her
silently, gazing at each other" (as they are) "—and we'll
simply say he and she have begun to re-think themselves
in historical terms." This is followed by a lateral tracking
shot of a brick wall, a street, and a trainyard, over which
the soundtrack presents a montage of riot sounds, snatches
of dialogue from the film, a commercial song ("The sun
shines over France and nothing else matters"), factory
noise, and the male and female filmmaking voices, who
say: "History—Me; Me—You; France—1972; *Me—You—
Him—Her—Us—You*."

The film continues, then, to define its terms, to define
itself: to discover images, however tentative, that will ad-
vance its process. Montand's and Fonda's self-definition
will continue too: part of a process that includes the strug-
gles both of the workers and of the image field. This

166

multiple construct is the key to the title. "Tout va bien" ("everything's fine") is Montand's phrase for the strike process; he says it to the exasperated factory boss, and later to his own secretary over a shot of Fonda's getting gasoline by herself, to go to the supermarket struggle by herself. So long as the struggle for self-definition is taking place, everything's fine.

10. *Two or Three Things I Know About Her* (The Museum of Modern Art Film/Stills Archive, courtesy of New Yorker Films): Juliette discusses time and identity with the camera, next to an inverted poster for Keaton's *The General.* "I was washing the dishes and I started to cry," she says at this moment; "I heard a voice saying to me, 'You are indestructible.' I, me, myself, everyone."

"Two or Three Things
I Know About Her"

Yes, how do you describe exactly what happened?
Of course, there's Juliette, there's her husband,
there's the garage. But do you really have to use
those very words and those images? Are they the
only possible ones? Are there no others? Am I
talking too loud? Am I looking too close or
from too far away? . . . Why are there so many
signs everywhere so that I end up wondering what
language is about, signs with so many different
meanings, that reality becomes obscure when it
should stand out clearly from what is imaginary?
—Godard, in *Two or Three Things*[1]

Call it a dream. It does not change anything.
—Wittgenstein[2]

Two or Three Things predates Godard's search for the
"just image," but not for the true one. The problem of
describing what happens and finding what it means, which
is implicit in *Tout va bien* (where alternative takes of
"events" occur in series), is here continually addressed and
explored. It is no coincidence that the tone of Godard's
whispered voice-over echoes that of Wittgenstein in his
Philosophical Investigations, or that the *Tractatus*'s key line
is a key to one of the film's principal metaphors. Where Witt-
genstein asserts that "the limits of my language mean the
limits of my world,"[3] Godard presents a world in search of

169

the language that gives it meaning. Across the field of the image, the expressor and what is expressed seek their points of conjunction.

The following excerpts from the *Investigations*, for example, could well have been whispered on the sound-track of *Two or Three Things*:

> "But *this* is how it is—" I say to myself over and over again. I feel as though, if only I could fix my gaze absolutely sharply on this fact, get it in focus, I must grasp the essence of the matter.
>
> . . . One thinks that one is tracing the outline of the thing's nature over and over again, and one is merely tracing round the frame through which we look at it.
>
> A *picture* held us captive. And we could not get outside it, for it lay in our language and language seemed to repeat it to us inexorably.[4]

This film is itself a philosophical investigation, and suggests a further direction for the genre of the self-conscious mindscreen. The mindscreen is conventionally used to present what a character imagines or remembers. In this sense it simultaneously records mental events and indicates mentation. In this film Godard introduces a subtle difference, and *thinks with* images and sounds, rather than simply recording his fantasies. It is this that Gorin identifies as the project of political film—to disconnect the normal links of reality so that one can recombine its elements at will, can create a space in which to breathe and think.

As Arnheim has suggested, "artistic activity is a form of reasoning, in which perceiving and thinking are indivisibly intertwined. A person who paints, writes, composes . . . thinks with his senses. . . . Truly productive thinking in whatever area of cognition takes place in the realm of imagery."[5] One can think, then, by presenting to the mind's eye a visualization of a hypothesis: "What would happen if—the ecology were upset in such and such a

manner; how would it look?" The mindscreen makes it possible to think, this way, on film. It is the director's privilege, and the genre's property (however imitative); the artistic challenge is to give the audience a sense of participating in the process, and one way to do this is to allow the audience to doubt what it sees, to recognize each event and image as a hypothesis, as *one* way of treating the subject—in other words, to encourage the viewer's self-consciousness.

Once the normative links of cutting, for instance, have been disconnected, it becomes extremely difficult to decide whose mindscreen is whose. In *Tout va bien*, when the workers explain to Fonda and Montand what it feels like to work in the factory, and one sees a shot of Montand sawing at pig carcasses, and then a shot of Montand listening to the workers, one would like to say that the image of Montand-as-worker is *his* mindscreen, but cannot do so with assurance. One can say only that the insert is hypothetical. The cause-and-effect relationship between shots is one of the undermined links. Hypothetical imagery is first answerable to the offscreen "mind" of the system, which is occasionally given a voice; the point is that the narrators, who are fictions or personae, present images as well as words, and that each kind of telling is equally mental, equally fictionalized—equally an expression of the offscreen mind. One begins with that assumption, and goes on to discover whether the mindscreen can be subattributed to a character: is it Alma's dream, or hers and Elisabeth's, or *Persona*'s?

Godard makes it easy to answer these questions in *Two or Three Things*, by identifying the "I" of its title as himself (at least in part) and reading his own commentary. He does not, however, transcend the narrative structure of the film; Godard or not, he is simply one of its voices. One reason that "reality," in this film, does not "stand out clearly from what is imaginary," is that each is being thought about, and is to that extent presented as mind-

screen. What language and world are coextensive, every-
thing is a sign, particularly when the mode of inquiry is
indivisibly mental and presentational. Only the early Sur-
realists and Expressionists, and their Hollywood counter-
parts, insisted on making the mindscreen *look* different
from the third-person shot (and sometimes even they as-
serted that these disortions corresponded to the real struc-
ture of the world, so that "third-person" objectivity was an
impossible, or pointless, mode). First person cannot stand
out from third person when the mindscreen is systemic—
when the world is a face, and its mirror is the camera.
Calling it a dream changes nothing.

Two or Three Things I Know About Her is the story of
a housewife who prostitutes herself in order to balance her
household budget. Its twenty-four-hour plot takes her from
the kitchen of her apartment, where she washes dishes, to
bed, and to Paris the next morning where she shops for
a dress, rejects a pimp, picks up a customer, uses the money
to buy the dress and get her hair done, goes to her hus-
band's garage, joins her friend in accommodating an Amer-
ican photographer, meets her husband in a café, goes home,
attends to her children, and goes to bed again. It is also,
according to Godard, comparable to "a sociological essay
in the form of a novel . . . [composed of] musical notes."[6]
Godard's analysis of the effect of Gaullist economics on
contemporary French society is actually a complex (or
intricate system) about a complex. The system being de-
scribed has several parts: the housewife, Juliette Janson;
her family and friends; her apartment; the economics un-
derlying that apartment; other housing complexes through-
out the city, and the process of their construction; the
prostitution she finds essential if she is to participate suc-
cessfully in that economic structure; and the attempts made
by most of the characters in the film—notably Juliette
herself—to understand their lives. All this is the primary
subject matter of the film, and Godard's point here is that
"in order to live in Parisian society today, at whatever

level or on whatever plane, one is forced to prostitute one-self in one way or another, or else to live according to conditions resembling those of prostitution."[7] The central subjects here are the housing "complex" in which Juliette lives, the city of Paris and its environs, and Juliette. (The "her" of the title refers both to Juliette and to "la région parisienne.") However, the film itself is a complex, and its elements are as interdependent as those noted above: the story of Juliette; the relationship of the actress, Marina Vlady, to her role as Juliette; the director's meditations on his attempt to make this film; and a scrutiny of the nature of two further complexes—that of language and that of Paris as a socioeconomic structure. It is in this identification of *itself* as a sign system, as a method of analyzing the Paris-system, that the film achieves self-consciousness.

Godard is the first director (or critic) I have encountered who explicitly identifies the succession of subject matter within a narrative film as a reflection of the consciousness (not simply the artistic intentions) of the filmmaker, i.e., of the activity of his offscreen mind: "I do not neglect conscience, since this is manifest in the cinematographic movement which directs me to these people or these things."[8] The self-consciousness of a mindscreen depends on the extent to which the audience is deliberately made aware of the activity, or tacit offscreen presence, of such a mind, and the tendency of the image or its elements (including the characters) to attend or relate to that structuring presence. Because the characters of this film so often address the camera, and analyze what they are doing (just as Godard meditates voice-over, and wonders what he is doing), the "I" of the title becomes ambiguous: it is also the "eye" of the camera, the field of a systemic mindscreen. *Two or Three Things* is not simply a film with a first-person narrator, but—like *Persona*, but perhaps with more daring—a film that speaks in the first person. Godard's spoken meditations are no more essential than Juliette's to the film's attempt at self-definition (and Paris-definition);

both are subordinate to the fact of the self-conscious image. It is a question of participation.

Among other things, this film offers a hard look at a political economy whose effect on character and society is such that objects seem more real than people, and people are treated, or treat themselves, as objects. Godard's initial approach to these materials is to describe them "as both objects and subjects . . . from the inside and the outside,"[9] making no distinction between people and things.[10] The latter method suggests an excellent metaphor for prostitution, but has several further aspects. The camera is as likely to study a beer tap as to hold on a human face, to follow a car through the wash as to record a conversation between the car's owner and her friend. One of the film's most brilliant meditations is on the pattern of bubbles in a cup of coffee—bubbles that at once suggest galaxies and subatomic particles, not only commenting visually on the nature of creation but also supporting Godard's monologue: "Since I can neither elevate myself to Being nor sink into Nothingness, since I can neither get rid of the subjectivity that crushes me nor of the objectivity that alienates me, I must look around me at the world, 'mon semblable, mon frère.' "[11] Having constructed, out of Sartre, Ponge, and Baudelaire, an ethos for staring at the world through his camera, he goes on to quote Wittgenstein's "The limits of my language mean the limits of my world" and to incarnate the aesthetic implications of that statement in a cinematic metaphor which is among the most striking and easy in all his work. Making one of his only references to the problem of clarity in a metaphysical context, he says, "When death abolishes all limits, everything will be fuzzy. . . ." As the bubbles swirl, out of focus, Godard says, "Things might come into focus"— and the image instantly focuses—"through an awakening of consciousness"—and the music of Beethoven starts up on the soundtrack. In that moment the artist's world achieves itself.

The people-as-things construct is examined throughout the film, most comprehensibly in Juliette's visit to her husband's garage, at the end of which the camera isolates the leaves of a large tree growing behind the MOBIL sign (a juxtaposition of two signs, or two ways of life, that is profoundly unsettling) and Godard, "overwhelmed by all these signs," and the difficulty of "rendering events," wonders whether he should have "spoken of Juliette or of these leaves." The culmination of this theme occurs near the end of the film, when Juliette gets in bed with her husband and, after a mild quarrel in which he exhibits his sexism (he treats her as an object no less than do her customers, or the economy, or the camera), lights a cigarette. Godard cuts to an extreme close-up, underexposed to such an extent that nothing is visible except the tip of the cigarette, which fills the screen, and that only when it is being inhaled on. The effect is that of a breathing cigarette, and it is an authoritative metaphor for Juliette's life-process.

Both person-objects and object-persons are signs. The shot which closely follows that of the cigarette and concludes the film is of various consumer goods (some bearing photographs) arranged on a lawn. While the cigarette was onscreen, Godard had whispered, "I listen to commercials on my portable radio, and thanks to Standard Oil, I take the road to dreams and forget the rest. I forget Budapest, Hiroshima . . ."—and the audience could make several important connections. The cigarette tip had been not only Juliette but also a holocaust, as the coffee bubbles had been galactic. Juliette's argument with her husband had concerned her reading (when she disagreed with one of the statistics in his "serious" book, he took it away from her and she picked up a women's magazine, pondering aloud on *its* variety of message, "how does false love differ from true"), which is seen as another vehicle for commercial messages, surrendering to which is a variety of sleep. The reference to the output of the portable

radio sums up the whole problem of media's power to educate, to lull, or to exert social control. As the holocaust is replaced—first by an *Idées* insert, and then by soap boxes, photographs of flowers, and other impeccable debris —a collection of signs, a vocabulary of consumerism— Godard's voice continues, "I'm back at zero, and have to start from here." It is as if a poker game had suddenly untangled itself into fifty-two individual cards; these are the raw materials of the language and world of this investigation: the director, the signs, and the landscape. It is an attempt to achieve Cinema Degree Zero.

But the signs in this film are problematic; they include not just consumer products and trees but verbal language, Juliette herself, and (as suggested above) any photographable object or recordable sound to which the director chooses to call attention. Throughout this film's hour-and-a-half analysis of its own structure, of structuring in general, one constantly hears, "For example:"—and the examples are sweaters, buildings, cranes, sentences, actions. In fact, one feels that the characters are speaking not "lines" but examples of sentences. Juliette even reminds herself at the beginning of the film that actors ought "to speak as if they were quoting"—quoting Brecht. Many shots are offered twice or more, sometimes from different camera angles, because of course a shot is as much an object as that which it photographs, and equally subject to analysis. *All* these signs must be confronted, and when Juliette says, "The thought process—it's substituting an effort of the imagination for the examination of real objects," one realizes that Godard is committed to both efforts, as he fashions the mindscreen into a tool of analysis. Without treading on the ineffable, Juliette insists, "It can't be expressed in words, but my face must mean something" —further justifying the value of a thought-medium that can deal with the physical and the visual, not simply with the verbal. Visual scrutiny and juxtaposition are ways of thinking.

176

The problematic nature of these signs proceeds from more than their variety. To Juliette, for example, words have their blind-spots. "My sweater is blue. I can see it's blue," she says, looking meanwhile at a red dress in a store, "but what if they called blue 'green' by mistake? That would be serious." At another point she says, "Words never say what I want them to—they're OK, but they won't behave. I wait. I watch." She supplements her verbal language with the visual, in order to make sense of herself and her world; but a visual language can be problematic too. Early in the afternoon Juliette, sitting at a table in a bar and hoping to attract a man, looks at a magazine. A girlfriend sits to one side, so that the two women's lines of sight are perpendicular to each other. (Further away sits a nervous man, staring into the metaphysical coffee cup.) The narrator whispers: "This is how Juliette, at 3:37 p.m., looked at the turning pages of an object known as a magazine. And this"—cutting from the magazine seen sideways to the magazine seen head-on—"is how, some 150 frames later, her friend saw the same image. Which is the truth, the full face or the profile? And what's an object, anyway?"[12] Besides raising the questions of whether the two views of the magazine are variations of one sign or two different signs, whether if they are two views one is more "true," and whether this object is more clearly apprehended as a visual sign or in the term "magazine," Godard throws overboard the whole notion of noncinematic time by insisting that in a movie, six seconds are not six seconds but 150 frames. In this case, as a matter of fact, the phrase "six seconds" would be inaccurate, since the two women are seeing the same image at the same time, but the audience observes the friend's view 150 frames after it begins to watch Juliette's view. Another way of putting this is to say that the film announces the distance, along its own length, between the full face and the profile—measuring the projection time between its deliberate manifestations of the two views. Within a film, this is the only method of measuring

time that makes any sense. "150 frames" is a particularly startling alienation effect, but one that is consistent with the tendency of self-conscious cinema to keep a finger on its own pulse.

One of the most problematic signs in this film is Juliette herself—not just because her face explains itself visually, but because she is both a character and an actress. Her physical presence is a double sign. Although this is true of any actor in a fiction, attention is explicitly called to it in her first scene—a scene that declares the film's self-consciousness in a way the film's first-person title, or even Godard's whispers, have not yet done. The actress is shown in close-up on the balcony outside "her" apartment. Godard whispers, "This woman is Marina Vlady. She is an actress. She's wearing a midnight-blue sweater with two yellow stripes. She is of Russian descent, and her hair is dark chestnut or light brown, I'm not sure which." Then the actress speaks as an actress, quoting Brecht, and when she has finished, there is a cut and Godard continues, "This woman is Juliette Janson. She lives here. She is wearing a midnight-blue sweater with two yellow stripes. Her hair is dark chestnut or else light brown, I'm not sure which. She is not of Russian descent."[13] Then the woman speaks as Juliette: "Two years ago in Martinique, just like a Simenon novel—no, I don't know which one—yes I do, it was *Banana Tourists*—I have to manage somehow—I believe Robert earns $220 a month"—alluding to her decision to prostitute herself, and responding to the questions of an offscreen interviewer whom the audience does not hear, and who is not necessarily Godard. The point is that what one sees, apart from a slight change of camera angle, is a double sign: Juliette Janson/Marina Vlady. As a result of this sequence, one is not allowed to interpret the sign "Juliette Janson" as "Marina Vlady impersonating Juliette Janson"; the image on the screen is one or the other, one and the other, but not one *in* the other. It is

with this paradoxical reservation that the image of this woman is able to become both: a self-conscious sign.

As a mindscreen, the image field of *Two or Three Things* is multivalent. It is the landscape of Godard's mentation, and of his eye, but also of Juliette's. In the first case, Godard is able to use the image to illustrate a thought of which he is both originator and spectator. During the car-wash sequence he says, "Yet language *per se* cannot precisely determine an image. For example:"—and there is a silent shot of Juliette and her friend Marianne getting out of the car, followed by other examples of images. "Are these the right images," he wonders, "are they the only ones?" And later: "Why all these signs? They make me doubt language—overwhelm me with meanings." The images have been offered not so much as events that have happened at a convenient point in Godard's meditation (since several of them repeat, and are thus clearly not happening in chronological sequence), but as dramatizations of his thoughts.

In the second case, there appears to be a story going on, in a landscape that includes the observer, whether that observer is termed "camera" or "audience" or "Godard." On many occasions, the characters address the camera directly, often revealing themselves completely. They appear to be answering the questions of an interviewer whom they are facing, so that the image field becomes the eye of the observer (the camera, the narrating mind). A young woman in a beauty shop, for example, says, "Movies? Two or three a month, but not in the summer"—responding to the (unheard) question, "Do you go to the movies?" (The film is set in August 1966.) She concludes poignantly, "When François and I get married, what else have I done? —Oh, a lot of banal things." Since the audience never hears these questions, as if they were asked by the camera eye itself, these sequences can almost be considered soliloquys, in which the characters attempt to relate themselves to the complex in which they live, if not to the inquiring eye of

179

the self-conscious complex in which they are finding expression.

In the third case, the image field is answerable to the meditations of Juliette in a way that clarifies the image's ability to "narrate itself," and points out Juliette's role as a center of consciousness. After saying how "words are OK, but they won't behave"—that she thinks in terms of and perhaps *by means of* the world she can see, Juliette continues: "I wait. I watch. My hair, the telephone," as the telephone rings. It is a demonstration, of which Juliette, as namer, is in partial control, of the act of paying attention to a telephone. She does more than comment on a system that includes her, however; that system and she are interdependent. In other words, she is at least a partial narrator of the story, one organizer of the image in which she participates. "I was my world and my world was me" addresses the entire Structuralist project, but also helps clarify the structure of narrative here.

To take another example: While pondering the nature of her own image in lamplight and in darkness, watching Marianne and their customer (an American photographer) have sex (and after Godard has compared the women— walking back and forth with flight bags over their heads— to crates being moved back and forth by the cranes that are helping construct more of this "new Paris"), Juliette says: "For example, I say I'm meeting Robert at the Elysée Café. And now I try to think without words." At that point the image cuts to a table at which Robert, her husband, sits waiting for her; voice-over, Juliette concludes her sentence: "Not out loud and not under my breath." This scene, which is worth analyzing in some detail, may be the visualization of her wordless thoughts concerning the place where Robert waits for her. On the other hand, nothing *in* the image suggests that the scene is in any way a fantasy, and it perfectly conforms with the "real" plot. The two essential points are these: first, the voice of Godard is absent from the café scene, so that one is not prompted to identify

it as *his* meditation; and second, because the café scene is exactly like most of the other scenes in the film, complete with probing camera and realistic sets, and does not contain any indication that it might be a fantasy, it is possible to consider all of the scenes in the film to be equally as mental, or as narrated, as this one. The problem thus becomes to establish the narrator, and the simplest answer appears to be: a sign system in the process of self-definition, whose repertory includes Juliette, Paris, and the voice of Godard.[14]

The café scene is a small masterpiece of comic persistence. It has four main elements: a woman playing pinball, Robert making notes and talking to a woman at the next table while waiting for Juliette, a Nobel Prize winner talking with a young girl, and two men writing a "found" poem while ordering a meal. The pinball is never quiet; the camera moves among the other three events, going from table to table for fourteen minutes, until a stymie point is reached. Robert's attempt to engage the woman near him in a discussion of sex and language is in tone with the rest of the film; their talk is entertaining, but it is the pinball behind Robert, the endless pile of coins, the shoving and the bells that hold one's attention like an endless, hilarious torture. Ivanov, the prizewinner, has his guard up; he autographs the girl's copy of his book, becomes patronizing when he finds she has not read it, makes some impenetrable remarks about communism from behind his pipe, and rejects her personal confidences. In the process she becomes disenchanted with him. ("I thought you would be more courageous."[15])

But the highpoint of the scene, apart from the woman and her "dialogue" with the pinball machine, is the poets' table, piled high with every sort of book. One man (Bouvard) reaches for a book, opens it and reads at random—a phone number, part of a poem or novel, an advertisement —and the other man (Pécuchet) writes it down. This chaotic, encyclopedic, clerkish poem, this collage of the

181

culture, is characterized by its acceptance of spontaneity, and doubtless by the search for some principle of unity, a mystery at the heart of the composition that will be the more unfailingly received, the more randomly they proceed. In any case their neostructuralist undertaking is characterized by surprise: each new line should surprise them, enlivening the disjunction of its context with an unpremeditated freshness. The poets are not above including reality in their poem, or perhaps the transcriber cannot help himself. The waiter takes their orders for dinner, and this conversation is apparently written into the text. The waiter asks what the writer will have for dessert; he orders a "mystère." (A mystère, which can translate as "a surprise," is an ice-cream dessert.) The waiter replies, and the writer writes, "There is no mystère"—and the poem is stymied. Bouvard continues to read ("Thought is linked to the coming of Being,") but Pécuchet is trapped in the crossfire of these words and the waiter's. Is there no surprise, no mystery? The relentless examination of signs, of surfaces and words and café behavior, in the poem and in the scene, has suddenly commented on itself. The writer looks up and stares into the camera for a very long time, looking beaten, enlightened, and sick.

Home at last, Juliette steps onto her balcony and meditates on her day. Soon, the camera will interview her husband and son: the husband will answer its questions, looking interrupted; the boy will shoot his plastic automatic rifle at it, twice. In this sequence, however, Juliette consolidates her position as the lyrical, meditative center of the film, and building on an insight she had had earlier in the day, she begins to consider her "connection with the world." "A landscape [*paysage*] is like a face [*visage*]," she had said, articulating the film's central insight. Now she elaborates: "I was my world, and my world was me. It would take volumes to explain." As the camera executes a 360° pan from her face, across the walls of the housing complex that is so integral to her needs and decisions, and back to her face, she

continues: "I'd like to say [about her face] 'she looks like Chekhov's Natasha, or Nanook of the North's sister.' It can't be put into words, but my face must mean something. As if I could say, 'I saw a particular face,' and then —and then—" It is not just contrivance that Juliette and Godard have been thinking, throughout the film, of the same problem: the relationship between Juliette and her world, between "her" and "la région parisienne." Nor is it coincidence that her words sound at first as if they were Godard's meditation on Juliette—nor that Raoul Coutard's brilliant wide-screen camera carries out both their investigations appropriately, by searching the visual signs of face and building for the meaning of her experience. Juliette has been as concerned with analyzing the film's economic, semiotic, and moral complex as has Godard; she has been as instrumental as his whispers in asserting the self-consciousness of the mindscreen. The essential quest of this film has been for the relation between signs and meaning— in particular, the relation that yields truth. Juliette is the *visage* and Paris is the *paysage*, but in a more immediate sense the mindscreen is both.

It is both, because it presents the world and its perception as one, because it is the mirror in which the seer is seen. The central theme of Godard's films is the interaction of consciousness and the world—more specifically, of their respective and finally inseparable languages. This interplay, or dialectic, is at the heart of any mindscreen, which presents the world as it is seen by an offscreen mind. The mindscreen field is both thought-about and thought-generated, and suggests itself not only as a useful first-person mode, but as the basis of an intriguing and edifying genre.

11. *Providence* (courtesy of Cinemà 5): Langham, alone in his room as the sun comes up, contemplates fiction, death, birthdays, and probably us.

Conclusion

The inside real
and the outsidereal.
—Ed Dorn,
Gunslinger

Alma sits across the table from Elisabeth. "I, me, we, us," she grapples; "many words and then nausea." Juliette washes dishes in her kitchen and is interviewed by the camera (fig. 10). "I, me, myself, everyone. . . . One often tries to understand, to define the meaning of a word, but it's too confusing. One must acknowledge that it's much easier to look upon such and such a thing as self-evident." Alma's breakdown occurs at "that point inside the movement of the film itself where words can no longer have any meaning"; Juliette's meditation occurs at that point inside the movement of her film where it begins to become essential that words *have* meaning, even if that meaning is new or out of reach. *Persona* and *Two or Three Things* themselves occur at that point in film history where the language of words seems incomplete or problematic, where the language of images feels the need to understand itself, where film begins to speak: "I, me, us, you." Within each of these films, a strong consciousness tries to find the words to express her isolation and her connectedness, her being-in-the-world, her being-in-the-mind; she tries out the pronouns, beginning with "I." The same is true of the films, which are in search of a language and a way of understanding that language, so that they can more fully be what they are: worlds transformed into discourse, under-

standing the laws of that discourse enough to speak in their own voices and not simply be spoken. The breakdown of one language is the birth of another; to film at "degree zero" is to find a place from which to start, not to huddle at a dead end. It is a way to become, in a new language-epoch, one's own historian.

Both the content of that history and its structure vary with who one is and with what analytic method one adopts. In Resnais's *Muriel*, for instance, Bernard Aughain attempts to document the ways in which his current life in Boulogne—and Boulogne itself, as a system or complex—corresponds to his recent life as a soldier in Algeria. He does this by making films and tapes: photographing a tree stump that looks like a city, noting those aspects of his stepmother's lover's behavior which suggest the way that man might have acted in Algeria, etc. "I watch," he says; "I'm not making cinema, I'm gathering evidence."[1] Bernard studies correspondences until the political, psychological, and ethical structure in which he lives becomes clear to him, and at that point he throws away his camera and takes action. Resnais, however, does not throw away his own camera, and continues to explore the Boulogne complex—but without suggesting that *Muriel* or himself or any intermediate narrator is involved in this quest the way Bernard is. *Muriel* is the story of a youth who probes with his camera and of a woman (Hélène) who examines her memories, and on the systemic level *Muriel* carries out a parallel of their investigations; but *Muriel* does not investigate itself or its own processes. It is, finally, a *story* about systems theory and an illustration of the ways in which ethics, emotion, architecture, time, capitalism, fascism, and documentation can interrelate. *Two or Three Things* builds, as Godard has said, on the accomplishments of *Muriel* (a poster for which is hung above Robert's short-wave set, the basic tool in his own efforts at political documentation); the difference between the two films grows out of Godard's decision to scrutinize language theory along

186

with the other elements of the city-complex, and to make his film systemically self-conscious, so that it could analyze itself along with everything else. What Bernard does within the fiction of *Muriel* (a third-person film) is done by the entire complex of *Two or Three Things* in its own first person. This is not meant to imply that Godard's film is better than Resnais's—in fact, I doubt that there are many films better than *Muriel*—but only that Godard's effort is more all-embracing, so that its autohistoric process engages the audience on a different level.

Even when a film is not systemically self-conscious, however, it can be full of mindscreens whose presence and arrangement can prompt the viewer to consider the problems of self-knowledge, self-definition, and self-deception (all of which are aspects of the problem of being-within-limits). This is the case in Resnais's most recent film, *Providence* (1977), most of which shows Clive Langham, an old, sick, alcoholic writer (played by John Gielgud) amusing himself during the course of a long, restless night by composing a novel in mindscreen (fig. 11). At the end of the film we discover that the characters of his fiction are based on his two sons and daughter-in-law, and that the real figures differ substantially from Langham's versions of them. The prototype so far is *The Wizard of Oz* (with the differences that Dorothy does not comment on her fiction as she dreams it and that she is not so wrong about the people she lives with), with a strong dose of *Citizen Kane* (the slow track through the grounds of the estate, the isolated power-figure, the relativism of fact). But near the end of the film Resnais calls attention to another level of the system. Langham and his family are having lunch outside; the camera pans 360°, revealing the beautiful daylight landscape of the estate named "Providence," and suggesting clearly that God is to his world as Langham is to his novel—that the creative mind is not necessarily hostile, dense, and self-protective, but that it *is* isolated—and isolated primarily because it is alone at its own systemic

187

level, somehow outside the world it dreams or makes. There is a level above Langham's, but it is not that of self-conscious film; it is that of the creator of the world Langham lives in. In terms of the fiction, that creator is God; in reality, of course, it is Resnais, but the film does not go out of its way to make us think in those terms. Langham, then, is an interface: one element of a system larger than he (an inhabitant of the world) and the controller of another system smaller than he (the writer of his own novel). The system he creates (the mindscreens) and the system he is within (the world) look basically the same; both have been created, and both (by the time we see them) are on film; both, then, are worlds-as-discourse. It is up to the self-conscious audience to make the next leap and see God as an element in the fiction; the element "above" God is that of the thought-generated film, *Providence*—a title that emphasizes the inextricability of creation and the creative intent. Until one makes this leap *Providence* is, like *The Wizard of Oz*, a systemically third-person film populated largely by mindscreens; but its title suggests—like that of *Shame*—a latent, offscreen, systemic self-awareness.

Of course a challenging structure, even an autohistoric one, is not enough to guarantee that a film will be interesting and successful. It helps to have the right subject, to care about it, and to be able to find the best images. Orson Welles's *F for Fake* (1977) and Bergman's *Face to Face* (1976) are both disappointing films, even if the former is rigorously self-conscious and the latter dynamically intercuts mindscreen and point of view. In each case the filmmaker strikes me as being insincere about his material, or perhaps just out of touch with it, with the result that each presents blatantly silly visualizations. Both these films are put to shame by Woody Allen's *Annie Hall* (1977), for instance—not because Allen uses virtually every trick in the book of mindscreen and self-consciousness (both authorial and systemic), but because those devices are called for by the very process at the heart of that film—Alvy Singer's

188

attempt to understand his love for Annie Hall ("I keep sifting the pieces of the relationship through my mind")— and because Allen cares enough about that process and his characters to let us care along with him, with the result that Alvy's mindscreen and Allen's theater screen stay in sync. The audience thinks along with Alvy and Allen, and comes to understand the emotional and structural process that motivates each associational cut, each shift of attention. I am speaking here not so much about the issue of audience comprehension—all three of these films are easy to understand, while Godard's *Numéro Deux* (1975), for example, is fairly difficult—but about that of authorial integrity (i.e., trusting the artist even when he's lying). The self-conscious mindscreen may be an intriguing device—and by calling attention to it in this book I hope to make more filmmakers aware of its possibilities, so that the mode can develop further, build up its own history, and advance the self-consciousness of its audience—but it is only a device, as the close-up is only a device. The gap between *F for Fake* and *Citizen Kane* is as great as that between *Face to Face* and *Persona*; we do better with *Annie Hall* and *Providence*. I have digressed into the category of the bad film to make a simple point: it is vital to build on an understanding of the mode, but the mode is not everything. In that light let us turn again to the master of mode-analysis, Christian Metz.

In his analysis of Jean Mitry's *Esthétique et psychologie du cinéma, Vol. II*, "Current Problems of Film Theory,"[2] Metz endorses Mitry's classification of subjective images into five categories. These are, to quote Metz:

The purely mental image (more or less impracticable in the cinema); the truly subjective or analytical image (i.e., what is looked at without the person looking), which is practicable in small doses; the semi-subjective or associational image (i.e., the person looking plus what is looked at, which is in fact looked at from

the viewpoint of the character looking)—the most gen-
eralizable formula; the complete sequence given over
to the imaginary, which does not raise special prob-
lems; and finally the memory image, which is in prin-
ciple simply a variety of the mental image but, when
presented in the form of a flashback with commentary,
allows for a specific filmic treatment which is far more
successful than in the case of other mental images.[3]

Before addressing the implications of Metz's value judg-
ments, I would like to recap my own subjective-image-
classification system:

1. Subjective camera (share my eyes). [Metz: "the truly
 subjective or analytical image"; example: *Lady in
 the Lake.*]
2. Point of view (share my perspective, my emphases).
 [Metz: "the semi-subjective or associational image";
 example: *The 400 Blows.*]
3. Mindscreen (share my mind's eye). [Metz: "the purely
 mental image," "the imaginary," and "the memory
 image"; example: *The Wizard of Oz.*]
4. Self-consciousness (share my reflexive perspective). [Ex-
 ample: *Persona.*]

Other first-person modes include subjective sound (share
my ears) and voice-over (listen to my words). All of these
modes depend on the audience's awareness that there is
some kind of offscreen narrator, presenter, colorist, or or-
ganizer who may be invisible in the particular image and
who may be a character (Dorothy), the-artist-as-an-aspect-of-
his-work (Brakhage, Godard), or an incorporeal and fic-
titious aspect of the system, *its* self (*Persona*). All are in-
stances of the world's being transformed into discourse,
and all are distinguishable from third-person modes on the
grounds not of how they look but of whose images they are.

 Metz's overview of "the mental image" bears quoting at
length:

190

Firstly, those intended to materialise a purely *mental* image: what a character imagines, dreams, the things he envisages in a state of fear, terror, desire, hope, etc.; in short, what he does not *see*. Jean Mitry, who in this respect aligns himself with the view most generally held by film theoreticians, observes that the cinema is not very suited to give a satisfactory translation of these purely "internal" views. The shots which make up the film can only render the visible, and they are helpless in the face of what no one has ever seen. The image which aims at being subjective—at least in this sense—is always experienced by the spectator as objective in the same way as its neighboring images and because of this it disturbs rather more than it enlightens. For as a view of the real it has no satisfactory meaning in relation to the rest of the film. The cinema is thus too "real" to translate effectively the imaginary views of its characters. Besides, "views" of this kind are by definition difficult to know in detail, and film makers who undertake to "render" them fall consciously into the arbitrary and gratuitous. (One has only to remember all those highly improbable "dream sequences!") Even if the *content* of the "vision" were knowable and adhered to, Mitry says, its objectification by the filmic image would nonetheless constitute an irrevocable "betrayal" since it would divest the imaginary objects—transformed into objects of perception—of that coefficient of felt-absence which is precisely what gives them their whole psychological specificity. For Mitry therefore, the project to *objectify the subjective* faces insurmountable problems and in this respect he clearly distinguishes himself from Béla Balázs and the majority of the "avant-gardists" of the twenties.[4]

This strikes me as an unnecessarily limited construct of the possibilities of good filmmaking. In the first place,

191

Balázs's notion that one can film "not the soul in the face but the face of the soul"[5] is a valuable one. One has only to remember all those highly stimulating and beautiful subjective transformations of the world: those of Vincente Minnelli, for instance, or Resnais. The trick is to *establish* "the meaning in relation to the rest of the film" of the mental image, which is largely a question of clarifying the relation between specific shots—usually through cross-cutting and repetition, as in the finger-twitch sequence from *Hiroshima, mon amour*. It is a question of making clear that this shot is first person, this shot is third person. Both third- and first-person shots present the world as discourse, not simply the world as something that can have been photographed. Both third- and first-person shots are equally "real," equally dependent on the audience's understanding the logic of their presentation. Both are equally mental phenomena, presented as such and understood as such. This is the gist of what I meant in the first sentence of this book, when I said that film is a dream. Of course not all films are of dreams, not all films behave like dreams, not all films are meant to be absorbed as dreams—but all films are *mentally presentational*, regardless of whether they "redeem physical reality." The mind reaches out to film and finds its own landscape, a version of its own process. Film can speak to the mind in the first person as well as the third, and no critical memory of an improbable dream sequence can mandate against the possibility of the mode's success.

Furthermore it is true that the mind's eye does see, that it speaks to itself in images, however colored they may be by nonverbal or even nonvisual emotion. (It is one mark of a competent director that he is able to infuse an image with emotional and intellectual content.) They may be " 'internal' views," but they *are views*. It is exactly to the point that the audience experiences the mindscreen "as objective in the same way as its neighboring images," because the mental universe—the discursive universe, the

world as film—is coherent, however intricate and diverse may be its elements. It all goes together. The amalgam of "felt-absence" applies to most mental events, and especially to the perception of any sign; the signifier is present, the signified absent (i.e., in need of being brought to mind), even if the sign is the word *word* (one still goes through the process). To put this another way: the third-person shot "betrays" the signified in the same way the first-person shot does; it is naive to argue that film is objective. To a great extent, the act of filming *subjectifies the objective*, takes it out of the physical and into the dark of the theater. One is always looking at the frame as well as through it, and can be expected to integrate that semiotic and formal distance into one's response. The exciting thing about self-conscious film in particular is that the work forthrightly incorporates an awareness of that distance into its own presentational structure, so that one has less suspending of disbelief to do and can deal with the film as a film rather than pretend it is something else. Like a person, art must be about itself before it can be about the rest of the world; it must reach from an articulate base; it must, on some level, say "I," which is one mark of systemic integrity.

First person, then, is not limited to narrative films, even if those are the easiest to discuss in these terms. The later films of Stan Brakhage, for instance, are (to quote him) "first person singular in a very clear way,"[6] not just because they are often about his personal life but because they remind the viewer that they are presenting what Brakhage sees with his own eyes. The documentaries of Marcel Ophuls (*The Memory of Justice* [1976]) are first person in just this sense, and those of Peter Watkins (*Edvard Munch* [1976]) employ both self-consciousness and mindscreen to deepen their impact. The key is the notion of the offscreen presenter to whom attention is called by the work; there is no need for that presenter to be fictitious.

The majority of mindscreen films have presented the world-views of isolates—characters who retreat from the

193

world to their own mental landscapes: Buster after his girlfriend has rejected him, Dorothy after a bump on the head and a fruitless attempt to get someone to help her save Toto, the inmate of Caligari's sanitarium. This is surely a reflection of commercial attitudes toward romanticism and madness rather than an inherent limitation of mindscreen. The self can say almost anything in private. Still, there *is* a principle of isolation at work: one is in a theater as one is in one's own head. Mindscreen often, therefore, is useful to stimulate the process of self-consciousness, at the heart of which is the possibility of community, self-acceptance, joy. There is in self-consciousness an implicit act of responsibility, one that can be turned to in moments of political self-doubt or artistic isolation (*Two or Three Things I Wish I Knew How to Know*), and it is because this acknowledgment lets us more fully *be* what we are and see our operative limits that we stand some chance of perceiving the system whole. It is a question of having to know the system to see past it, of moving from the isolated Langham to the hair-raising Bunny, from Bergman's nightmare to Godard's struggle. *The Memory of Justice* builds as much on the self-conscious freedom of *The Man with a Movie Camera* as it does on the implications of the Nuremberg trials. It is on this awareness of self that first-person cinema draws, and there are no rules about the kind of self that is.

NOTES

1

1. Lewis Jacobs, *The Rise of the American Film: A Critical History*, p. 38.

2. This last is Bergman's own interpretation of the opening sequence of *Persona*. See chap. 7.

3. Dialogue, then, is theatrical.

4. Christian Metz, *Film Language: A Semiotics of the Cinema*, trans. Michael Taylor, p. 21.

5. Ibid., p. 20.

6. Ibid., p. 105. This is true of documentary, experimental, and "narrative" film.

7. In addition, one could perhaps make a case for propaganda films as being in the second person, in that they tell the audience ("you") what to think and do. It is also worth noting that there are two categories of self-consciousness: authorial and systemic. See pp. 112-116.

2

1. *Film as Film: Understanding and Judging Movies*, p. 124. Cf. Raymond Spottiswoode, in *A Grammar of the Film*, p. 132: "The camera is the eye of the director."

2. For a related discussion of the title, see Joseph McBride, *Orson Welles*, p. 45.

3. Quoted from the RKO Cutting Continuity of *Citizen Kane*, in Pauline Kael, Herman J. Mankiewicz, and Orson Welles, *The Citizen Kane Book*, pp. 356-359.

4. Ibid., p. 355. Compare Leland on the campaign "promises."

5. Ibid., p. 361.

6. Ibid., p. 387.

7. Ibid., pp. 369-370.

8. Ibid., p. 395. It should be remembered that Kane did not expect to *have* to build an opera house to give Susan a place to sing. He built it when he found that no one would book her—that he had to erect a world he could control.

9. In Leland's story, Kane had been hooked on the music question because of its association with mothers, as noted above. It is interesting that Susan leaves this aspect of their relationship (and its implications for her career) out of her own version. "You know how mothers are" is for Kane and Leland a significant line, but for Susan—apparently—just something to say and forget.

10. Jorge Luis Borges, "Citizen Kane," *Sur* 83 (1945); reprinted in Ronald Gottesman, *Focus on Citizen Kane*, pp. 127-128.

11. Welles, "*Citizen Kane* is Not about Louella Parsons' Boss," *Friday* 2 (1941); reprinted in *Focus on Citizen Kane*, pp. 67-68.

12. For a discussion of these plans, see McBride, pp. 12, 30; and Charles Higham, *The Films of Orson Welles*, pp. 9-10.

3

1. *Writings and Drawings by Bob Dylan*, p. 43.

2. Siegfried Kracauer, *From Caligari to Hitler: A Psychological History of the German Film*, pp. 63-71; and Lotte Eisner, *The Haunted Screen: Expressionism in the German Cinema and the Influence of Max Reinhardt*, trans. Roger Greaves, pp. 17-20.

3. Kracauer, *From Caligari to Hitler*, p. 69.

4. Frank McConnell, *The Spoken Seen: Film and the Romantic Imagination*, p. 31.

5. Lionel Abel, *Metatheatre: A New View of Dramatic Form*, pp. 40-58.

6. See Robert Alter, *Partial Magic: The Novel as a Self-Conscious Genre*.

7. Marsha Kinder and Beverle Houston, *Close-Up: A*

Critical Perspective on Film, p. 366 (for an extended reading of *Performance*, see pp. 359-376).

8. Wittgenstein, *Tractatus Logico-Philosophicus*, trans. D. F. Pears and B. F. McGuinness, p. 115.

9. Ibid., p. 151.

10. Ibid., p. 117.

11. For a discussion of this aspect of Keaton's imagination (which Rudi Blesh ultimately attributes to Keaton's infant confrontation with a cyclone), see McConnell's analysis of Cartesian space in film: *The Spoken Seen*, pp. 44-87.

12. In David Robinson's enjoyable rendering of this sequence, the dynamited log "[parts] like the Red Sea"; the metaphor is highly appropriate. David Robinson, *Buster Keaton*, p. 104.

<div align="center">4</div>

1. Metz, *Film Language*, p. 115.

2. The New York Times, p. 238.

3. The same "obtuseness" is evident in the Duke's lines, from which Jacques takes his cue, although the Duke's puns verge on Bugs's variety of self-consciousness:

> Thou seest we are not all alone unhappy.
> This wide and universal theatre
> Presents more woeful pageants than the scene
> Wherein we play in (II, vii, 136-139).

4. Sarris, "Why Do We Expect Movies to Make Sense?," *The Village Voice*, 15 March 1976, p. 147.

5. Poole, *Towards Deep Subjectivity*, pp. 6-7.

6. This scene, which was singled out (by those critics who could find nothing else to praise) as the film's comic highpoint—and from which fig. 4 is taken—has always struck me as tasteless and exploitative. It is comparable, I feel, to the card-playing scene in *Cheyenne Autumn* (1964), in that it suggests the director's lack of faith in the interest of his central subject, and his consequent decision to give the pre-

sumably hostile audience a few moments of "good old-fashioned entertainment."

7. The sexist convention of keeping men in underpants and women nude during sex-play scenes (which reaches its anticlimax in *Last Tango in Paris* [1972]) is here used to signify Joe's refusal to commit himself or to unmask.

8. On his TV show, however, he taunted his audience for watching, mocking our dread-and-encouragement of the criminal, and our boob-tube passivity, along with the "necessary Evil" of his advertisers.

5

1. Perkins, *Film as Film*, p. 133.

2. See Bruce Kawin, *Telling It Again and Again: Repetition in Literature and Film*, chap. 4.

3. See Alain Robbe-Grillet, *For a New Novel*, trans. Richard Howard, pp. 138-139 and 152-154.

4. Resnais's first feature, *Hiroshima, mon amour*, although it experiments with several of the first-person devices employed in *Marienbad*, maintains a lyrical balance between its objective and subjective worlds, and so remains coherent. His masterpiece, *Muriel, ou le temps d'un retour* (1963), adopts an approach opposite to *Marienbad*'s, restricting itself to the objective world and cutting only forward in time (with the exception of a montage of the streets of Boulogne, early in the film, that includes day shots in the middle of a nighttime conversation). By photographing only the present (as opposed to the subjective, continuous present), *Muriel* paradoxically achieves an intense dramatization of the influence of the past on its characters; by portraying only the outer world, it suggests the inner. In the same way, the world that *Marienbad* refuses to show (in this case, the strictly outer one) dialectically suggests itself in terms of the world that *is* shown. Considered together, these three films are among the greatest experiments in film narration, comparable to Griffith's successive develop-

ment of the film epic (*Birth of a Nation* [1915]), treatise (*Intolerance* [1916]), and lyric drama (*Broken Blossoms* [1919]).

5. Harry Geduld, *Film Makers on Film Making*, p. 158.

6. Ibid., p. 166.

7. *Tractatus*, pp. 49-53.

6

1. Münsterberg, *The Film: A Psychological Study*, p. 74.

2. Simon, *Ingmar Bergman Directs*, p. 43.

3. Wood, *Ingmar Bergman*, pp. 172-174.

4. Ibid., p. 174.

5. See Siegfried Kracauer, *Theory of Film: The Redemption of Physical Reality*.

6. Stig Björkman, Torsten Manns, and Jonas Sima, *Bergman on Bergman*, trans. Paul Britten Austin, p. 79.

7. Looked at in this light, *Cries and Whispers* appears to be one of Bergman's key works. Like the first films, it deals in an anthology format with the fulfillments and frustrations of several women; like the second group, it is an intimate and symbolic period piece; like the third it involves a searing investigation of the problems of faith and isolation; like the fourth it merges its characters' objective and subjective worlds in a complex first-person format that is as painful in its intimacy and "realistic" in its style as it is hallucinatory; and with those of the fifth period, to which it chronologically belongs, it is stylistically influenced by television (a drama of close-ups) and interested more in emotional conflicts than in intellectual issues.

8. According to Bergman, the latter was not intended to be a symbolic castration scene; see Charles Samuels, *Encountering Directors*, p. 200.

9. Bergman considers the ending, in which the boy reads his aunt's note in the foreign language, clearly positive—the only hope. Björkman et al., *Bergman on Bergman*, p. 185.

10. Bergman agrees with Samuels's insight that this priest

could be considered the son from *Through a Glass Darkly* grown up, who realizes that he has again lost touch with his "Father." Samuels, *Encountering Directors*, p. 185.

11. Björkman et al., *Bergman on Bergman*, p. 168.

12. In retrospect, then, *The Touch* and *Scenes from a Marriage* appear to belong to a fifth, domestic period, characterized by its lack of interest in both mindscreen and self-consciousness. *Cries and Whispers* looks back to his earlier work, and *The Magic Flute* (1975) reflects his growing interest in television. In this latter respect, his development continues to be comparable (at least in part) to that of Godard, who has concentrated much of his recent energies on TV production (*Le Gai savoir* [1968], *A bout de souffle numéro deux* [1975]). It should also be noted that it is during this anti-intellectual period that he has given most of his interviews. *Face to Face* (1976) marks a return to mindscreen psychology, but fails to achieve the resonance of his fourth period.

7

1. Sontag, "Bergman's *Persona*," in *Styles of Radical Will*, p. 139.

2. Samuels, *Encountering Directors*, p. 183.

3. My analysis of *Persona*, then, is not grounded on what Bergman was thinking about when he made the film. I am more interested in what the finished film, as it stands, suggests to me. Bergman states flatly, for instance, that he was through talking about God when he made this film (Simon, *Ingmar Bergman Directs*, p. 28); I think *Persona* includes an eloquent treatment of the relations between God and man. (Arthur Gibson too has argued that *Persona* extends the religious arguments of *The Silence*, etc. See his book, *The Silence of God*, pp. 135-153.) The opening sequence of *Persona*, which strikes me as having great thematic relevance to the rest of the film, was to Bergman simply an auto-

biographical poem about the difficulty of concentrating on his work—and so on.

4. The film's original title was *Kinematography*.

5. Samuels, *Encountering Directors*, p. 186. In his interview with Simon, Bergman puts it slightly differently: "I felt like that little boy. I was lying there, half dead, and suddenly I started to think of two faces, two intermingled faces, and that was the beginning, the place where it started." (Simon, *Ingmar Bergman Directs*, p. 39.) Another possible starting place is Dreyer's *Gertrud* (1964), in which Herr Kanning says to his wife, "You're silent because you don't want to lie."

6. Samuels, *Encountering Directors*, pp. 186-187.

7. Simon, *Ingmar Bergman Directs*, p. 30.

8. Bergman, *Bergman: Persona and Shame*, trans. Keith Bradfield, p. 101.

9. The following analysis is based on the U.S. prints of the film, in which this sequence has been partially censored.

10. Björkman et al., *Bergman on Bergman*, pp. 198-199.

11. Ibid., pp. 9-10.

12. (Compare the opening of Beckett's *The Unnamable*.) If one is not prepared to go beyond the-boy-as-Bergman, and refuses to consider him an element of the image, or a character, one greatly impoverishes much of Bergman's other work as well, which often begins as autobiography but goes on to create fictions (*Wild Strawberries*, for example, or *Hour of the Wolf*). Other connections between *Persona* and *The Silence* are discussed by Sontag: *Styles of Radical Will*, pp. 124, 132.

13. *Partial Magic: The Novel as a Self-Conscious Genre*, pp. x-xi.

14. Ervin Laszlo, *The Systems View of the World*, pp. 22-23.

15. Ibid., p. 91.

16. The boy's resurrection from the dead when he is summoned by the face (or the phone) could be interpreted as Bergman's feeling, upon beginning this film, that he was not dead as an artist, but would overcome his illness.

17. The screenplay makes the point even clearer: "Where did it break? Where did you fail? Was it the role of mother that finally did it? It certainly wasn't your role as Electra. That gave you a rest." (Bergman, *Bergman: Persona and Shame*, p. 41.)

18. See *Ingmar Bergman Directs*, pp. 208-310, for Simon's challenging and perceptive essay and for an extremely useful visual analysis of many frames from the film. The pioneering essay, however, is Sontag's: *Styles of Radical Will*, pp. 123-145.

19. Wood, *Ingmar Bergman*, pp. 143-159. Wood's essay analyses the dream sequences in depth, and has many excellent insights about the psychology of the two women and the self-consciousness of the film.

20. In the screenplay, the last line reads, "The great shout of our faith and doubt against the darkness and silence is the most terrifying evidence of our forlornness, our terrified unexpressed knowledge." (Bergman, *Bergman: Persona and Shame*, p. 47. These and other discrepancies may be the work of the subtitle-writers.)

21. Simon, *Ingmar Bergman Directs*, pp. 293-303; Wood, *Ingmar Bergman*, pp. 151-158.

22. Bergman, *Bergman: Persona and Shame*, pp. 93-94. The original order of the dream sequences was: the encounter with Mr. Vogler; the bloodsucking sequence, in which Elisabeth speaks (in a voice "not hers, nor Alma's") and Alma appears like a corpse; the breakdown; and the scene with the boy's picture, including the "Nothing" dialogue. (It is worth noting that such a meditation as this would appear in the soundtrack of a Godard film, but is reserved as a private working-note by Bergman.)

23. See Kawin, *Telling It Again and Again*, p. 85.

24. As spoken in the film. Compare Bergman, *Bergman: Persona and Shame*, pp. 96-97.

25. Samuels, *Encountering Directors*, p. 189. Also see Sontag, *Styles of Radical Will*, pp. 3-34, 142-145.

26. Simon, *Ingmar Bergman Directs*, p. 290.

27. Ibid., p. 32.

8

1. Sontag, *Styles of Radical Will*, p. 141.
2. *Filmfacts*, 15 January 1969.
3. Bergman, *Bergman: Persona and Shame*, p. 23.
4. Ibid., p. 108.
5. Ibid., pp. 145-146.
6. Ibid., pp. 188-190.
7. McConnell, *The Spoken Seen*, p. 99.
8. Emily Dickinson, *Complete Poems*, ed. Thomas H. Johnson, p. 423 (poem 894). Compare p. 574 (poem 1323).
9. *Tractatus*, p. 149.
10. Fictitious in that the mind is a *persona* of the artist, a caricature of God, or an unspecified, made-up dreamer.

9

1. Martin Walsh, "Godard & Me: Jean-Pierre Gorin Talks," *Take One* 5 (February 1976), 14-17. (Paraphrase of a 1974 interview.)
2. Peter Harcourt, *Six European Directors: Essays on the Meaning of Film Style*, pp. 212-254.
3. "Godard," in Sontag, *Styles of Radical Will*, pp. 147-189.
4. Ibid., pp. 170-171. According to Gorin, what Godard has always been attempting to do is to "make diaries" ("Godard & Me," p. 16).
5. My point here is that one is aware, in Godard's early work, of the artist's ambivalence, personality, etc., just as one is of James Joyce's or John Ford's, but that Godard did not explore self-conscious mindscreen narration until 1966. (The collaboration with Gorin dates from May 1968; Sontag's essay was written in February 1968.) Before *Two or Three Things* the mindscreen may have *been* his, as literally as that of *The Scarlet Empress* is Von Sternberg's, but Godard was not casting himself *within* the narrative fiction (even if some of his personality traits are recognizable in such characters as Pierrot, etc.).

6. In some ways, the coherence of Godard's career is comparable to that of Tolstoy's. Even if Tolstoy denounced *Anna Karenina* as "an abomination," and devoted most of the energies of his later years to educating disciples and writing didactic pamphlets, the philosophic concerns of both phases of his work are similar, proceeding as both do from the artist's intense analysis of his own perceptions.

7. When a *Cahiers* interviewer observed, "There is a good deal of blood in *Pierrot*," Godard answered, "Not blood, red." Tom Milne, *Godard on Godard*, p. 217.

8. In most of Godard's later films, the emphasis is on the meta-language of political cinema; the following examples relate more to the meta-language of cinema in general. But the world itself, once perceived, is so like language, or *a* language, that to investigate cinema, or the structure that frames one, is also to investigate "the world, mon semblable, mon frère."

9. Several critics (Sadoul and Collet included) have identified Cleopatra as the wife of Ulysses and Venus as the wife of Michelangelo. Armes thinks Cleopatra is the mother, while the other three are her children. The impression I get is that Cleopatra is Ulysses' wife, Venus is her daughter, and Michelangelo is Ulysses' younger brother. In any case, the sexual relationship between Venus and Michelangelo is only pubescent.

10. Georges Sadoul, *Dictionary of Films*, trans. Peter Morris, p. 52. (Rossellini collaborated on the screenplay.)

11. Ulysses, the head of the household, sports the cigar and hat of a petty thug; Michelangelo salutes "great artists" in the person of a Rembrandt self-portrait that hangs in a house they are about to blow up, portrait and all.

12. Even though Godard condemns *Potemkin* in *Wind from the East*, Eisenstein's film here appears to be invoked without undue ambivalence. For a different reading of this sequence, see Harcourt, *Six European Directors*, p. 248.

13. Gorin: "All Jean-Luc's films are done for a certain ten minutes in them (like *Weekend*, which was made for the

long traffic jam sequence). . . . And now he's going to be able to make those ten minute films and to link them together. He's more interested in that than in anything else." Walsh, "Godard & Me," p. 16.

14. Kent E. Carroll, "Film and Revolution: Interview with the Dziga-Vertov Group," *Evergreen Review* 14, No. 83; reprinted in Royal S. Brown, *Focus on Godard*; see esp. pp. 57, 61-62.

15. The implications of Godard's camera work in the late 1960s have been analyzed by Brian Henderson in "Towards a Non-Bourgeois Camera Style," *Film Quarterly* 24, pp. 2-14.

16. Walsh, "Godard & Me," p. 15.

17. Harcourt, *Six European Directors*, p. 251.

18. Poole, *Towards Deep Subjectivity*, p. 6.

19. Walsh, "Godard & Me," p. 16.

20. See James Roy MacBean, "*Wind from the East* or Godard and Rocha at the Crossroads," in Godard, *Weekend and Wind from the East*, trans. Fry, Sinclair, and Adkinson, esp. pp. 113-114; and Robin Wood, "Godard and *Weekend*," ibid., esp. pp. 10-11.

10

1. In *Godard: Three Films: A Woman is a Woman, A Married Woman, Two or Three Things I Know About Her*, ed. Alistair Whyte [*Two or Three Things* trans. Marianne Alexander], pp. 154-155.

2. Wittgenstein, *Philosophical Investigations*, 3rd ed., trans G.E.M. Anscombe, p. 216e.

3. Wittgenstein, *Tractatus*, p. 115.

4. Wittgenstein, *Philosophical Investigations*, p. 48e.

5. Rudolf Arnheim, *Visual Thinking*, p. v.

6. Milne, *Godard on Godard*, p. 242.

7. Ibid., p. 239.

8. Ibid., p. 242. This process is, however, clearly at work in the films of Stan Brakhage and other experimental filmmakers. ("La conscience" can mean consciousness.)

9. Ibid., p. 239.

10. Ibid., p. 242. See the poetry of Francis Ponge, which inspired much of this approach.

11. Paraphrase. *Godard: Three Films*, p. 139.

12. Mistranslated on p. 138 of *Godard: Three Films*. For a further analysis, see Poole, *Towards Deep Subjectivity*, p. 114.

13. Quoted from Richard Roud, *Jean-Luc Godard*, 2nd ed., p. 120. See pp. 100-129 for an excellent analysis of this film.

14. I mean to suggest not that the film actually defines itself, but that this is a good description of the narrative persona, which is a fiction.

15. This line may be intended to echo Bernard's asking Robert "What is courage?" during one of the crucial café scenes in *Muriel*. Resnais's scene uses parallel montage to interrelate two encounters in the same café—one between Ernest and Alphonse, and another between Bernard and Robert—encounters in which both Ernest and Bernard manifest their guarded but forceful integrity, and Robert and Alphonse their secretive destructiveness. Although the themes explored in these scenes are not identical, and Godard's montage is essentially slower, they strike me as structurally complementary.

11

1. Compare Juliette's "words never say what I want them to—they're OK, but they won't behave. I wait. I watch. My hair, the telephone."

2. Metz, *Screen* 14 (Spring/Summer 1973), 40-87.

3. Ibid., p. 49.

4. Ibid., p. 46.

5. Béla Balázs, *Theory of the Film*, trans. Edith Bone, p. 179.

6. Letter from Brakhage to Kawin, 10/9/76.

LIST OF WORKS CONSULTED

A. FILMS

Note: This is a list of all the movies mentioned in the text, and beyond that an attempt at a selected filmography of first-person cinema. Most of these films are notable for their use of mindscreen (*The Story of Adele H., The Gold Rush*), or voice-over (*Badlands, The Lady from Shanghai*), or subjective camera (*Olympia, It Came from Outer Space*), for their approach to self-consciousness (*Blow-Up, Sullivan's Travels*), or for their treatment of hypothetical material (*Belle de jour, Dead of Night*); others, like *The Virgin Spring*, appear simply because of their role in the argument. The list is limited by my decision to include only those films I have seen. Movies are listed by director; dates are usually those of first release; alternate translations of titles are separated by a slash.

Allen, Woody. *Annie Hall.* 1977.
Altman, Robert. *Images.* 1972.
———. *Three Women.* 1977.
Anthony, Joseph. *Tomorrow.* 1971.
Antonioni, Michelangelo. *Deserto Rosso (Red Desert).* 1964.
———. *Blow-Up.* 1966.
Apollinaire, Guillaume. *La Bréhatine* (unproduced screenplay). 1917.
Arnold, Jack. *It Came from Outer Space.* 1953.
———. *The Incredible Shrinking Man.* 1957.
Arzner, Dorothy. *Christopher Strong.* 1933.
Bergman, Ingmar. *Musik i mörker (Music in Darkness/ Night Is My Future).* 1947.
———. *Fängelse (Prison/The Devil's Wanton).* 1949.
———. *Sommern med Monika (Summer with Monika/ Monika).* 1952.

Bergman, Ingmar. *Gycklarnas afton* (*The Clown's Evening/Sawdust and Tinsel/The Naked Night*). 1953.

———. *Kvinnodröm* (*Journey into Autumn/Dreams*). 1955.

———. *Sommarnattens Leende* (*Smiles of a Summer Night*). 1955.

———. *Det Sjunde Inseglet* (*The Seventh Seal*). 1956.

———. *Smultronstället* (*Wild Strawberries*). 1957.

———. *Nära livet* (*So Close to Life/Brink of Life*). 1957.

———. *Ansiktet* (*The Face/The Magician*). 1958.

———. *Jungfrukällen* (*The Virgin Spring*). 1959.

———. *Såsom i en spegel* (*Through a Glass Darkly*). 1961.

———. *Nattsvardsgästerna* (*The Communicants/Winter Light*). 1962.

———. *Tystnaden* (*The Silence*). 1963.

———. *För att inte tala om alla dessa kvinnor* (*Now About These Women/All These Women*). 1964.

———. *Persona.* 1966.

———. *Vargtimmen* (*Hour of the Wolf*). 1966, released 1968.

———. *Skammen* (*Shame*). 1967, released 1968.

———. *Riten* (*The Rite/Ritual*). 1968, released 1969.

———. *En Pasion* (*A Passion/The Passion of Anna*). 1969.

———. *Beröringen* (*The Touch*). 1970.

———. *Viskningar och Rop* (*Cries and Whispers*). 1972.

———. *Scener ur ett äktenskap* (*Scenes from a Marriage*). 1972 (TV), 1974 (film).

———. *Ansikte mot Ansikte* (*Face to Face*). 1976.

Bertolucci, Bernardo. *Last Tango in Paris.* 1972.

Bogdanovich, Peter. *Targets.* 1968.

Brakhage, Stan. *Sincerity.* [In progress.]

Brook, Peter. *The Persecution and Assassination of Jean-Paul Marat as Performed by the Inmates of the Asylum at Charenton under the Direction of the Marquis de Sade* (*Marat/Sade*). 1966.

Brooks, Mel. *Blazing Saddles*. 1973.

———. *Silent Movie*. 1976.

Brown, Clarence. *Intruder in the Dust*. 1949.

Buñuel, Luis. *Un Chien Andalou (An Andalusian Dog)*. 1928. [Co-director, Salvador Dali.]

———. *L'Age d'or*. 1930. [Co-director, Dali.]

———. *Las Hurdes (Terre sans pain/Land without Bread)*. 1932.

———. *Los Olvidados (The Young and the Damned)*. 1950.

———. *El Angel Exterminador (The Exterminating Angel)*. 1962.

———. *Belle de jour*. 1967.

———. *La Voie lactée (The Milky Way)*. 1968.

———. *Tristana*. 1970.

———. *Le Charme discret de la bourgeoisie (The Discrete Charm of the Bourgeoisie)*. 1972.

———. *Le Fantòme de la Liberté (The Phantom of Liberty)*. 1974.

Bute, Mary Ellen. *Finnegans Wake*. 1965.

Byrum, John. *Inserts*. 1976.

Capra, Frank. *It's a Wonderful Life*. 1946.

Carné, Marcel. *Quai des brumes (Port of Shadows)*. 1938.

———. *Le Jour se lève (Daybreak)*. 1939.

———. *Les Enfants du paradis (Children of Paradise)*. 1945.

Chaplin, Charles. *The Gold Rush*. 1925.

———. *Limelight*. 1951.

Clair, René. *Entr'acte*. 1924.

Clayton, Jack. *The Innocents*. 1961.

———. *The Pumpkin Eater*. 1964.

Cline, Eddie. *One Week*. 1920. [Co-director, Buster Keaton.]

———. *The Balloonatic*. 1923. [Co-director, Keaton.]

———. *Never Give a Sucker an Even Break*. 1941.

Cocteau, Jean. *Le Sang d'un poète (Blood of a Poet)*. 1930.

———. *Orphée (Orpheus)*. 1950.

Cohl, Emile. *Hasher's Delirium.* 1906.

Collins, Jack. *Blue Jeans.* 1917.

Coppola, Francis Ford. *The Godfather, Part I.* 1972.

———. *The Conversation.* 1973.

———. *The Godfather, Part II.* 1974.

Corman, Roger. *X—The Man with the X-Ray Eyes.* 1963.

———. *The Trip.* 1967.

Costa-Gavras, Costi. *Z.* 1969.

———. *State of Siege.* 1972.

Crichton, Charles. *Dead of Night.* 1945. [Episode; coordinator, Basil Dearden.]

———. *The Lavender Hill Mob.* 1951.

Cukor, George. *A Woman's Face.* 1941.

Curtiz, Michael. *Yankee Doodle Dandy.* 1942.

———. *Casablanca.* 1942.

Daves, Delmer. *Dark Passage.* 1947.

Dearden, Basil. *Dead of Night.* 1945. [Co-directors, Alberto Cavalcanti, Charles Crichton, Robert Hamer; Dearden directed the linking story.]

DePalma, Brian. *Obsession.* 1976.

———. *Carrie.* 1976.

Deren, Maya. *Meshes of the Afternoon.* 1943. [Co-director, Alexander Hammid.]

———. *Ritual in Transfigured Time.* 1946.

Dieterle, William. *Love Letters.* 1945.

Disney, Walt. *Through the Mirror.* 1936.

———. *Snow White and the Seven Dwarfs.* 1937.

———. *Fantasia.* 1940.

———. *Dumbo.* 1941.

———. *Alice in Wonderland.* 1951.

Dmytryk, Edward. *Murder My Sweet (Farewell My Lovely).* 1944.

———. *Mirage.* 1965.

Donen, Stanley. *Singin' in the Rain.* 1952. [Co-director, Gene Kelly.]

———. *Two for the Road.* 1967.

Downey, Robert. *Putney Swope.* 1969.

———. *Two Tons of Turquoise to Taos Tonight.* 1976.

Drach, Michel. *Les Violons du bal.* 1974.

Dreyer, Carl. *La Passion de Jeanne d'Arc (The Passion of Joan of Arc).* 1928.

———. *Vampyr (The Strange Adventure of David Gray/ Not Against the Flesh/Castle of Doom).* 1931, released 1932.

———. *Gertrud.* 1964.

Eisenstein, Sergei. *Bronenosets "Potyomkin" (Battleship Potemkin/Potemkin).* 1925.

———. *Oktyabr' (October/Ten Days that Shook the World).* 1927, released 1928.

Emerson, John. *The Mystery of the Leaping Fish.* 1916.

Enrico, Robert. *La Rivière du Hibou (An Occurrence at Owl Creek Bridge).* 1961, released 1962 as part of *Au Coeur de la vie.*

Epstein, Jean. *La Chute de la maison Usher (The Fall of the House of Usher).* 1928.

Erice, Victor. *Spirit of the Beehive.* 1974.

Faulkner, William (screenwriter). *War Birds.* 1933, unproduced.

———. *Dreadful Hollow.* n.d. (1940s), unproduced.

Fellini, Federico. *Otto e mezzo (8½).* 1963.

———. *Giulietta degli spiriti (Juliet of the Spirits).* 1965.

———. *I Clowns (The Clowns).* 1970.

———. *Amarcord.* 1974.

Fleischer, Richard. *20,000 Leagues under the Sea.* 1954.

Fleming, Victor. *The Wizard of Oz.* 1939.

———. *Dr. Jekyll and Mr. Hyde.* 1941.

Ford, John. *The Informer.* 1935.

———. *How Green Was My Valley.* 1941.

———. *The Quiet Man.* 1952.

———. *The Searchers.* 1956.

———. *The Man Who Shot Liberty Valance.* 1962.

———. *Cheyenne Autumn.* 1964.

Frampton, Hollis. *Zorns Lemma.* 1970.

Frankenheimer, John. *Seconds.* 1966.

Freund, Karl. *The Mummy.* 1932.

Galeen, Henrik. *Der Student von Prag (The Student of Prague).* 1926.

Gance, Abel. *La Folie du Docteur Tube (The Madness of Dr. Tube).* 1914.

———. *Napoléon vu par Abel Gance (Napoleon).* 1927.

———. *Bonaparte and the Revolution.* 1971.

Ginsberg, Milton Moses. *Coming Apart.* 1969.

Godard, Jean-Luc. *Une Histoire d'eau.* 1958. [Co-director, François Truffaut.]

———. *A bout de souffle (Breathless).* 1959.

———. *Le Petit soldat (The Little Soldier).* 1960.

———. *Une Femme est une femme (A Woman Is a Woman).* 1961.

———. *Les Carabiniers (The Riflemen).* 1963.

———. *Le Mépris (Contempt/A Ghost at Noon).* 1963.

———. *Bande à part (Band of Outsiders).* 1964.

———. *Une Femme mariée (A Married Woman).* 1964.

———. *Alphaville: Une étrange aventure de Lemmy Caution (Alphaville).* 1965.

———. *Pierrot le fou (Crazy Pete).* 1965.

———. *Masculin-féminin (Masculine-Feminine).* 1966.

———. *Made in U.S.A.* 1966.

———. *Deux ou trois choses que je sais d'elle (Two or Three Things I Know About Her).* 1966.

———. *Loin du Vietnam (Far from Vietnam).* 1967. [Episode; coordinator, Chris Marker.]

———. *La Chinoise.* 1967.

———. *Weekend.* 1967.

———. *Le Gai savoir.* 1968.

———. *One Plus One (Sympathy for the Devil).* 1968.

———. *Un Film comme des autres (British Sounds/See You at Mao).* 1968. [Co-director, Jean-Pierre Gorin.]

———. *Pravda.* 1969. [Co-director, Gorin.]

———. *Vent d'est (Vento Dell'Est/Wind from the East).* 1969. [Co-director, Gorin.]

———. *Tout va bien (Just Great)*. 1972. [Co-director, Gorin.]

———. *Letter to Jane*. 1972. [Co-director, Gorin.]

———. *A bout de souffle numéro deux (Numéro Deux)*. 1975.

Griffith, David Wark. *After Many Years*. 1908.

———. *Enoch Arden*. 1911.

———. *Judith of Bethulia*. 1914.

———. *The Birth of a Nation*. 1915.

———. *Intolerance: A Sun Play of the Ages*. 1916.

———. *Broken Blossoms*. 1919.

Hamer, Robert. *Dead of Night*. 1945. [Episode; coordinator, Basil Dearden.]

———. *Kind Hearts and Coronets*. 1949.

Hawks, Howard. *Red River*. 1948.

Herzog, Werner. *Herz aus Glas (Heart of Glass)*. 1976.

Hill, George Roy. *Period of Adjustment*. 1962.

Hitchcock, Alfred. *Rebecca*. 1940.

———. *Suspicion*. 1941.

———. *Spellbound*. 1945.

———. *Notorious*. 1946.

———. *Strangers on a Train*. 1951.

———. *Rear Window*. 1954.

———. *Vertigo*. 1958.

———. *Psycho*. 1960.

———. *Marnie*. 1964.

Hopper, Dennis. *The Last Movie*. 1971.

Huston, John. *The Maltese Falcon*. 1941.

———. *Freud (Freud—the Secret Passion)*. 1962.

———. *The Man Who Would Be King*. 1975.

Jessua, Alain. *La Vie à envers (Life Upside Down)*. 1964.

Jones, Chuck. *Hair-Raising Hare*. 1945.

———. *The Scarlet Pumpernickel*. 1950.

———. *Dripalong Daffy*. 1951.

———. *Duck Amuck*. 1953.

———. *Beanstalk Bunny*. 1955.

———. *Gee Whizz*. 1956.

213

Kazan, Elia. *The Last Tycoon*. 1976.

Keaton, Buster. *One Week*. 1920. [Co-director, Eddie Cline.]

———. *The Goat*. 1921. [Co-director, Mal St. Clair.]

———. *The Balloonatic*. 1923. [Co-director, Cline.]

———. *Sherlock Junior*. 1924.

Kirsanoff, Dimitri. *Ménilmontant*. 1925.

Kobayashi, Masaki. *Seppuku (Harakiri)*. 1962.

———. *Kaidan (Kwaidan)*. 1964.

Korty, John. *The Crazy-Quilt*. 1966.

Krish, John. *The Unearthly Stranger*. 1963.

Kubrick, Stanley. *Lolita*. 1962.

———. *2001: A Space Odyssey*. 1968.

———. *A Clockwork Orange*. 1971.

Kurosawa, Akira. *Rashomon*. 1950.

———. *Ikiru (To Live)*. 1952.

———. *Dodes'ka-den*. 1970.

———. *Dersu Uzala*. 1975.

Lanfield, Sidney. *The Hound of the Baskervilles*. 1939.

Lang, Fritz. *Der Müde Tod (Destiny)*. 1921.

———. *Dr. Mabuse der Spieler* (esp. Part Two, "Inferno").
1922.

———. *Metropolis*. 1926.

———. *Scarlet Street*. 1945.

Léger, Fernand. *Ballet mécanique*. 1924.

Leisen, Michael. *Lady in the Dark*. 1944.

Lumet, Sidney. *The Pawnbroker*. 1965.

Lumière, Louis. *Le Déjeuner de Bébé (Baby's Breakfast)*.
1895.

———. *Arrivée d'un train en gare*. 1895.

Makavejev, Dusan. *Nevinost bez zastite (Innocence Unpro-
tected)*. 1968.

———. *WR—Misterije organizma (WR—Mysteries of the
Organism)*. 1971.

———. *Sweet Movie*. 1975.

Malick, Terrence. *Badlands*. 1973.

Mamoulian, Rouben. *Dr. Jekyll and Mr. Hyde*. 1931.

Marker, Chris. *La Jetée*. 1962, released 1964.

————. *Loin du Vietnam* (*Far from Vietnam*). 1967. [Directors, Jean-Luc Godard, Joris Ivens, William Klein, Claude Lelouch, Alain Resnais; Agnès Varda's episode not included.]

Maysles, Albert; David Maysles; and Charlotte Zwerin. *Gimme Shelter.* 1971.

McBride, Jim. *David Holzman's Diary.* 1968.

McCay, Winsor. *Gertie the Trained Dinosaur.* 1910.

McLeod, Norman Z. *The Secret Life of Walter Mitty.* 1947.

Medak, Peter. *The Ruling Class.* 1971.

Minnelli, Vincente. *The Pirate.* 1947.

————. *Father of the Bride.* 1950.

————. *An American in Paris.* 1951.

————. *Designing Woman.* 1957.

Montgomery, Robert. *Lady in the Lake.* 1946.

Murnau, Friedrick Wilhelm. *Der letzte Mann* (*The Last Laugh*). 1924.

Murphy, Dudley. *The Emperor Jones.* 1933.

Newman, Paul. *Rachel, Rachel.* 1968.

Nichols, Mike. *Catch-22.* 1970.

————. *Carnal Knowledge.* 1971.

Ophuls, Marcel. *The Sorrow and the Pity.* 1970.

————. *The Memory of Justice.* 1976.

Pabst, Georg Wilhelm. *Geheimnisse einer Seele* (*Secrets of a Soul*). 1926.

————. *Die Liebe der Jeanne Ney* (*The Love of Jeanne Ney*). 1927.

Pasolini, Piero Paolo. *Teorema* (*Theorem*). 1968.

————. *Medea.* 1971.

Peckinpah, Sam. *Straw Dogs.* 1971.

Penn, Arthur. *Bonnie and Clyde.* 1967.

————. *Little Big Man.* 1970.

Polanski, Roman. *Repulsion.* 1965.

————. *The Tenant.* 1976.

Porter, Edwin S. *The Life of an American Fireman.* 1903.

————. *The Great Train Robbery.* 1903.

————. *Dream of a Rarebit Fiend.* 1906.

Pudovkin, Vsevolod I. *Mat* (*Mother*). 1926.

Ray, Man. *Retour à raison* (*Return to Reason*). 1923.

Renoir, Jean. *Le Crime de M. Lange* (*The Crime of Mr. Lange*). 1936.

——. *The Southerner*. 1945.

——. *Le Petit théatre de Jean Renoir* (*The Little Theatre of Jean Renoir*). 1971.

Resnais, Alain. *Nuit et brouillard* (*Night and Fog*). 1955.

——. *Hiroshima, mon amour*. 1959.

——. *L'Année dernière à Marienbad* (*Last Year at Marienbad*). 1961.

——. *Muriel, ou le temps d'un retour* (*Muriel*). 1963.

——. *La Guerre est finie* (*The War Is Over*). 1966.

——. *Loin du Vietnam* (*Far from Vietnam*). 1967. [Episode; coordinator, Chris Marker.]

——. *Je t'aime, je t'aime*. 1968.

——. *Stavisky*. 1974.

——. *Providence*. 1977.

Reynaud, Emile. *Un bon bock*. 1891.

——. *Pauvre Pierrot*. 1891.

——. *Rêve au coin de feu*. 1894.

Richardson, Tony. *Sanctuary*. 1961.

——. *The Loneliness of the Long Distance Runner*. 1962.

Riefenstahl, Leni. *Olympia*. 1938.

Rivette, Jacques. *Paris nous appartient*. 1960.

Robbe-Grillet, Alain. *L'Immortelle*. 1962.

——. *Trans-Europ Express*. 1966.

——. *L'Homme qui ment* (*The Man Who Lies/Shock Troops*). 1969.

Robinson, Arthur. *Schatten* (*Warning Shadows*). 1922.

Roeg, Nicolas. *Performance*. 1970. [Co-director, Douglas Cammell.]

——. *Walkabout*. 1971.

——. *Don't Look Now*. 1973.

——. *The Man Who Fell to Earth*. 1976.

Rosi, Francesco. *Salvatore Giuliano*. 1961.

Ross, Herbert. *Play It Again, Sam.* 1972.

Rossellini, Roberto. *Roma, Città Aperta (Open City).* 1945.

Rowland, Ray. *The 5000 Fingers of Dr. T.* 1953.

Russell, Ken. *The Boy Friend.* 1971.

Rydell, Mark. *The Reivers.* 1969.

Rye, Stella. *Der Student von Prag (The Student of Prague).* 1913.

Schepisi, Fred. *The Devil's Playground.* 1976.

Schneider, Alan. *Film.* 1965.

Scola, Ettore. *We All Loved Each Other So Much.* 1975.

Scorsese, Martin. *Mean Streets.* 1973.

Sennett, Mack. *Mabel's Dramatic Career.* 1913.

———. *Astray from the Steerage.* 1920.

Sjöberg, Alf. *Hets (Frenzy/Torment).* 1944.

———. *Fröken Julie (Miss Julie).* 1951.

Sjöström, Victor. *Körkarlen (The Phantom Chariot).* 1920.

Sternberg, Josef von. *Der blaue Engel (The Blue Angel).* 1930.

———. *The Scarlet Empress.* 1934.

Stiller, Mauritz. *Thomas Graals bästa film (Thomas Graal's Best Film/Wanted—An Actress).* 1917.

———. *Sangen om den eldröba (Song of the Scarlet Flower/ The Flame of Life).* 1918.

———. *Erotikon.* 1920.

Strick, Joseph. *The Balcony.* 1963.

———. *Ulysses.* 1967.

Stroheim, Erich von. *Greed.* 1923. [As originally planned.]

———. *The Wedding March.* 1928.

Sturges, Preston. *Sullivan's Travels.* 1942.

Tanner, Alain. *Jonah Who Will Be Twenty-Five in the Year 2000.* 1976.

Thompson, J. Lee. *The Reincarnation of Peter Proud.* 1975.

Tourner, Jacques. *I Walked with a Zombie.* 1943.

Tourneur, Maurice. *The Bluebird.* 1918.

Truffaut, François. *Les Mistons (The Mischief Makers).* 1957.

Truffaut, François. *Une Histoire d'eau.* 1958. [Co-director, Jean-Luc-Godard.]

——. *Les Quatre cents coups (The 400 Blows).* 1959.

——. *Tirez sur le pianiste (Shoot the Piano Player).* 1960.

——. *Jules et Jim (Jules and Jim).* 1961.

——. *La Nuit Americaine (Day for Night).* 1973.

——. *L'Histoire d'Adele H. (The Story of Adele H.).* 1975.

Varda, Agnès. *Uncle Yanco.* 1968.

Vertov, Dziga. *Kino-Pravda (Film Truth).* 1922-25.

——. *Chelovek s kinoapparatom (The Man with a Movie Camera).* 1928.

Watkins, Peter. *Culloden.* 1964.

——. *The War Game.* 1965.

——. *Privilege.* 1966.

——. *Gladiatorerna (The Peace Game/The Gladiators).* 1968.

——. *Punishment Park.* 1971.

——. *Edvard Munch.* 1976.

Watson, Dr. James Sibley and Melville Webber. *The Fall of the House of Usher.* 1928.

Welles, Orson. *Citizen Kane.* 1941.

——. *The Magnificent Ambersons.* 1942.

——. *The Lady from Shanghai.* 1947.

——. *F for Fake.* 1977.

Wertmüller, Lina. *Seven Beauties.* 1975.

Wiene, Robert. *Das Kabinett des Dr. Caligari (The Cabinet of Dr. Caligari).* 1919.

Wilder, Billy. *Double Indemnity.* 1944.

——. *The Lost Weekend.* 1945.

——. *Sunset Boulevard.* 1950.

Zinnemann, Fred. *Julia.* 1977.

B. PRINTED SOURCES

Abel, Lionel. *Metatheatre: A New View of Dramatic Form.* New York: Hill and Wang, 1963.

Alter, Robert. *Partial Magic: The Novel as a Self-Conscious Genre*. Berkeley and Los Angeles: University of California Press, 1975.

Andrew, J. Dudley. *The Major Film Theories: An Introduction*. New York: Oxford University Press, 1976.

Armes,. Roy. *The Cinema of Alain Resnais*. New York: A. S. Barnes, 1968.

————. *French Cinema Since 1946*. 2 vols. 2nd ed. New York: A. S. Barnes, 1970.

————. *Film and Reality: An Historical Survey*. Baltimore: Penguin Books, 1974.

Arnheim, Rudolf. *Film as Art*. Berkeley and Los Angeles: University of California Press, 1957.

————. *Art and Visual Perception*. Berkeley and Los Angeles: University of California Press, 1967.

————. *Visual Thinking*. Berkeley and Los Angeles: University of California Press, 1969.

————. "On the Nature of Photography." *Critical Inquiry* 1 (Sept. 1974), 148-161.

Balázs, Béla. *Theory of the Film: Character and Growth of a New Art*. Translated by Edith Bone. New York: Dover, 1970.

Barthes, Roland. *Writing Degree Zero and Elements of Semiology*. Translated by Annette Lavers and Colin Smith. Boston: Beacon Press, 1970.

————. *Mythologies*. Translated by Annette Lavers. New York: Hill and Wang, 1973.

Baudelaire, Charles. *Baudelaire: Selected Verse*. Edited by Francis Scarfe. Baltimore: Penguin Books, 1961.

Bazin, André. *What Is Cinema?* Translated by Hugh Gray. 2 vols. Berkeley and Los Angeles: University of California Press, 1967, 1971.

Beckett, Samuel. *The Unnamable*. New York: Grove Press, 1958.

————. *Endgame*. New York: Grove Press, 1958.

————. *Film*. New York: Grove Press, 1969.

Benjamin, Walter. *Illuminations.* Translated by Harry Zohn. New York: Schocken Books, 1969.

Bergman, Ingmar. *Four Screenplays of Ingmar Bergman: Smiles of a Summer Night, The Seventh Seal, Wild Strawberries, The Magician.* Translated by Lars Malmstrom and David Kushner. New York: Simon and Schuster, 1960.

―――. *Three Films by Ingmar Bergman: Through a Glass Darkly, Winter Light, The Silence.* Translated by Paul Britten Austin. New York: Grove Press, 1970.

―――. *Bergman: Persona and Shame.* Translated by Keith Bradfield. New York: Grossman, 1972.

―――. *Scenes from a Marriage: Six Dialogues for Television.* New York: Pantheon Books, 1974.

―――. *Face to Face.* Translated by Alan Blair. New York: Pantheon Books, 1976.

―――. *Four Stories by Ingmar Bergman: The Touch, Cries and Whispers, The Hour of the Wolf, The Passion of Anna.* Translated by Alan Blair. Garden City: Anchor Press/Doubleday, 1977.

Björkman, Stig; Torsten Manns; and Jonas Sima. *Bergman on Bergman.* Translated by Paul Britten Austin. New York: Simon and Schuster, 1973.

Blesh, Rudi. *Keaton.* New York: Macmillan, 1966.

Booth, Wayne. *The Rhetoric of Fiction.* Chicago: University of Chicago Press, 1961.

Brecht, Bertolt. *The Measures Taken.* Translated by Eric Bentley, in *The Modern Theatre: Volume Six,* ed. Eric Bentley. Garden City: Doubleday, 1960.

―――. *Parables for the Theatre: The Good Woman of Setzuan and The Caucasian Chalk Circle.* Translated by Eric Bentley and Maja Apelman. New York: Grove Press, 1963.

Breton, André. *Manifestes de Surréalisme.* Paris: J. J. Pauvert, 1962.

Brontë, Emily. *Wuthering Heights.* Boston: Houghton Mifflin, 1956.

Brown, Royal S. *Focus on Godard*. Englewood Cliffs: Prentice-Hall, 1972.

Büchner, Georg. *Woyzeck: Ein Fragment*. Stuttgart: Reclam, 1966.

Burgess, Anthony. *A Clockwork Orange*. New York: W. W. Norton, 1963.

Carroll, Lewis. *Alice in Wonderland: Alice's Adventures in Wonderland, Through the Looking-Glass, The Hunting of the Snark*. Edited by Donald J. Gray. New York: W. W. Norton, 1971.

Carson, L. M. Kit and Jim McBride. *David Holzman's Diary*. New York: Noonday, 1970.

Cavell, Stanley. *The World Viewed: Reflections on the Ontology of Film*. New York: Viking Press, 1971.

Cawkwell, Tim and John M. Smith. *The World Encyclopedia of the Film*. New York: A & W Visual Library, 1972.

Conrad, Joseph. *Heart of Darkness*. Edited by Robert Kimbrough. New York: W. W. Norton, 1971.

DeGeorge, Richard and Fernande, eds. *The Structuralists from Marx to Lévi-Strauss*. Garden City: Doubleday, 1972.

Dickens, Charles. *A Tale of Two Cities*. New York: E. P. Dutton, 1906.

———. *Oliver Twist*. New York: Oxford University Press, 1966.

Dickinson, Emily. *Complete Poems*. Edited by Thomas H. Johnson. Boston: Little, Brown & Co., 1960.

Dorn, Ed. *Gunslinger*. Berkeley: Wingbow Press, 1975.

Duras, Marguerite. *Hiroshima, Mon Amour*. Translated by Richard Seaver. New York: Grove Press, 1961.

———. *Four Novels*. Translated by Sonia Pitt-Rivers et al. New York: Grove Press, 1965.

Dylan, Bob. *Writings and Drawings by Bob Dylan*. New York: Alfred A. Knopf, 1973.

Ehrmann, Jacques. *Structuralism*. Garden City: Doubleday, 1970.

Eisenstein, Sergei. *The Film Sense*. Translated by Jay Leyda. New York: Harcourt Brace and World, 1947.

———. *Film Form: Essays in Film Theory*. Translated by Jay Leyda. New York: Harcourt Brace and World, 1949.

———. *Film Essays and a Lecture*. Translated by Jay Leyda. New York: Praeger, 1970.

Eisner, Lotte. *The Haunted Screen: Expressionism in the German Cinema and the Influence of Max Reinhardt*. Translated by Roger Greaves. Berkeley and Los Angeles: University of California Press, 1969.

Faulkner, William. *The Sound and the Fury*. New York: Cape and Smith, 1929.

———. *As I Lay Dying*. New York: Cape and Smith, 1930.

———. *Absalom, Absalom!* New York: Random House, 1936.

———. *The Wild Palms*. New York: Random House, 1939.

Fitzgerald, F. Scott. *The Great Gatsby*. New York: Charles Scribner's Sons, 1953.

Foucault, Michel. *The Order of Things*. New York: Pantheon Books, 1970.

Geduld, Harry. *Film Makers on Film Making*. Bloomington: Indiana University Press, 1969.

Genet, Jean. *The Balcony*. Translated by Bernard Frechtman. New York: Grove Press, 1960.

———. *The Blacks: A Clown Show*. Translated by Bernard Frechtman. New York: Grove Press, 1960.

Gibson, Arthur. *The Silence of God: Creative Response to the Films of Ingmar Bergman*. New York: Harper and Row, 1969.

Godard, Jean-Luc. *Le Petit Soldat*. Translated by Nicholas Garnham. New York: Simon and Schuster, n.d.

———. *Alphaville*. Translated by Peter Whitehead. New York: Simon and Schuster, n.d.

———. *Pierrot Le Fou*. Translated by Peter Whitehead. New York: Simon and Schuster, n.d.

———. *Masculine-Feminine*. New York: Grove Press, 1969.

————. *Weekend and Wind from the East*. Translated by Nicholas Fry, Marianne Sinclair, and Danielle Adkinson. New York: Simon and Schuster, 1972.

————. *Godard: Three Films: A Woman Is a Woman, A Married Woman, Two or Three Things I Know About Her*. Translated by Jan Dawson, Susan Bennett, and Marianne Alexander. New York: Harper and Row, 1975.

Gombrich, E. H. *Art and Illusion: A Study in the Psychology of Pictorial Representation*. 2nd ed. Princeton: Princeton University Press, 1961.

Gottesman, Ronald. *Focus on Citizen Kane*. Englewood Cliffs: Prentice-Hall, 1971.

Halliwell, Leslie. *The Filmgoer's Companion*. 4th ed. New York: Avon Books, 1975.

Harcourt, Peter. *Six European Directors: Essays on the Meaning of Film Style*. Baltimore: Penguin Books, 1974.

Heidegger, Martin. *Being and Time*. Translated by John Macquarrie and Edward Robinson. New York: Harper and Row, 1962.

Henderson, Brian. "Towards a Non-Bourgeois Camera Style." *Film Quarterly* 24 (Winter 1970-1971), 2-14.

Higham, Charles. *The Films of Orson Welles*. Berkeley and Los Angeles: University of California Press, 1971.

Jacobs, Lewis. *The Rise of the American Film: A Critical History*. New York: Teachers College Press, 1969.

Joyce, James. *Ulysses*. New York: Random House, 1961.

————. *Finnegans Wake*. New York: Viking Press, 1958.

Kael, Pauline; Herman Mankiewicz; and Orson Welles. *The Citizen Kane Book*. Boston: Little, Brown & Co., 1971.

Kafka, Franz. *The Penal Colony: Stories and Short Pieces*. Translated by Willa and Edwin Muir. New York: Schocken Books, 1961.

Kaminsky, Stuart M. and Joseph Hill. *Ingmar Bergman: Essays in Criticism*. New York: Oxford University Press, 1975.

Kant, Immanuel. *Critique of Pure Reason.* Translated by Norman Kemp-Smith. New York: St. Martin's Press, 1965.

———. *Foundations of the Metaphysics of Morals.* Translated by Lewis White Beck. Indianapolis: Bobbs-Merrill, 1959.

———. *Critique of Judgment.* Translated by J. H. Bernard. New York: Hafner, 1961.

Kawin, Bruce F. *Telling It Again and Again: Repetition in Literature and Film.* Ithaca: Cornell University Press, 1972.

———. *Faulkner and Film.* New York: Ungar, 1977.

Kinder, Marsha and Beverle Houston. *Close-Up: A Critical Perspective on Film.* New York: Harcourt Brace Jovanovich, 1972.

Koch, Howard. *Invasion from Mars.* Princeton: Princeton University Press, 1940.

Kracauer, Siegfried. *From Caligari to Hitler: A Psychological History of the German Film.* Princeton: Princeton University Press, 1947.

———. *Theory of Film: The Redemption of Physical Reality.* New York: Oxford University Press, 1960.

Lacan, Jacques. *The Language of the Self: The Function of Language in Psychoanalysis.* Translated by Anthony Wilden. New York: Dell, 1975.

Laffay, Albert. *Logique du cinéma.* Paris: Masson, 1964.

Laing, R. D. *The Divided Self: An Existential Study in Sanity and Madness.* Baltimore: Penguin Books, 1965.

———. *The Politics of Experience.* New York: Ballantine, 1968.

Langer, Suzanne K. *Feeling and Form.* New York: Charles Scribner's Sons, 1953.

Laszlo, Ervin. *The Systems View of the World.* New York: George Braziller, 1972.

Lessing, Doris. *The Golden Notebook.* New York: Simon and Schuster, 1962.

Lévi-Strauss, Claude. *Totemism*. Translated by Rodney Needham. Boston: Beacon Press. 1963.

Lyons, John. *Introduction to Theoretical Linguistics*. Cambridge: Cambridge University Press, 1968.

MacBean, James Roy. *Film and Revolution*. Bloomington: Indiana University Press, 1975.

Macgowan, Kenneth. *Behind the Screen: The History and Techniques of the Motion Picture*. New York: Dell, n.d.

McBride, Joseph. *Orson Welles*. New York: Viking Press, 1972.

McCay, Winsor. *Dreams of the Rarebit Fiend*. New York: Dover, 1973.

McConnell, Frank. *The Spoken Seen: Film and the Romantic Imagination*. Baltimore: John Hopkins University Press, 1975.

Márquez, Gabriel García. *One Hundred Years of Solitude*. Translated by Gregory Rabassa. New York: Harper and Row, 1970.

Mast, Gerald and Marshall Cohen, eds. *Film Theory and Criticism: Introductory Readings*. New York: Oxford University Press, 1975.

Melville, Herman. *Moby-Dick*. Edited by Harrison Hayford and Hershel Parker. New York: W. W. Norton, 1967.

Metz, Christian. "Current Problems in Film Theory." Translated by Diana Matias. *Screen* 14 (Spring/Summer 1973), 40-87.

————. *Film Language: A Semiotics of the Cinema*. Translated by Michael Taylor. New York: Oxford University Press, 1974.

————. *Language and Cinema*. Translated by Donna Jean Umiker-Sebeok. The Hague: Mouton, 1974.

————. "The Imaginary Signifier." Translated by Ben Brewster. *Screen* 16 (Summer 1975), 14-76.

Milne, Tom. *Godard on Godard*. New York: Viking Press, 1972.

Mitry, Jean. *Esthétique et psychologie du cinéma.* 2 vols. Paris: Editions Universitaires, 1963, 1965.

Monaco, James. *The New Wave.* New York: Oxford University Press, 1976.

———. *How to Read a Film.* New York: Oxford University Press, 1977.

Münsterberg, Hugo. *The Film: A Psychological Study.* New York: Dover, 1970.

The New York Times. *The White House Transcripts.* New York: Bantam Books, 1974.

Noyes, Russell, ed. *English Romantic Poetry and Prose.* New York: Oxford University Press, 1956.

O'Neill, Eugene. *The Plays of Eugene O'Neill.* 3 vols. New York: Random House, 1955.

———. *Long Day's Journey into Night.* New Haven: Yale University Press, 1956.

Ornstein, Robert E. *The Psychology of Consciousness.* San Francisco: W. H. Freeman, 1972.

———. *The Nature of Human Consciousness: A Book of Readings.* San Francisco: W. H. Freeman, 1973.

Panofsky, Erwin. *Meaning in the Visual Arts: Papers in and on Art History.* Garden City: Doubleday, 1955.

Pechter, William S. *Twenty-Four Times a Second: Films and Film-makers.* New York: Harper and Row, 1971.

Perkins, V. F. *Film as Film: Understanding and Judging Movies.* Baltimore: Penguin Books, 1972.

Pirandello, Luigi. *Naked Masks.* Edited by Eric Bentley. New York: E. P. Dutton, 1952.

———. *Tonight We Improvise.* Revised and rewritten by Marta Abba. New York: Samuel French, 1960.

Poole, Roger. *Towards Deep Subjectivity.* New York: Harper and Row, 1972.

Pynchon, Thomas. *Gravity's Rainbow.* New York: Viking, 1973.

Rich, Adrienne. "Images for Godard." In *The Will to Change.* New York: W. W. Norton and Co., 1971.

226

Robbe-Grillet, Alain. *Last Year at Marienbad*. Translated by Richard Howard. New York: Grove Press, 1962.

———. *Two Novels: Jealousy and In the Labyrinth*. Translated by Richard Howard. New York: Grove Press, 1965.

———. *For a New Novel: Essays on Fiction*. Translated by Richard Howard. New York: Grove Press, 1965.

Robinson, David. *Buster Keaton*. Bloomington: Indiana University Press, 1969.

Roud, Richard. *Jean-Luc Godard*. 2nd ed. Bloomington: Indiana University Press, 1970.

Sadoul, Georges. *Dictionary of Film Makers*. Translated by Peter Morris. Berkeley and Los Angeles: University of California Press, 1972.

———. *Dictionary of Films*. Translated by Peter Morris. Berkeley and Los Angeles: University of California Press, 1972.

Samuels, Charles. *Encountering Directors*. New York: G. P. Putnam's Sons/Capricorn, 1972.

Śaṅkara. *The Vedānta Sutras of Bādarāyana, with the Commentary by Śaṅkara*. Translated by George Thibaut. 2 vols. New York: Dover, 1962.

Sarraute, Nathalie. *The Age of Suspicion: Essays on the Novel*. Translated by Maria Jolas. New York: George Braziller, 1963.

Sarris, Andrew. *Interviews with Film Directors*. New York: Bobbs-Merrill, 1967.

———. *The American Cinema: Directors and Directions 1929-1968*. New York: E. P. Dutton, 1968.

———. "Why Do We Expect Movies to Make Sense?" *The Village Voice*, 15 March 1976, pp. 147-148.

Sartre, Jean-Paul. *Being and Nothingness: An Essay in Phenomenological Ontology*. Translated by Hazel Barnes. New York: Philosophical Library, 1956.

Saussure, Ferdinand de. *Course in General Linguistics*. Translated by Wade Baskin. New York: McGraw-Hill, 1966.

Schickel, Richard. *The Men Who Made the Movies*. New York: Atheneum, 1975.

Scholes, Robert. *Structuralism in Literature: An Introduction*. New Haven: Yale University Press, 1974.

Shakespeare, William. *Complete Plays and Poems*. Edited by William Allan Neilson and Charles Jarvis Hall. Boston: Houghton Mifflin, 1942.

Simon, John. *Ingmar Bergman Directs*. New York: Harcourt Brace Jovanovich, 1972.

Sontag, Susan. *Against Interpretation and Other Essays*. New York: Dell, 1969.

———. *Styles of Radical Will*. New York: Dell, n.d.

Spicer, Jack. *The Collected Books of Jack Spicer*. Edited by Robin Blaser. Los Angeles: Black Sparrow Press, 1975.

Spottiswoode, Raymond. *A Grammar of the Film*. Berkeley and Los Angeles: University of California Press, 1950.

Stein, Gertrude. *Writings and Lectures 1909-1945*. Edited by Patricia Meyerowitz. Baltimore: Penguin Books, 1971.

Sterne, Laurence. *The Life and Opinions of Tristram Shandy, Gentleman*. Edited by James Aiken Work. Indianapolis: Bobbs-Merrill/Odyssey Press, 1940.

Stoppard, Tom. *Rosenkrantz and Guildenstern Are Dead*. New York: Grove Press, 1967.

Strindberg, August. *Six Plays*. Translated by Elizabeth Sprigge. Garden City: Doubleday, 1955.

Talbot, Daniel. *Film: An Anthology*. Berkeley and Los Angeles: University of California Press, 1967.

Tolstoy, Leo. *War and Peace*. Translated by Louise and Aylmer Maude. New York: W. W. Norton, 1966.

———. *Anna Karenina*. Translated by Louise and Aylmer Maude. New York: W. W. Norton, 1970.

———. *What Is Art?* Translated by Aylmer Maude. Indianapolis: Bobbs-Merrill, 1960.

Twain, Mark. *The Adventures of Huckleberry Finn*. Boston: Houghton Mifflin, 1958.

Vertov, Dziga. "The Writings of Dziga Vertov." In *Film Culture Reader*, ed. P. Adams Sitney. New York: Praeger, 1970.

Walsh, Martin. "Godard & Me: Jean-Pierre Gorin Talks." *Take One* 5 (February 1976), 14-17.

Wedekind, Frank. *Spring's Awakening: A Tragedy of Childhood*. Translated by Eric Bentley, in *The Modern Theatre: Volume Six*, ed. Eric Bentley. Garden City: Doubleday, 1960.

Weinberg, Herman G. *The Complete Greed*. New York: E. P. Dutton, 1973.

Weiss, Peter. *The Persecution and Assassination of Jean-Paul Marat as Performed by the Inmates of the Asylum at Charenton under the Direction of the Marquis de Sade*. Translated by Geoffrey Skelton and Adrian Mitchell. New York: Atheneum, 1965.

Whitehead, Alfred North. *Science and the Modern World*. New York: Macmillan, 1925.

Whitman, Walt. *Leaves of Grass: The First (1855) Edition*. Edited by Malcolm Cowley. New York: Viking Press, 1959.

Wilder, Thornton. *Our Town*. New York: Coward McCann, 1938.

Wittgenstein, Ludwig. *Tractatus Logico-Philosophicus*. Translated by D. F. Pears and B. F. McGuinness. London: Routledge and Kegan Paul, 1961.

———. *Philosophical Investigations*. Translated by G.E.M. Anscombe. 3rd ed. New York: Macmillan, 1975.

Wollen, Peter. *Signs and Meaning in the Cinema*. 3rd ed. Bloomington: Indiana University Press, 1972.

Wood, Robin. *Hitchcock's Films*. 2nd ed. New York: A. S. Barnes, 1969.

———. *Ingmar Bergman*. New York: Praeger, 1970.

INDEX

231

LIBRARY OF CONGRESS CATALOGING IN PUBLICATION DATA

Kawin, Bruce F 1945-
 Mindscreen.

 Bibliography: p.
 Includes index.
 1. Moving-pictures—Aesthetics. 2. Bergman,
Ingmar, 1918- 3. Godard, Jean Luc, 1930-
I. Title.
PN1995.K34 791.43'01 78-51173
 ISBN 0-691-06365-6
 ISBN 0-691-01348-9 pbk.